2-

14/11

Bunny Petroff

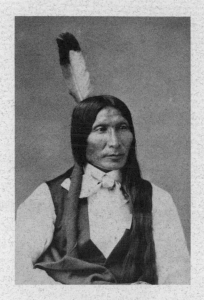

The circle, considered the perfect form by the Plains Indians, has no beginning or end. By tracing the four circles that symbolized the lives of Native Americans—the family, the tribe, humanity, and the unknown—this exhibition guides us through an important part of our country's heritage.

American Express is honored to join the National Endowment for the Arts and the National Endowment for the Humanities in supporting *Circles of the World*. We are also grateful to the Denver Art Museum, Curator Richard Conn, and his special consultants for conceiving this exhibition and bringing it to fruition.

Circles of the World reinforces American Express's continuing commitment to broaden cultural perspectives worldwide. We are proud to be able to share the richness of Native American cultures with people across the United States and in Europe.

James D. Robinson III
Trustee, American Express Foundation,
Chairman and Chief Executive Officer,
American Express Company

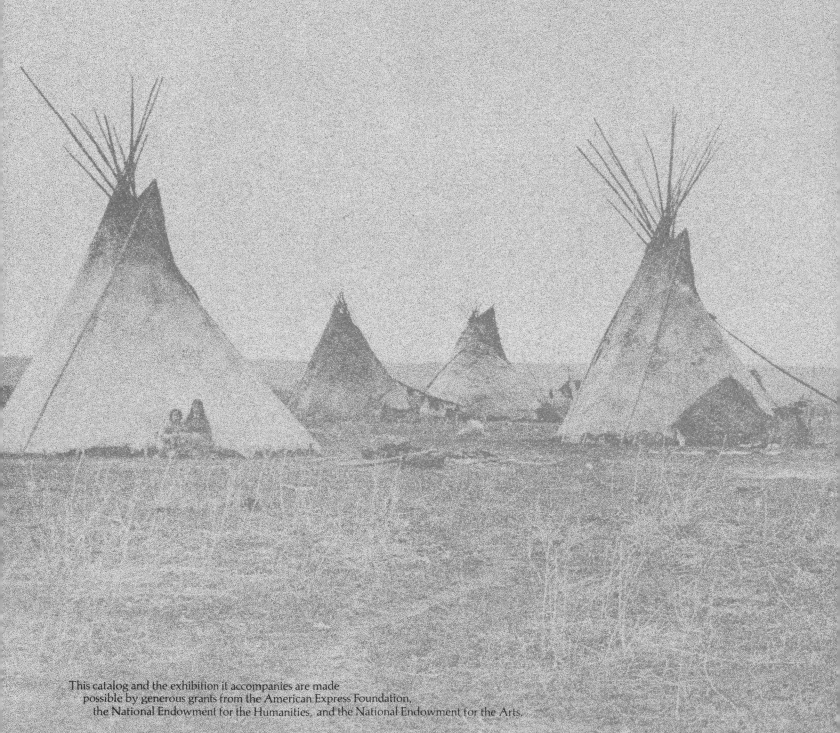

This catalog and the exhibition it accompanies are made
possible by generous grants from the American Express Foundation,
the National Endowment for the Humanities, and the National Endowment for the Arts.

CIRCLES OF THE WORLD

THE
WORLD

Traditional Art of
the Plains Indians

by Richard Conn
Denver Art Museum

Participating Museums

Denver Art Museum
April 21–June 13, 1982

Royal Scottish Museum
Edinburgh, Scotland
August 17–November 28, 1982

Museum des 20. Jahrhunderts
Vienna, Austria
January 20–March 13, 1983

Musée du Petit Palais
Paris, France
May 3–July 31, 1983

Muséum d'Histoire Naturelle de Toulouse
Toulouse, France
September 1–November 6, 1983

Museum of Fine Arts
Boston, Massachusetts
December 12, 1983–February 26, 1984

Cooper-Hewitt Museum
New York, New York
April 24–July 15, 1984

The Fine Arts Museums of San Francisco
M. H. deYoung Memorial Museum
San Francisco, California
Autumn 1984

Copyright © Denver Art Museum 1982
All rights reserved
Library of Congress Catalog Card Number 82-70497
ISBN 0-914738-27-5
Printed in the United States of America

Denver Art Museum
100 West 14th Avenue Parkway
Denver, Colorado 80204

Editors: Marlene Chambers, Margaret Ritchie
Editorial assistant: Carol Rawlings
Photographer: Lloyd Rule
Designer: Fred Rainey

Historic photographs: American Museum of Natural History, Bureau
of American Ethnology, and the Office of Anthropology

Typography by Lettergraphics/Denver, Inc.
Lithography by A. B. Hirschfeld Press

Cover
130. Crow ceremonial pipe

Early in the twentieth century, at a time when American Indian arts were considered the exclusive province of anthropology and natural history museums, the Denver Art Museum, with great perceptiveness and foresight, established an unwavering commitment to the acquisition of Native American art on the basis of its esthetic worth. Since the 1920s, an energetic and astute collection program has resulted in holdings in excess of 16,000 works which explore the artistic invention of our indigenous peoples.

Much of the credit for the development of the collection belongs to Anne Evans, daughter of Colorado's second territorial governor, who first advocated collecting native art and generously supported its acquisition, and Frederic H. Douglas, curator of the museum's native arts collection during its formative period. Through his pioneer field work and enormous enthusiasm, Douglas brought the collection to its present prominence and actively contributed to the increased awareness and appreciation of Native American art throughout the nation. Although other prestigious art museums have begun to assemble collections of Native American art and to organize major exhibitions in this area, the preeminent esthetic quality of the Denver Art Museum's collection remains unchallenged.

While its Native American holdings represent virtually every tribal group from Mesoamerica to the Arctic, the museum's Plains Indian collection is particularly noteworthy for its quality and depth. *Circles of the World* focuses on this segment of the collection, an impressive array of clothing, jewelry, military and ceremonial regalia, household objects, and horse equipment made by nomadic tribes who roamed the Great Plains from the Mississippi Valley to the Rocky Mountains. This exhibition is the first to bring a significant and unique part of the Denver Art Museum's collection to a wide audience; others are planned for the near future. By sharing the greatest strengths of our collection—areas of art considered nontraditional by most western standards—we have a special opportunity to bring to the world new perceptions of art and the cultures which produced it.

The Board of Trustees shares my profound gratitude to Richard Conn, curator of native arts, who conceived the exhibition, organized it in every regard, and wrote the impressive and informative catalog. His thorough knowledge and understanding of the Plains Indian culture and its arts are fully manifested in the exhibition and publication.

The trustees and staff of the museum are also deeply grateful for the exceptional financial support provided by the American Express Foundation, the National Endowment for the Humanities, and the National Endowment for the Arts. Their generosity has made possible all aspects of the exhibition and its circulation to eight museums in four nations. They have been equally generous in providing supportive guidance and expertise.

The Denver Art Museum is privileged to have this opportunity to share with the people of the United States and several European countries its commitment of more than half a century to the art of the people of the American plains.

Thomas N. Maytham
Director, Denver Art Museum

Preparing an exhibition for only one venue is a task involving endless details and numerous problems. Should the exhibition travel, the attendant demands increase still more. But preparing an exhibition for international travel is the greatest undertaking of all. In coping with the many facets of the *Circles of the World* exhibition, I have been privileged to enjoy the cooperation of many people both in Denver and wherever the exhibition is to appear. There are so many of them that I despair of making a complete listing. Any names omitted here must be considered an oversight of the moment and by no means a gauge of my very real and lasting gratitude for their help in making this project a reality.

When the exhibition was first suggested, I appreciated the encouragement of the museum's director, Thomas Maytham, and the Board of Trustees. Cathey McClain Finlon and Laura Lefkowits were crucial to the search for necessary financial support. As the project got underway, the labors of David Irving, assistant curator of native arts, began and have continued in every imaginable way. Mary Pachello and the Accounting Department staff advised on establishing budgets and records and showed superhuman patience in making them function smoothly. L. Anthony Wright and Susan Cambier undertook all details of travel arrangements with their usual efficiency. Glen Miller accomplished the formidable task of designing and building the shipping crates.

Marlene Chambers and her staff were responsible for producing the catalog and other printed materials. Their uncompromisingly high standards and dedication are always an assurance of excellence. Lloyd Rule, assisted by John Cowell and Palmore Clarke, created the handsome photographs reproduced in the catalog. An especial pleasure has been the collaboration of our humanities consultants, Dr. Beatrice Medicine, George Horse Capture, Dr. Omer Stewart, and Richard Tallbull, who reviewed the exhibition and catalog to assure its accuracy and its inclusion of the perspective of the Plains Indian people themselves. Other Native Americans served as models: Black Horse Foster, Charles Janis, Red Fawn Martin, Jolynne Peters, and Terry Eaglefeather.

Further preparations for the exhibition were undertaken by the Education Department, which devised programs realizing its informative potential, and the Public Relations Department, which disseminated information to an incredible number of media outlets. Four Denver women—Christl Kober and Luci Atkinson, born in Vienna, and Suzanne McLucas and Annie Miller, natives of France—worked diligently to provide accurate translations of all materials pertaining to the exhibition.

Although the bulk of the material in the exhibition comes from the Denver Art Museum's collection, we are honored by the generosity of those who made available objects of special interest. They are the Eastern Washington State Historical Society, Richard A. Novak, Harrison Eiteljorg, and Robert and Marcie Musser.

To install the exhibition, the museum staff under Jeremy Hillhouse was joined by Gordon Ashby, who served as design consultant. Mannequins were conceived by Leonard McCann and made by Raelee Fraser. Special object conservation was skillfully undertaken by Eryl Platzer and Charles Patterson. Student interns Elizabeth Stroh and Lucy Congdon labored in various ways to prepare the materials. Finally, the task of directing nontechnical repair fell into the capable hands of Mary Will Sassé, who gave more hours of patient and careful work than can be counted. She was assisted by an equally dedicated crew: Ann Houston, Dena Mann, Evelyn Dibble, Kathleen Burton, Kathy Moore, and Ronald Winters. These volunteers donated their work as a true labor of love. Without them this exhibition could never have taken place.

Richard Conn
Curator of Native Arts,
Denver Art Museum

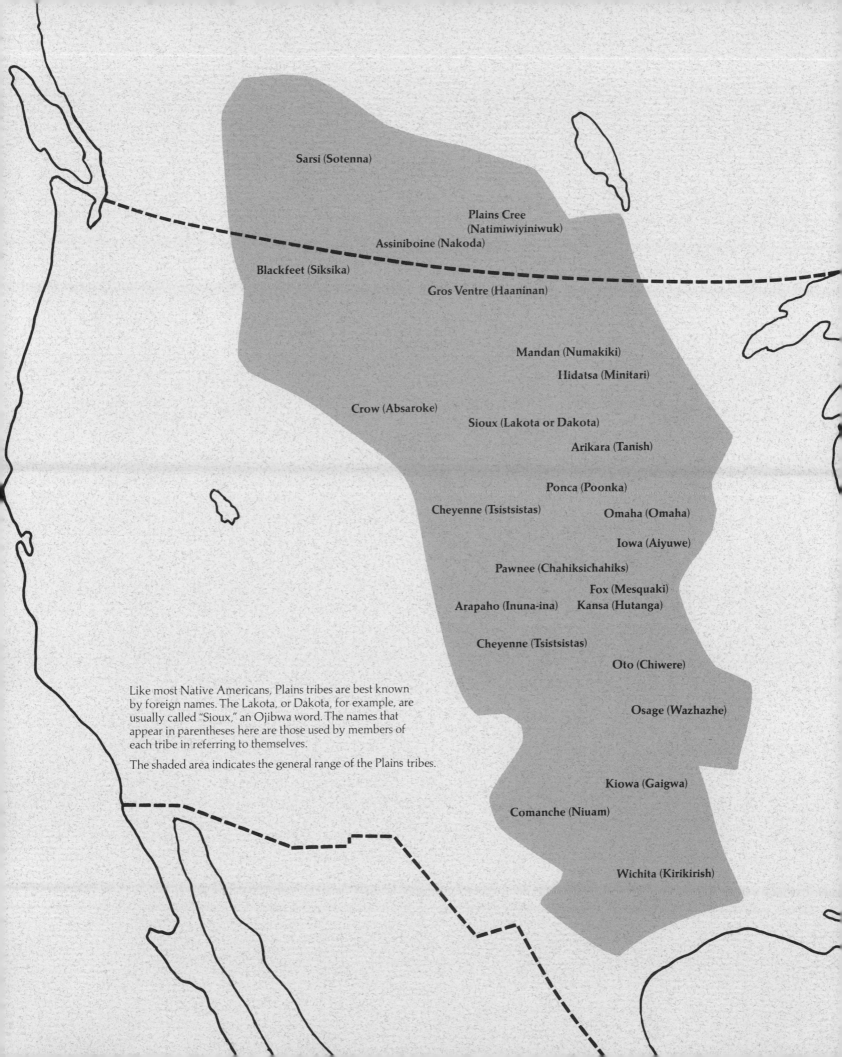

Sarsi (Sotenna)

Plains Cree
(Natimiwiyiniwuk)
Assiniboine (Nakoda)

Blackfeet (Siksika)

Gros Ventre (Haaninan)

Mandan (Numakiki)

Hidatsa (Minitari)

Crow (Absaroke)

Sioux (Lakota or Dakota)

Arikara (Tanish)

Ponca (Poonka)

Cheyenne (Tsistsistas) Omaha (Omaha)

Iowa (Aiyuwe)

Pawnee (Chahiksichahiks)

Fox (Mesquaki)
Arapaho (Inuna-ina) Kansa (Hutanga)

Cheyenne (Tsistsistas)

Oto (Chiwere)

Osage (Wazhazhe)

Like most Native Americans, Plains tribes are best known
by foreign names. The Lakota, or Dakota, for example, are
usually called "Sioux," an Ojibwa word. The names that
appear in parentheses here are those used by members of
each tribe in referring to themselves.

The shaded area indicates the general range of the Plains tribes.

Kiowa (Gaigwa)

Comanche (Niuam)

Wichita (Kirikirish)

Ever since they first became known to the outside world, the native people of the North American plains have fascinated the public imagination. These bold warriors, moving across their lands in a perpetual hunt, seemed like no other people on earth. The early nineteenth century hailed them as the epitome of Rousseau's "noble savage" living in a New World Eden. Scholars and artists from Europe and the eastern United States made long journeys to behold "Natural Man" in his pristine state and came away lauding the free, independent existence he lived. As the native people were forced into competition and conflict with expanding American society, this attitude changed, and the Plains tribes began to be denounced as "red devils" or, conversely, defended as oppressed people justly protecting their rights. But, even at the height of conflict, no American writer found them dull or uninteresting. Even their archenemy, General George Custer, expressed admiration for the people he pursued so ruthlessly.

From the beginning, European and American perceptions of Plains society were reinforced by the material goods produced and used by the nomadic tribes. Brightly decorated leather garments and fantastic feather ornaments seemed appropriate to the stereotype beginning to attach itself to the native people. Uncivilized man would naturally be expected to deck himself in the skins of beasts and the plumage of birds of prey. In time, specimens of Plains handiwork were available to be seen in London or Philadelphia, and the romantic notions non-Indian viewers invested them with became more and more distorted.

As the nineteenth century took on its distinctive stamp of morality and gentility, the negative side of the Indian stereotype became apparent. Insofar as they dehumanized the native people, these negative attributes were useful in rationalizing unjust behavior toward the Indian. Still viewed as brave warriors and clever craftsmen, the Plains tribes were depicted as lacking all domestic virtue or higher emotion. Further, it was rumored, their religion consisted of little but dark and fearsome superstition. Thus, Victorian conceptions of native Plains culture were polarized. Herman Melville denounced "snivelization" and opted for life in a tribal society while General W.T. Sherman declared "the only good Indians I ever saw were dead." Unfortunately, this two-sided stereotype persists in films, television dramas, novels, and comic strips, where such marvelous foolishness still passes as historical truth.

Because stereotypes, like prejudices, are generally held dear, they are very hard to break down. This exhibition is offered in an attempt to set part of the record straight. Its aim is to show examples of Plains art in its many forms and to explain how each served some area of traditional life. By this means, we hope to illuminate portions of Plains culture which have been overlooked or underestimated, such as the warmth of family relationships and the constructive aspect of native religious belief. The products of Plains Indian society can be properly appraised only when we have arrived at a balanced and mature view of the society itself.

The Circle: The Perfect Form

The circle has been chosen as the central device of the exhibition because the Plains people considered it an ideal form. Having neither beginning nor end, it reflected the eternal continuity of life. Further, like the reassuring bonds of family or tribal affiliation, a circle was all-encompassing. In the context of the plains landscape, these comparisons take on a greater significance. On the open plains, one can see in all directions a continuous horizon which is more or less level. All points thus appear equally distant, and there is an impression of living inside a circular field of vision and experience. This perception was well expressed by the Lakota holy man Eagle Voice in recalling a mystical experience of his youth:

I was standing on the highest hill in the center of the world. There was no sun,

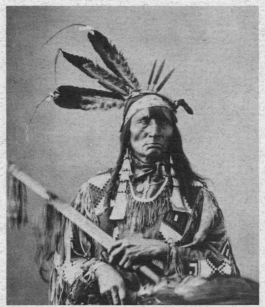

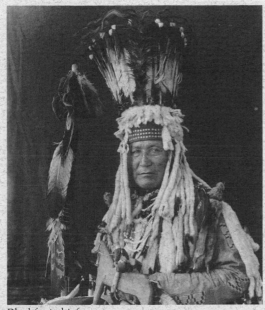

Walking Shooter, Hunkpapa Lakota, 1872

Blackfeet chief

but so clear was the light that what was far was near. The circle of the world was a great hoop with the two roads crossing where I stood, the black one and the red. And all around the hoop more peoples than I could count were sitting together in a sacred manner. The smokes of all the peoples' little fires stood tall and straight and still around the circle, and by the murmur of the voices of the peoples, they were happy.[1]

The Plains people drew upon the circle form in many ways. They lived in conical homes with circular bases which they arranged into camps in a ring formation. Circles also appear in the design of ritual properties like the magic hoops carried in major religious ceremonies. On a secular level, the shape occurs in game equipment and household objects like food bowls. However, the concept of the circle as a perfect shape was most pervasive on the intellectual level, where the universe was seen as a series of concentric horizons, beginning with the home and extending finally to the infinite. These circles corresponded to the individual's growing perceptions as he progressed from infancy to old age. Life began within the circle of the family and moved to the circle of the tribe, which encompassed the individual within the larger camp circle of tipis like his own. The tribal circle was and still is an important entity to the Plains Indians. Their metaphors of the last century frequently equate the tribal group with the notion of circularity: "the sacred hoop of the tribe" or "the circle of council fires." Remarks recorded in the nineteenth century emphasize the unity and strength of these circles and the necessity of maintaining them unbroken.

A third, larger circle included all humanity. Thus, Eagle Voice saw the "great hoop" of all peoples sitting in amity. Although this circle actually contained more enemies than friends, Eagle Voice suggests some common bond of humanity uniting all men. An important extension of the circle of humanity was the circle of the natural world, which included all other life forms. We have not dealt with nature *per se* in the exhibition since no objects were made in relation to it, although it was often the subject for the nonvisual art of storytelling. Many myths explain the origins of various species, recall their adventures, and tell of a legendary time when men, animals, and plants all lived in close community and understood one another's speech. Finally, the greatest of all circles comprised the unknowable world, *wakan*, containing beings and forces which man could neither see nor control. Significantly, the Plains people made their paramount ritual approach to these forces in the circular Sun Dance lodge each midsummer.

Within each of these circles, there were goals to be attained. These ranged from the

1. John G. Neihardt, *When the Tree Flowered* (New York: Macmillan, 1951), p. 53.

pursuit of individual needs through the search for prestige and honor to unselfish concern for the general welfare. In each case, the Plains people created objects to aid in achieving these goals, and the objects were designed with their ultimate purposes in mind. The basic forms of many artifacts, as well as the nature and extent of their decoration, reflect their intended use, whether physical or spiritual. It is these goal-oriented objects, variously described as Plains Indian art or as material culture, that are presented in this exhibition.

Plains Indian Art and Western Esthetics

Today one often hears the manufactures of traditional Plains culture called art objects. Questions of classification and relationship must arise whenever tribal creations are defined by the western term *art*. By whose definition can these objects be called art? Most perplexing of all, how is western civilization to look at them in comparison with the venerated accomplishments of a Michelangelo or Rembrandt?

Since art is to some extent a subjective and cerebral activity, it has always been difficult to define. Attempts to do so have ranged from very pragmatic statements to vague images in blank verse. Among the criteria that have been proposed to identify a genuine work of art, four seem particularly applicable to Plains Indian material culture: virtuosity, formal structure, expressiveness, and transcendence. Virtuosity refers to the artist's ability to manipulate his materials to the full extent of their possibilities. Formal structure is a historical element and reflects the accepted conventions and directions of each artist's time. Every work of art shows an understanding and application of current precepts. Thus, a baroque trio sonata reveals the composer's awareness of the accepted form, which he either followed or adapted to his needs. Expressiveness is the means by which an artist speaks through his work. He may give the observer some information about the subject, or he may make his work the vehicle for his own feelings. Without this expressiveness, a work becomes a mere exercise in virtuosity. Finally, the enduring nature of art is based on its transcendence. Even though succeeding generations will not relate to the work in the same way as the artist's contemporaries, its ability to continue to hold significance will transcend its original intentions. Although few today worship the ancient Greek gods, their statues have been hailed by millions who value them for their artistic merit alone.

Admittedly, many other definitions for art have been proposed by western philosophers and critics. Some have said that art should exist only of and for itself, playing no other role than esthetic enrichment. Related to this "art-for-art's-sake" position is the emphasis western thought has placed on the dichotomy between fine and applied art. According to this view, purely esthetic works such as paintings and sculpture are considered fine art, while applied art is defined as comprising all functional objects, such as ceramics or furniture, which have been designed and embellished by an artist's hand. Although this is a practical distinction, it carries the unfortunate connotation that the functional is somehow less important than the purely esthetic.

Some of these western criteria do, in fact, apply to traditional Plains objects, but only in very qualified terms. No people in the world have attained the virtuosity of Native Americans in the preparation of soft leathers, and their bead and quill embroidery shows a technical mastery that exploits the full potential of both materials. In the context of Indian stylistic traditions, paintings on leather and rawhide show the same high level of excellence as those on Greek vases. Formal structure can also be found in all Plains works. Since they were very conscious of tribal taste, the Plains people worked within accepted canons which they obviously understood and frequently modified for innovative effect. Expressiveness also occurs in Plains objects, though the idea of conveying personal feeling is decidedly uncommon. Instead, Plains artists generally transmitted factual messages of personal experience or accomplishment. One of the few exceptions is an interesting Lakota war song:

Friend, in common life

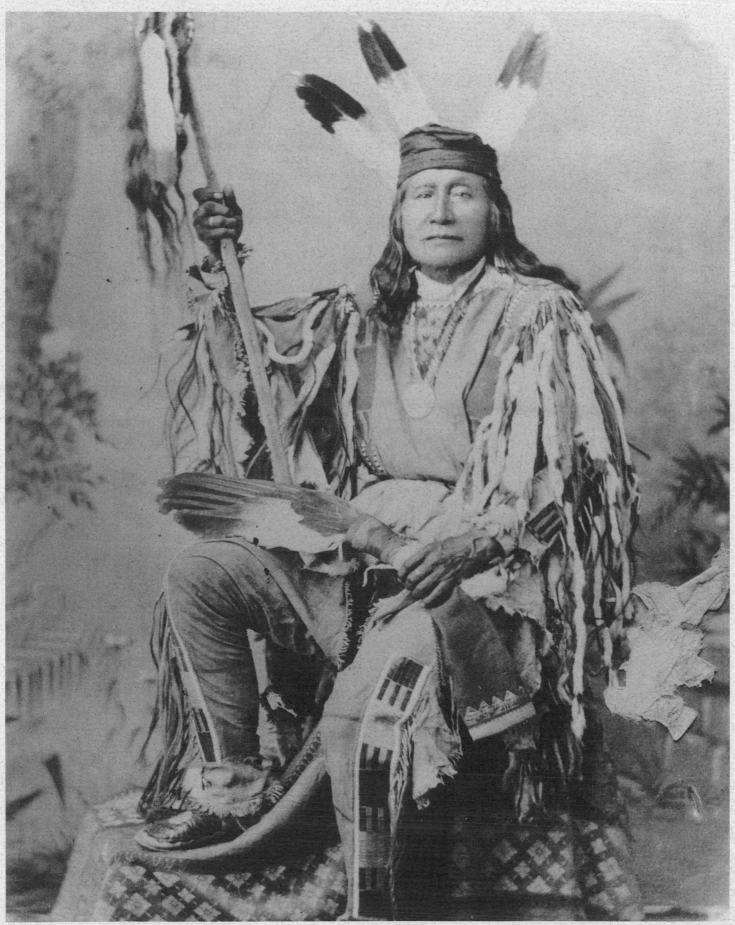

Son of the Star, Arikara chief

The customs are many.
Friend, those are not my interest.[2]

The singer expresses boredom with the polite behavior expected while in camp and a preference for the freedom he finds on war expeditions. Finally, since they are often appreciated today for esthetic reasons divorced from their original purpose, some forms of Plains art could be said to have attained transcendence. To a certain degree, then, traditional Plains objects satisfy some of our western criteria for art. Works in media like painting and embroidery seem to fit best, while, as classes, sculpture and metalworking fall short of western standards. A significant problem arises, though, when we apply the distinction between fine and applied arts. The majority of traditional Plains objects were meant to be functional. Their makers had little conception of producing anything purely for contemplation and inspiration, unless religious. Such objects would have been impediments in their nomadic lives. Thus, Plains material culture can be said to meet western definitions of art only with qualification and in partial disregard for its makers' actual intentions.

Plains Indian Esthetics

The Plains people themselves had definite ideas about the role of creative endeavor in their society. Because most objects made and owned by nineteenth century Plains Indians had some purpose to serve, the culture's artistic inclinations were directed toward beautifying and improving functional objects. In time, decoration and good design came to be perceived as increasing the effectiveness of an object and, thus, as integral to its purpose. This idea later gave rise to the belief that the artist enhanced his worthiness as a tribal citizen through the quality of his craftsmanship.

The Plains people also had their own artistic conventions and esthetic concepts. For instance, military narrative paintings were always drawn in full profile with no attempt at foreshortening or modeling. Because these paintings were meant to document actual battle scenes, accurate detail was required in the representation of essentials: weapons, war clothing, and sacred paraphernalia. Incongruously to our eyes, convention also dictated the use of abstract symbols to summarize complex actions like the warrior/artist's specific assignment in a particular battle.

Among Plains esthetic concepts were appropriateness, harmony, and sacredness. Design and decoration were expected to be appropriate to the object's intended use. Thus, garments or other artifacts made for secular use reflect a very different mood from those prepared for religious ceremonies. The Plains ideal of harmony required that objects used together be compatible, each contributing to an effective whole, neither detracting from nor dominating it. The concept of sacredness pronounced all sacred things beautiful simply because of what they represented. Thus, even natural objects could take on esthetic importance because of the benevolent power they contained.

In the Plains Indian culture, there were no professional artists: no member of the society devoted himself exclusively to creative activities, nor did the society encourage anyone to produce objects intended only to inspire or delight. According to Plains philosophy, creative activity was meant to augment and improve function. In pursuit of this goal, the society recognized and esteemed artistic talent, innovation, and technical virtuosity, as well as adherence to tribal styles of design and canons of taste and judgment. The creations of the Plains Indians were art by their standards, not ours. This distinction must be made in considering most works of art produced outside the western tradition, for, while we can appreciate transcendent esthetic aspects of an unfamiliar form in a museum exhibit, those who judge from this point of limited understanding miss much of the work's true significance.

It should not be supposed that the Plains people and their western contemporaries thought in totally different ways. In their attitudes toward their own art forms, we can find points of agreement as well as difference. The Victorian family sitting under a print

2. Frances Densmore, *Teton Sioux Music*, Bureau of American Ethnology Bulletin no. 61 (Washington: Smithsonian Institution, 1918), p. 335.

of Stuart's portrait of George Washington had much in common with the Cheyenne family gathered before a tipi lining painted with scenes of battle. To both families, these works represented and reinforced values their societies endorsed. Washington's portrait reminded one family of the leader who helped found their nation while the tipi lining inspired the other with recollections of tribal glory. The difference was that the tipi lining also kept out drafts of cold air: it served a practical function in addition to the emotion it aroused and the cultural messages it communicated.

Although the motives of the two groups in producing and using art objects may have had underlying similarities, the styles through which they were expressed frequently did not. The intricate crocheted antimacassars and delicate floral needlepoint cushions of the Victorian home had analogues in Cheyenne tipi furnishings, but the bead or quill embroidery that decorated the Cheyenne objects expressed a dedicated realism far removed from the romantic confections of Victorian ornamentation. As the pendulum of style and cultural attitudes swung back and forth throughout the next century, one society's perceptions of the other's art changed drastically. The bold beaded figures which the Victorians regarded as curiosities became very fashionable in this century when western taste turned in that direction. Plains beadwork, in the meantime, took on a more diffuse, cluttered, Victorian appearance. The nineteenth century looked with disapproval upon the color groupings of blue and green or pink and orange found in Crow beadwork. Today these combinations are considered chic, and the Crow are admired for having been so far ahead of their time.

Toward an Understanding

How are we to approach the unfamiliar forms of an alien art? The answer lies in building an understanding. Obviously we must learn a bit about unconventional media in order to know the possibilities and limitations inherent in each. In the case of tribal arts, we must also learn something of the producing society since its institutions gave the art birth and shape. With this information, it is possible to acquire a valid critical appreciation. We begin to see how and why these unfamiliar forms arose and grew. More significantly, we also perceive that these objects are not complete cultural statements in themselves. Rather, they were meant to function in a society that was vigorous and complex. When we are able to regard them in this light, they regain their original significance.

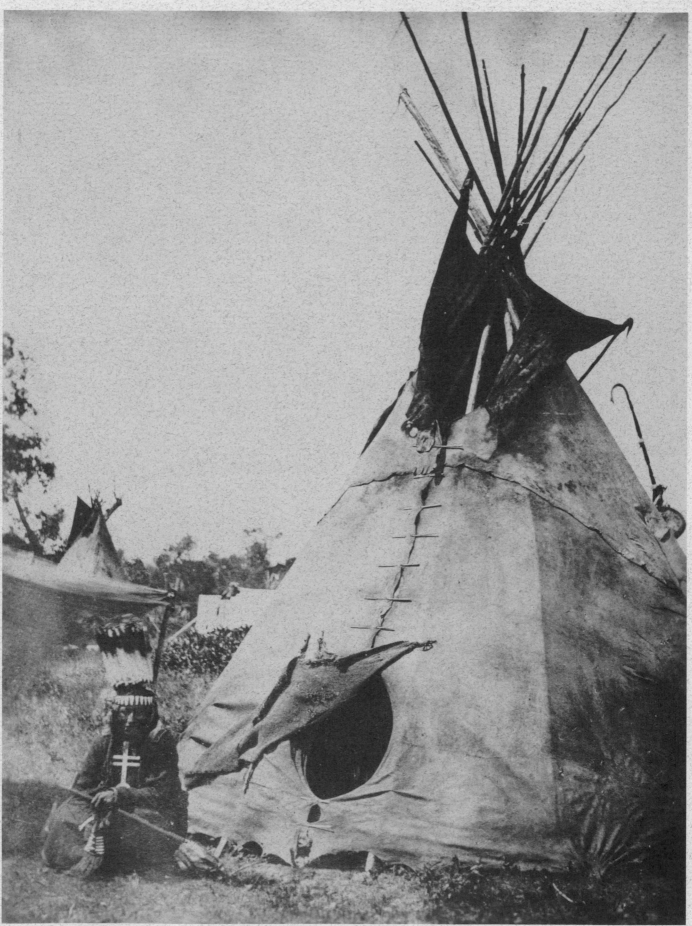

Little Big Mouth, Kiowa, c. 1870

The first horizon for a Plains Indian child was his home. Here he spent most of his early days with the people to whom he would be closest throughout his life, his family. Appropriately, like the world itself, the perimeter of this dwelling was a circle, and, as family members entered, they placed themselves inside its circumference around a central fire. Consisting of long, slender poles set in a conical shape and covered with a snug leather or canvas envelope, this portable home was called a *tipi*, a Lakota word meaning "a place for living."

The Tipi

For centuries most Plains tribes had made small portable tents. Some also built so-called "earth lodges"—heavy wooden frames sheathed with fine poles and branches and finished with an insulating coat of packed earth. Remains of these early houses, many of them circular, have been found over most of the plains region; some were as large as fifteen meters in diameter. Agricultural tribes inhabiting the eastern margin of the Great Plains, such as the Pawnee and Arikara, continued to live in earth lodges until late in the nineteenth century. Large houses were often occupied by extended families, which, depending on tribal customs, might include grandparents, unmarried daughters, and all the sons with their families. Each person was allotted personal space around the perimeter, with grandfather at the place of seniority opposite the door.

With the acquisition of horses in the eighteenth century, about half of the Plains tribes abandoned their earth lodges and gardens in favor of a nomadic hunting existence. Clearly this lifestyle required a new kind of home—the tipi. It must have taken considerable experimentation to perfect its design because the tipi is one of the most efficient temporary shelters man has yet devised. The plains can be a treacherous environment, with hard rains, heavy winds, blowing dust, and extreme temperatures. Properly erected, a tipi is proof against all these. In addition, it may serve as a vehicle for military and sacred art.

The refinement and perfection of the large nineteenth century tipi is revealed in its construction. The frame consists of about twenty long, slender evergreen poles which have been stripped of their bark and trimmed absolutely smooth. Although tribal methods vary, the poles are arranged to assure solidity and maximum strength. Three or four are tied together at a carefully measured point near their tops to form a tripod or tetrapod. Spreading the poles apart causes them to lock against one another and the tie rope and prevents the whole frame from collapsing. The remaining poles are then placed in predetermined positions: the base of each rests at a specific point on the tipi's circumference, and each tip falls into the correct notch at the top. This arrangement strengthens the frame by bracing the poles against each other at the tie point and makes the bundle of poles at the top compact enough for the cover to fit smoothly.

Although the tipi cover is generally thought to resemble a semicircle, the straight side, to which projecting smoke flaps are attached, stops short of the semicircle's true diameter so that when the cover is placed upon its frame, it forms a conical shape tilting noticeably away from the front opening. By cutting tipi covers in this manner and by placing the frames to face east, the source of each new day, the Plains people further braced their houses against the prevailing west winds. Another advantage of the tilted cone shape was that the smoke vent came more directly over the fire.

One other aspect of the tipi's careful engineering deserves mention. Tipis are usually fitted with interior linings—leather or canvas panels covering the lower fourth of the poles and the perimeter of the floor. Not only do the linings block cold drafts coming under the cover, they also deflect them upward to improve smoke removal.

Having established the structural ingenuity of the Plains Indian's residence, let us examine his home as an expression of art, the first art a Plains infant would know. The tipi was the domain of the Plains Indian woman, and in most tribes it was also considered her property. It was the scale by which her friends and community took her measure. Although several roads for establishing personal merit were open to a Plains woman, there was one unavoidable prerequisite: before she could aspire to membership in a prestigious religious or craft society, she had to prove her housekeeping skills. These were indeed a true test of her energy and creative ability because she customarily prepared the tipi poles, cover, and linings, all her family's household goods and clothing, and often even her children's toys. In the nineteenth century, when European trade goods became increasingly important in Plains households, she also tanned the bison robes and furs she used to purchase metal tools and weapons, cloth, and glass beads. Thus, a woman's success as mistress of her home lay in her own hands.

It was not enough that a woman created her family's residence, she was also expected to decorate it as beautifully as she could. After sewing the tipi linings, she painted and embroidered them, as she did robes, backrests, and the various containers which held all the family's belongings. Because women were responsible for decorating these objects, distinct styles of art practiced only by them arose in each of the nomadic tribes. Designs were restricted to nonrepresentational geometric patterns usually painted on stiff rawhide and soft leather or embroidered with porcupine quills and native fibers or glass trade beads. Tribal and regional variations appeared in preferences for certain compositions, color combinations, symbols, and the overall design of the object. For example, the Cheyenne backrest (7) exhibits proportions favored in the central plains, as well as unique Cheyenne decoration—painted willow rods and groups of quill and leather pendants. The Blackfeet backrest (6) displays the preference of Northern Plains Indians for a taller, narrower shape; Blackfeet decorative elements include cloth-bound edges and the distinctive beaded leather panel at the top, which, earlier in the century, would have been quilled. The shapes, compositions, and color groupings favored by women of several tribes are illustrated in a sampling of rawhide containers (32-41).

Women's decorative styles probably developed over a period of time as a convergence of community taste crystallized into tribal preferences. What the majority of tribal members thought attractive gradually became the approved way to design or decorate some object. When asked today why their ancestors favored certain shapes or decorative systems, Plains women often respond, "It is our way." Further discussion, however, draws out their exact sense of the appropriate and tasteful nature of something made in accordance with these tribal precepts. Tribal decorative style may also have developed as a means of reinforcing patriotism and group cohesion, for the Plains people take great pride in their beautiful decorative art and are quick to identify with tribal examples in museums.

While his mother's role in the home was primary, a Plains child could soon see that every family member contributed to its maintenance. His father's foremost duty was to provide food and protection, but he also made a limited number of household objects—utilitarian stone and metal tools and handsome, carved wooden bowls and wooden or horn spoons. Although the Plains people did little woodworking in comparison to Native Americans living in forested regions, they knew sufficient carving technology to master the convoluted hardwood burls preferred for bowls. They also learned to boil and carve fresh animal horns into complex spoons.

Hardwood bowl forms (11, 12) were probably well developed before nomadic life began and have changed little since. When they reached their optimum functional effectiveness—before the first surviving examples were collected early in the nineteenth century—their makers undoubtedly saw little reason to alter them. Spoon forms were apparently influenced by the raw material. An animal horn made a spoonlike implement with little alteration; the bowl area was easily increased by softening and reshaping fresh,

still pliable horn, and the maker might add decorative carving on the handle before passing the spoon to his wife for some quillwork or beaded embellishment. As soon as age permitted, Plains children began to learn their parents' ways of making household objects. Little girls sorted and dyed quills for embroidery or helped their mothers prepare paints for rawhide containers; boys learned to make spoons and bowls by watching their fathers. By the time she married, a girl was expected to know everything necessary to set up her own household, and her husband was supposed to take up his role as provider and protector.

Some Guests for Dinner: Etiquette and Hospitality

A Plains child soon learned that everyone, himself included, was expected to follow proper rules of conduct. He had to be still when there was serious conversation among his elders. He also had to recognize that many things belonged to others and could not be used as playthings without permission. Along with his language, he was taught the proper forms of address for every kind of relative, and, when persons from outside the family came into his home, the child learned about hospitality.

The Plains people considered hospitality a primary virtue and sharing one's resources a necessity everyone should undertake willingly. Hospitality was measured not by the richness of the meal offered but by the friendly spirit with which outsiders were welcomed into the home. An important part of hospitality was serving food, which might require making special utensils. When Plains families invited friends for informal meals, usually after a successful hunt, guests understood they were to bring their own bowls and spoons. For visitors from distant places or guests of importance, however, formal meals were served. At these times, the host family was expected to provide the dinner service. Because these utensils took time to make and proved bulky to transport, most families relied on borrowing for the occasion, but families of chiefs, who were often called upon to give formal meals, owned at least the key serving pieces.

Formal eating utensils were similar to those for everyday although they were usually larger and always decorated. Spoons and ladles (8-10) were often embellished with quilled or beaded wrappings while bowls might have carved flanges on their rims. In addition to special utensils, formal meals required that food be served and cleared in a prescribed manner, and, above all, that correct behavior be observed during the after-dinner speeches. The child, who remained silent and unobtrusive as all this took place, soon began to understand the codes of personal conduct that governed tribal life.

Children in the Home

Like people the world over, Plains Indians looked upon children as their hope for the future continuity of the tribe and its customs. Because a child was also loved deeply for his own sake, his family lavished their creative skill on objects made for his use. In anticipation of his birth, a decorated cradle was prepared. Because the cradle was a symbol of welcome to the new life and proof to the little spirit of his family's love, its making was considered a great honor, usually undertaken by an aunt. Family members in some tribes also prepared a small decorated amulet in which the umbilical cord would be placed (27, 28). It was thought some harm might come to the child unless the cord was preserved as he grew and gained strength, a belief perhaps reflecting the high infant mortality rate of the nineteenth century. First attached to the cradle and later to the child's clothing, the amulet was eventually put aside as a keepsake.

When the child outgrew his cradle, family affection was demonstrated by other things made to supply his expanding needs. Female relatives made articles of clothing, usually small-scale versions of adult garments, many of which survive today, presumably because they were soon outgrown and kept as possible gifts for other children. During the first year, the child's ears were pierced and adorned with shell or bone earrings made

by his father. The occasion, which was as significant as a baptism to a Christian family, was marked by a formal feast. Finally, children received gifts of toys which often foreshadowed the adult roles they would one day assume. In anticipation of their lives as hunters and warriors, boys were given small bows and arrows or toy horses made by male relatives, although a woman of the family might contribute a decorated bridle or saddle blanket for a little wooden horse. Girls received dolls, miniature tipis, and even tiny replicas of household goods often made by doting grandmothers. The cycle of gift giving never actually ended, for older children made toys for baby brothers and sisters, and, as their abilities advanced, they made presents for adult relatives. Girls, for instance, took great pride in presenting to a grandmother or favorite aunt objects which demonstrated their skills in leather tanning or embroidery.

Thus, Plains children entered early into the system of reciprocal giving that characterized Plains life at all levels. Within the family, gifts were presented as indications of affection and respect; if one noticed that a sibling or cousin lacked some useful thing, it became a great source of pleasure to make and present it. Like hospitality, generosity has always been greatly esteemed on the plains and reflects one aspect of Plains psychology. Because a nomadic society found limited benefit in accruing material wealth, people placed a high value on the intangible rewards of public approval for good deeds, including giving. Pride in giving, both inside and outside the family, encouraged the high standards of craftsmanship typical of the Plains Indians' finest works.

Moving Day

The first exposure of a Plains child to the bustle of camp life may have come as his family took down their tipi and moved to a new campsite. As nomads dependent on hunting, the Plains tribes moved camp often to follow the wandering herds of bison and other game. Although everyone worked hard, moving days had a festive air. Women showed their industry and skill in housekeeping by their efficiency in packing and by the quality of horse equipment they provided for their families. Because it was important to camp security that no family slow up the march, it became a point of pride for each woman to have her tipi down and packed as quickly as she could. It was even more important to have it promptly set up and furnished after the new campsite was reached so that her husband, who had been riding as a guard on the outskirts of the marching column, would find his home ready and not be obliged to wait for a meal or the comfort of his couch.

Frequent moving, of course, depended on owning horses. Although some Plains people maintain that horses always lived on the North American plains, the predominant view argues that this New World species had migrated to Asia during an earlier epoch and only returned to the Americas with the Spanish explorers and colonists. The Apache and other tribes near settlements such as Santa Fe and San Antonio began to acquire horses, bridles, saddles, and other equipment there in trade. As these tribes and the Plains people with whom they traded became proficient horsemen, the practice of stealing horses, both from settlers and from other tribes, became widespread and, indeed, a point of honor. Examples of Spanish bits and quirts were found in use in the late nineteenth century as far away as Alberta, and Spanish tack may have provided the principal models for native-designed accoutrements like the high-pommeled woman's saddle, a lineal descendent of the sixteenth century European jousting saddle. Even basic equipment reveals Spanish influence: saddle blankets, for instance, illustrate the pervasiveness of Spanish archetypes in the pendants at their rear corners and the general placement of decorative elements.

Construction of the handsome riding equipment created by the Plains people was shared by men and women. Men built saddle frames, made bridles, and carved the wood or antler handles of riding quirts. Women decorated these pieces, embroidered saddle cloths, and made cruppers and martingales for festive occasions. The purpose of all this artistic effort, like that of home decoration, was to show the world that here was a family

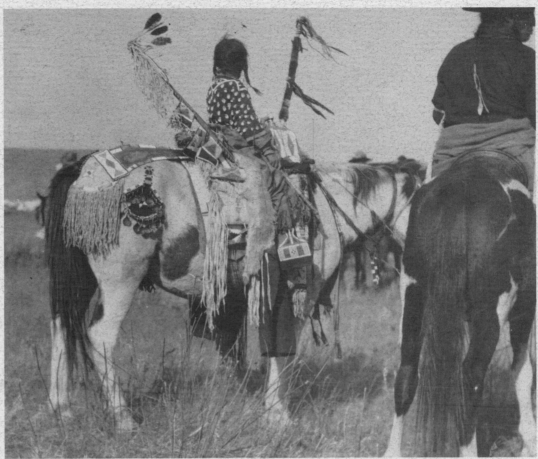

Crow girl on horseback

of industry and accomplishment. Women and young children riding in the camp column, as well as men and older boys serving as flank guards, could take pride in their community standing as they rode among their friends. Even pack horses bore decorated possible bags on top of their more prosaic loads.

Plains Household Art:
More than Decoration

Thus, life within the circle of a Plains Indian family provided impetus for the development of decorative arts. Plains Indian women dominated this sphere by creating for their homes beautiful objects which demonstrated their personal worth and concern for their families. Tribally endorsed styles eventually acquired patriotic significance. Because a Plains woman created and embellished functional objects, her work may correctly be described as applied, or decorative, art. It must be remembered, however, that her motives went further than mere decoration. She was, in fact, sustaining the deeper moral values of her world—industry, hospitality, and generosity. When the household arts of the Plains are viewed in this light, they take on the true significance their makers intended.

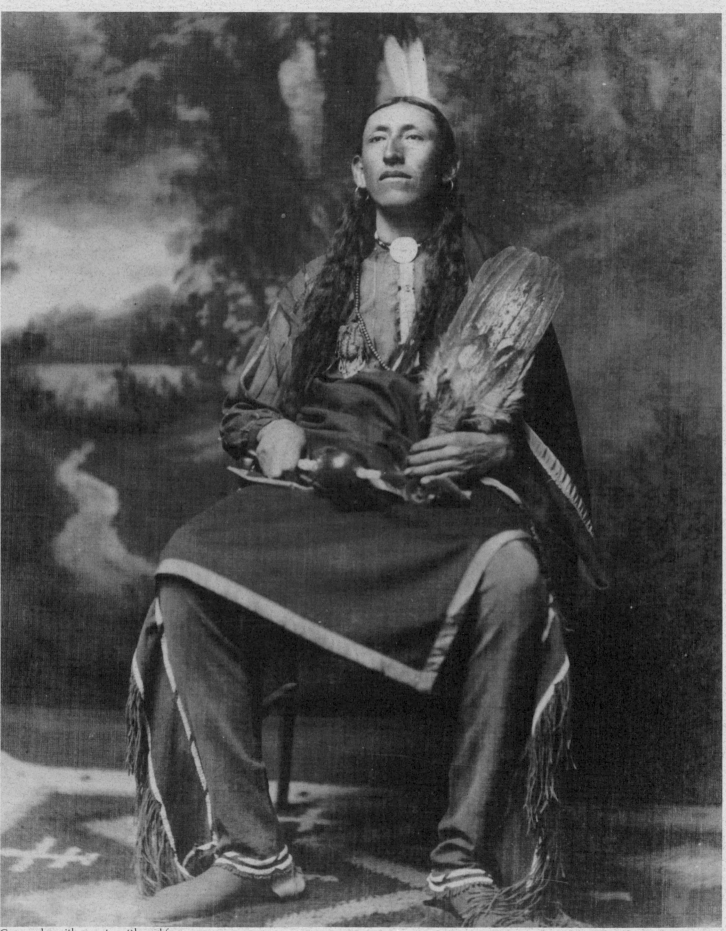

Comanche with peyote rattle and fan

Just beyond his immediate family circle, at his tipi entrance, the growing Plains child encountered the wider world of fellow tribesmen. They spoke his language, followed his customs, and perhaps even lived in the same camp. They were understandable, friendly people of his own kind. But the child found many new experiences within the tribal circle, for it included people from other households who were not his relatives and toward whom he was expected to behave differently. Moreover, there were tribesmen from other camps, both relatives and fellow citizens, whom he might meet only once or twice a year. The child's vital early lessons included how to distinguish tribesmen from strangers.

The tribal group was a loosely organized social unit of people who shared a common language and way of life and could even act at times as a political or legislative body. Sometimes a leader was designated as supreme chief, empowered to deal with foreigners on behalf of all the subsidiary bands that made up the tribe. Although these factors supported a sense of tribal unity, economic reality prevented the Plains tribes from becoming integrated, organized republics. Since they depended on animal herds for food, the Plains people lived in small scattered bands to avoid overtaxing their food base. In winter, when game became scarce, these bands broke into even smaller camp groups. Important religious ceremonies occurred at midsummer, when food supplies were plentiful enough to support a large gathering of the tribe. Even then, tribal assemblies were practical for only a few days. The Plains child learned to know well those of his own camp and to recognize remote tribesmen he saw only from time to time. A new horizon of activities and interaction with his tribal fellows opened up as the child's circle of acquaintances grew. In this expanding world, the need to create material goods also increased. Tribesmen observed forms of etiquette in their relationships with one another, which, like family courtesies, often required the production and use of beautiful objects.

Dress Clothing: Making a Proud Appearance

Intratribal secular occasions demanded the manufacture of dress clothing that would inspire admiration and respect. When Plains people say that someone "made a proud appearance," they mean that he conducted himself in a proper manner and that he was correctly dressed. Correctness of dress required adherence to specific tribal styles, as well as observance of two general principles of Plains esthetics: appropriateness and harmony.

Dress clothing had to be appropriate to the occasion itself and one's role in it. As a rule, Plains people reserved their most colorful and best-decorated clothing for the happiest secular events, such as a social dance after the return of a successful war party or a parade on horseback at the midsummer Sun Dance. Those who played leading roles were expected to "dress up to their places," with faces painted and new clothing if possible. Those who were only spectators were expected to dress with more simplicity and restraint, but well enough to show their respect and support for the principal participants. Although Plains people often mention the concept of appropriate dress, they generally do not have a precise definition. It is, they explain, a question of taste and sensitivity which one must learn. They cite examples of adolescent boys who became ludicrous figures of general amusement at dances for which they had overdressed. Presumably the wise child learned by careful observation to avoid such pitfalls.

The concept of harmony dictated that components of an ensemble should blend compatibly. Like appropriateness, however, harmony has been loosely enough defined to allow a variety of interpretations. At one extreme, some twentieth century Plains people have made entire ensembles with matching colors and figures in every beaded element. Although these are usually admired for the effort and workmanship represented, the general preference seems to be for harmony which includes variety as well as unity. Thus,

some of the most effective ensembles of festive clothing include unmatched garments whose colors harmonize and whose decorative elements combine pleasingly. The principle of harmony may be seen at its best, or worst, in men's ensembles. A man must integrate several main garments—shirt, leggings, and breechcloth—before selecting appropriate moccasins, headdress, and ornaments. A woman, on the other hand, need only coordinate her accessories with one garment, her dress.

The bold, bright colors preferred by Plains people since the latter part of the nineteenth century may seem harsh and discordant when seen out of context. In the bleaching plains sunlight, in combination with the tawny complexion and black hair of the Plains people, brilliant colors soften and blend into a unified, luminous harmony. The scarlet trade cloth favored for women's dresses and men's leggings is similarly transformed in this context. Anyone who has seen a Plains girl in a red dress will attest to the warm, rich appearance she achieves, quite different from that of a fair-skinned blond wearing the same color.

Although a Plains Indian, like people everywhere, lavished effort on secular dress clothing to improve his individual appearance, he had another equally important motive associated with tribal patriotism. To a greater extent than other native North Americans, Plains people developed distinct tribal clothing styles, which probably evolved from an unspoken consensus of what was pleasing to become an implied proclamation of citizenship. Tribal variations extended to every aspect of Plains clothing: cut of garments, preferred materials, and, above all, the media and nature of decoration.

Although Indians tend to be conservative, they enjoy lively innovation within appropriate limits, and, as the years passed, styles changed in response to foreign influences and the availability of new materials. Before 1840, Plains clothing was made principally of native materials, mostly leather and quills, with scarce trade goods limited to decoration. Because natural paints and dyes produce subtle shades, early nineteenth century garments give an overall impression of soft tones and finely detailed decoration. As trade goods became more accessible, brighter colors and bolder designs appeared in Plains clothing. For example, since no material indigenous to the plains yielded a true blue dye or paint, Venetian glass beads, available in shades from indigo to powder blue, brought a new element to the decorative spectrum. Clothing produced by the Kiowa and Comanche of the southern plains exemplifies the impact of trade materials and foreign contacts on tribal taste. In the early nineteenth century, these groups covered their garments almost completely with earth paints. Further decoration was limited to long, thin fringes sometimes painted to contrast with the rest of the garment. In the late 1870s, however, these tribes began to use beaded instead of painted decoration. Since 1900, their leather clothing has been natural, creamy white decorated only with fringe and beadwork, a change probably influenced by the beaded clothing of nearby Cheyenne and Arapaho. No matter how styles changed, however, the Plains tribes maintained important distinctions calculated to reinforce tribal identity.

While not generally thought of as jewelry makers, the Plains people have a long tradition in this craft, shaped by the same esthetic and patriotic factors as clothing design. Their earliest jewelry was made of animal claws, horns, antlers, and pieces of carved bone or wood. When glass beads were introduced, they were adopted for making separate jewelry pieces, as well as applied decoration. Traders suggested metal as an appropriate jewelry material by offering for sale simple rings and bracelets which had been crafted at the trading post. By watching the post blacksmith at work, Plains men learned rudimentary metalworking and soon began to buy metal in sheets or small ingots to create jewelry of their own design.

Apparently inspired by disparate sources, Southern Plains tribes developed a regional style for metal hair ornaments, belts, horse bridles, and necklaces. Silver pectoral ornaments, for example, show kinship to Spanish bridle faceplates based, in turn, on a Moorish form. Similarly, round brooches and belt and hair ornament discs may have

derived from metal designs adapted from ancient shell jewelry by displaced Southeast tribes that had been relocated on the southern plains. To these adopted forms, Kiowa and Cheyenne metalsmiths added distinctive touches to create a unique style of metal ornamentation. In the 1860s, with the introduction of German silver—an alloy of copper, nickel, and zinc which was less expensive, but less malleable, than sterling—Plains smiths modified existing ornament types and, in the late nineteenth century, created entirely new ones for the Native American Church. Today Plains smiths continue to work in traditional styles and experiment with new forms.

Gifts of Honor

All Plains tribes considered generosity a basic virtue which everyone was expected to practice. As we have seen, family members took great pleasure in making fine things for one another as evidence of their affection, but the concept of gift giving to show regard and bestow honor extended far beyond the family circle. Among the simplest of the occasions which required the presentation of gifts were those marking some event in a child's life which his family wished to commemorate. For example, when he received his first name or when his ears were pierced, his family gave a small formal meal to which two or three honored members of the camp were invited. On behalf of the child, these guests were presented with gifts in gratitude for their participation; later, they reciprocated by giving gifts to the child and publicly commending him on some suitable occasion. By such means, the child became established in the community.

More significant celebrations occurred when a boy brought home his first game or a girl made her first important garment or container showing a satisfactory level of craftsmanship. On such occasions, the achievement itself played a central role in the celebration. The boy's catch, if only a rabbit, was cooked by his mother and shared with as many people as possible. The girl's handiwork was presented to an elderly relative or some respected tribesman. The entire camp might be invited to the feast, and gifts were presented to everyone who came to witness the young person's first steps on the path of adult responsibility.

An even greater festival took place when a boy achieved his first victory in intertribal war. His early military experience would have included tending the bivouac and guarding the horses while he watched the battle. When he finally achieved some solid accomplishment of his own to which veteran warriors could attest, he began his career as a man. On that day, his family invited everyone in camp to the biggest feast they could prepare and perhaps a victory dance, an important social event. The family liberally distributed gifts to honor the new warrior—tipi furnishings, containers, decorated robes, and even valuable horses—often to their own impoverishment.

Gifts intended to show esteem might be presented at any time. Lakota parents could declare their unbounded love for a favorite child by having a holy man bless him at a formal honoring ceremony called *Hunka.* Ritual objects were made expressly for this ceremony, and the honoree often received a badge which he might wear for the rest of his life (60). In addition, gifts were distributed to the holy man and all the guests. The Blackfeet system for honoring children, *minipoka,* was not a ceremony but a lifelong pampering and giving of gifts in the child's name. Mothers might make particularly fine dolls (19, 20) or other toys for *minipokas,* who, as children and adults, were showered with the best the family had: beautiful clothing, the finest horses, and the choicest foods.

Finally, a general Plains custom called the giveaway, like other honoring ceremonies, continues to be a very important event which strengthens bonds of unity among tribesmen and allows families to express their love for one another. The giveaway might occur as a spontaneous event at a dance or celebration held for some other purpose. One

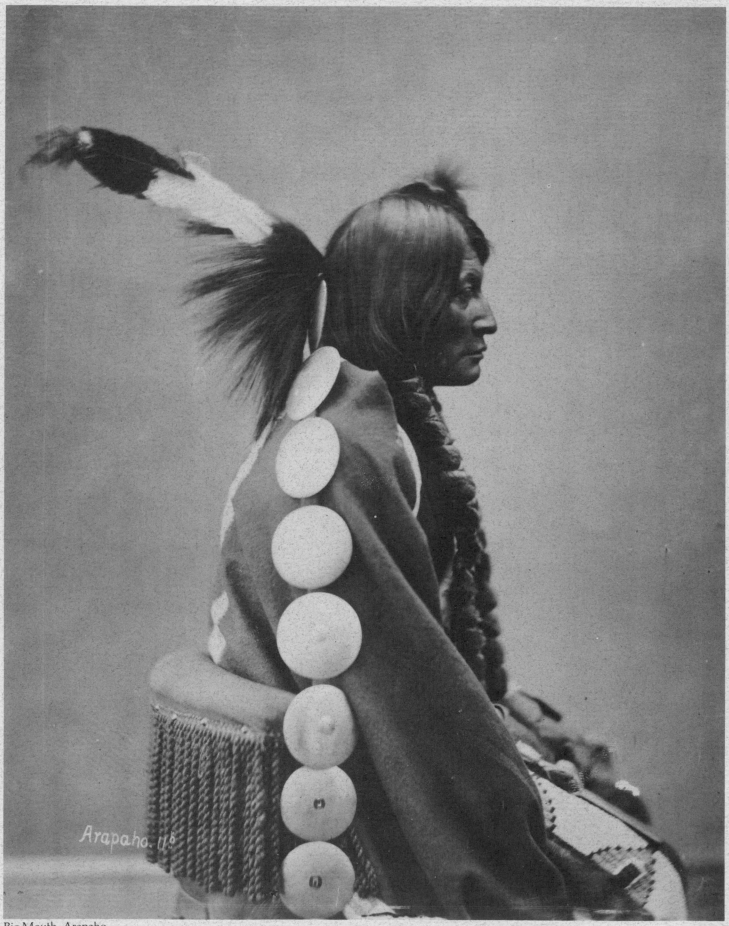

Big Mouth, Arapaho

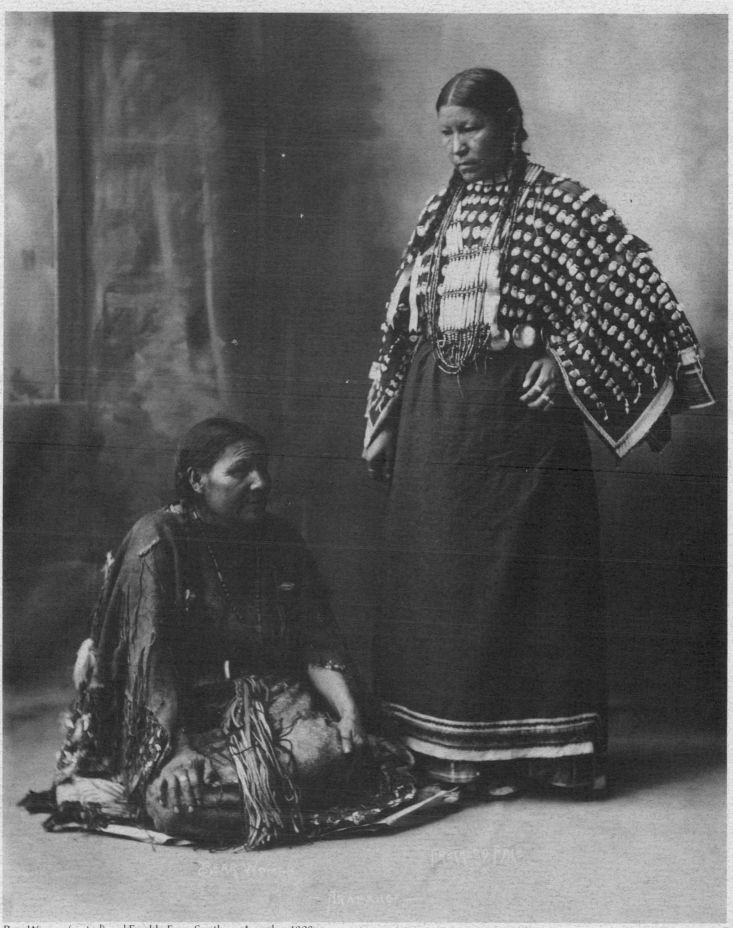

Bear Woman (seated) and Freckle Face, Southern Arapaho, 1898

individual might suddenly decide to honor another by giving away some personal thing in the latter's name. The great giveaways, particularly memorials to the dead, are lavish. A family might require a year or more to gather sufficient gifts, and, although they might have to live modestly for some time afterward, their liberality brings great satisfaction. Those who expend so much to hold a giveaway are actually richer, for their generosity brings them far greater respect than accumulated wealth could. They can also expect to be honored recipients at other giveaways.

The philosophy of giving to gain honor may find its source in the realities of Plains life. In prereservation times, life expectancy was short, and, under the circumstances of nomadic existence, amassing material wealth was impractical; it was wiser to distribute one's surplus property in exchange for public approval than to pack it about. For the Plains people, being respected for one's generosity and hospitality, as well as for personal accomplishment as a homemaker or warrior, meant far more than possessions.

A New Household: Courtship and Marriage

Although family ties continued to be important throughout life, marriage was the occasion for a significant new commitment. Everyone in camp took an interest in couples who courted, married, and established the new households upon which perpetuation of the tribe depended. Before marriage came the delicious agony of courtship. When parents considered a girl ready for marriage, her father casually let it be known that suitors might approach. Interested young men visited the family to make formal overtures to the girl, who pretended to be politely indifferent. If the family didn't rebuff him, the suitor concealed himself at night near the girl's tipi and serenaded her with traditional love songs played on a sweet-toned courting flute. Made specifically for this purpose, these wooden tubes, similar to recorders, were often decorated on the bell end or sound block. The Lakota frequently carved the bell to resemble the open beak of a bird and called the flute *siyo tanka*, "the big prairie chicken," presumably in reference to the courting antics of this species (81). Other tribes sometimes carved the image of a horse's head on the sound block, perhaps to suggest a parallel to the virility of this spirited animal (82).

If a Lakota boy's musical overtures met with favor, he proceeded to the next stage of courtship. Wrapped in a two-colored courting blanket (80), he walked near the girl's tipi at dusk, hoping she would come out and speak to him. If she did, he wrapped the blanket around them both and together they promenaded about the camp, an act equivalent to a public announcement of their engagement. As the courtship progressed, the boy and the two fathers met to agree on an exchange of gifts which would solemnize the marriage.

Unlike courtship, a Plains wedding did not require ritual objects. The bride and groom did not even wear clothing of distinctive design but simply dressed as well as possible. Although nineteenth century accounts refer to "wedding dresses," these were probably new garments prepared for the occasion, but not reserved for this one-time use. Similarly, the colorfully beaded "wedding blanket" included in the Crow bride's trousseau would continue to be worn on special occasions for years to come (84).

Order in the Camp

The Plains ideal stressed harmonious relations within the camp and the tribe. Naturally, disagreements between tribesmen did arise, and, when this happened, tribal police were called upon to maintain order. The role of policing fell to the military societies of experienced warriors, who, when not actively engaged in battle, took turns serving as camp guardians. They stopped quarrels and other breaches of the peace and patrolled the camp outskirts to forestall prowling enemies. Members of the society on duty carried a badge of office, a distinctive horse whip or club (113), or, at times, a special pipe to indicate they were acting for the chief (87). These objects were symbols of

authority which demanded respect from all members of the camp. To break up a fight, the police separated the combatants, who were then required to touch the official badge of office, an action that obliged them to work out a peaceful solution or submit to the chief for arbitration. In this case, the antagonists agreed to have their argument heard by smoking a pipe offered by the chief. After judgment was delivered, both smoked again to indicate their willingness to abide by the decision. Refusal to accept the chief's judgment could result in expulsion from camp, a fate considered so dire that few risked it.

Camp chiefs also represented their people in dealings with foreigners. Visitors were expected to obtain permission from the chief before pursuing their business. Whatever agreement was finally reached—permission to visit, a safe conduct, or an intertribal pact —was ratified by a ceremonial pipe with the chief's council. Although non-Indians often called these "peace pipes," they had another use. When Plains tribes found it necessary to unite against a common enemy, a pipe was sent around the camps to enlist military support. If, after conferring with his people, the chief "touched the pipe," he committed them all to action. These official pipes are distinct from sacred pipes and those reserved for personal use. Even women made their own small pipes for private enjoyment (86).

Plains Art and the Tribal Circle

A favorite Kiowa expression to describe an admired person was "brave and courteous," recalling Chaucer's "parfit gentle knight." Like his medieval counterpart, the Plains Indian was supposed to display unflinching courage against adversaries but to observe a gentle politeness with his own people. Art objects associated with intratribal activities reflect and support the Plains ideal of openhanded kindness. Families and individuals established their merit in the eyes of fellow tribesmen partly through making a proud appearance but primarily through demonstrating a generous character. Objects of art played a significant role in reinforcing the positive social values of self-respect and altruism which underlay intratribal relationships. They served to maintain social cohesiveness and internal order. On the plains today, generosity is still admired and giveaways are often held. Because the Plains people consider such attitudes and practices important avenues to attaining social goals, they continue to turn their artistic skills to serving this cause.

Most Native American tribes had names for themselves meaning "the people," or something similar, which reflected their view of the immediate tribal group as the center of existence. But beyond this familiar circle was a much larger one of alien tribes and people. Elders told remarkable stories about these strangers and their comical or revolting behavior, their outlandish ways, and especially their subhuman ferocity. Plains people encountered them as raiders in their own camps, as opponents on the battlefield, and sometimes as envoys on peaceful missions.

When Strangers Meet

Interaction between Plains tribes increased during the nineteenth century. Some tribes formed lasting alliances: the Cheyenne and Arapaho, for instance, became friends in the eighteenth century and have remained on good terms ever since. The Crow and Lakota, however, relished an enmity which still exists today. In the late 1860s, desperation forced the Plains tribes to make greater efforts to unite against the "white peril," although they never achieved a federation capable of checking American expansion. As intertribal contacts increased, there was some intermarriage, a fairly simple matter among tribes whose customs were similar. Growing interaction also affected tribal art forms, although this influence found expression in general concepts rather than in specific details of style. Thus, while the Kiowa adopted the Cheyenne idea of beaded clothing decoration, their colors, motifs, and design placement are so different from the Cheyenne prototype that each tribal style can be easily identified.

Although peaceful relations between tribes increased in the nineteenth century, warfare was a more common and significant kind of encounter. For nearly a century, popular films and western tales by writers like German novelist Karl May have given most Americans and Europeans a distorted view of the military nature of Plains Indian society by emphasizing the bitter conflict between Plains tribes and the U.S. Army from 1860 to 1890, a period when the Indians were struggling to maintain their very existence. The true character of native Plains warfare, however, has been completely submerged in this stereotype. When it had been an intertribal matter, warfare had been conducted with no idea of annihilating the enemy or conquering territory. Its main goals were to achieve personal honor and to ensure the continuous existence of the tribe by providing role models for future warriors. Secondary aims were the acquisition of valuable horses and, at times, revenge. That people were killed or taken captive was quite incidental to these objectives.

That All Men Shall Know My Name

Although a Plains man might win fame as a doctor or holy man, his main road to prestige was the war trail, a path almost everyone was expected to try. While the concept of conscientious objection was unknown, Plains society did make allowance for those few men who chose pacifism. In general, though, proof of personal bravery in war was as important to Plains men as demonstration of household skills was to women. Glory was gained by performing specific kinds of brave deeds in battle before the eyes of one's fellows. These are referred to as *coups*: when a warrior publicly narrated his exploits, he was said to be "counting his coups." A coup that was considered the height of bravery by most tribes required a warrior to approach an enemy, touch him with his hand or weapon, and then withdraw to safety. Even greater honor was attained if the brave had to make his escape across an open battlefield. Other important coups included shooting an enemy, running an opponent down with one's horse, and rescuing a wounded comrade under fire. Coups were ranked in consequence according to the personal bravery necessary to attempt them.

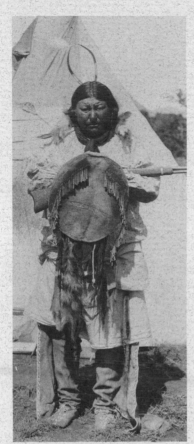

White Horse, Kiowa

One class of coups involved theft of enemy horses. While stealing any horse earned some merit for the thief, valuable animals brought greatest honor. Most prized by the Plains people were their "buffalo runners." Trained to run unflinchingly beside a thundering bison so that their riders could have both hands free to shoot, these hunting mounts were so precious that they were herded apart and kept under guard at all times; at night they were picketed by their owners' tipis. There are even accounts of men sleeping with hackamore ropes tied to their arms or legs as a further deterrent to prowling horse stealers. The greater the risk, the sweeter the prize, however, and some Plains warriors became specialists in stealing livestock. Novices began with the least valuable animals grazing outside camp in herds guarded only by one or two adolescents. In this situation a group of horses could quickly be driven off while a friend stampeded the others to delay pursuit. Experienced thieves could creep into sleeping camps and take better animals with tactics that were proof against harness bells, wakeful owners, and even hackamore ropes. The skill of Plains horse thieves was documented in 1872 when, under the very nose of army sentries, a group of Comanches "requisitioned" fifty-one government animals from a stone-walled corral at Fort Sill, Oklahoma. In humiliating a powerful enemy, they no doubt felt a mocking joy similar to that expressed by the Lakota horse stealer Two Shields, who was still singing in his old age:

> Crow Indian
> You must watch your horses
> A horse thief
> Often am I.[3]

Men often boasted publicly about their coups. In fact, all formal speeches were customarily prefaced with a synopsis of an important coup to establish the speaker's credentials. Brave deeds also became the basis of personal names. After some outstanding accomplishment, a man could change his name to reflect what he had done or bestow a new name on one of his children. For example, when the daughter of the Blackfeet warrior Mad Wolf was kidnapped, he attacked boldly and slashed at her captors on all sides until she was rescued. From this feat she got her name "Strikes on Both Sides."

A remarkable military art of narrative drawings applied to tipi covers and linings, bison robes, clothing, and sometimes shields also kept public attention on warriors' deeds. Whereas women's paintings on leather and rawhide were limited to nonrepresentational geometric patterns, military paintings, done exclusively by men, were figurative and effectively communicated events and actions. The earliest examples show profile stick figures of men and horses combined with simplified depictions of war equipment. Abstract symbols represented circumstances that were harder to draw, like holding some special office in a war party. Although not sophisticated, this early military style was governed by rules affecting esthetics, as well as subject matter. Figures were usually conventionalized according to tribal preferences, and they were often filled with arbitrary colors for decorative effect. The composition was arranged on the field with attention to balance and organization, as well as consideration of the negative areas of unpainted leather.

About the middle of the nineteenth century, this simple style gave way to a more detailed and naturalistic one in certain tribes. Lakota, Cheyenne, and Kiowa artists began to draw figures with more correct proportions, rudimentary facial features, fingers, and costumes. By the time the style reached its best-known form in the the late 1860s, artists could accurately depict action, details of military clothing and weapons, and sacred regalia, such as face painting and protective amulets, all of which were requisite for conveying the true story of a coup; any deviation from total veracity would have been challenged. Indeed, military art had become so accomplished that one could distinguish a Springfield carbine from a Remington. But artists also had opportunities for innovation. Apart from harness details, horses were highly stylized. Legs and necks grew long and graceful, heads were reduced and bodies streamlined, giving the images a heroic elegance

3. Frances Densmore, *Teton Sioux Music,* p. 337.

lacking in real Indian mustangs. In addition, artists often colored their horses blue, pink, or other fanciful shades. Because there was no tradition of arranging episodes in chronological order, the artist could organize his material to make the best composition. In a painted muslin work (96), the Crow warrior White Swan placed a large camp at the center and arranged episodic sketches on either side of it. Only two of these are sequential, as the path of footprints connecting them indicates.

Several theories attempt to account for the sudden maturing of the Plains narrative drawing style in the 1850s and 1860s. One holds that military activity expanded with the introduction of firearms during this period, and, consequently, more paintings were produced. The converse might be equally true, however, because the increase in warfare would have left Plains warriors far less time to paint accounts of their triumphs. Another possibility merits consideration. In the 1830s, Mandan and Hidatsa artists were introduced to European drawing conventions through the visits of George Catlin and Karl Bodmer, who recorded in their diaries that native people always clustered about as they sketched. From observing the European style, native artists may have attempted more realism in their own work, although specific influences would be difficult to document. For one thing, the Mandan, among whom Catlin and Bodmer did most of their work, were decimated by a smallpox epidemic in 1837 before they could have brought these new ideas to fruition, and it would have fallen to tribes like the Crow, who traded at Mandan villages, to advance a more realistic style. But because the center of this development lay with tribes such as the Cheyenne, whom Bodmer at least never visited, the extent of direct European influence remains vague and is probably negligible.

Plains narrative painting has an interesting further history. In the early reservation period, disarmed and frustrated warriors continued to produce traditional paintings retelling their vanished days of glory. These works drew the admiration of army officers and government officials, who supplied native artists with materials and commissions which resulted in the noted ink and watercolor paintings on muslin or in ledger books. These native works in European media were soon hailed as outstanding examples of a truly Native American art form. Several artists, such as Amos Bad Heart Bull and Howling Wolf, have since become well known, and their drawings are sought by museums and collectors today.

Whether made for personal use or for sale, paintings from the reservation period were exercises in nostalgia for the free life that was gone, and artists often went beyond battle scenes to illustrate other events from prereservation days. Their depictions of dances, feasts, courtship, horse races, hunting, and other activities offer lively glimpses of the old Plains life—views we would not otherwise have seen. Because of the Plains tradition that only protagonists held the right to paint their adventures and observations, narrative painting came to an end in the early twentieth century as the old warriors died. Since the 1940s, however, Plains artists have incorporated many of its forms and ideas into their work. In doing so, they are not concerned with its original role of recording individual prowess. Rather, they take pride in narrative painting as a traditional style which they wish to perpetuate.

Military Societies:
The Warrior Elite

Besides paintings which commemorated the actions of war, Plains artists made objects to take into battle, including weapons and magical protective amulets and garments. The most interesting weapons are the clubs designed for hand-to-hand combat. The best examples are wooden and were made along the eastern margin of the Great Plains, where a greater variety of hardwoods grow; some show a relationship to clubs made farther east. For example, a well-known type of Lakota club (112) is representative of a widely diffused club form made from the Atlantic coast to the northern plains. Farther west, where wood was scarce, stone-headed clubs were made. Although less interesting sculpturally, they were often handsomely decorated with quillwork or beading (114).

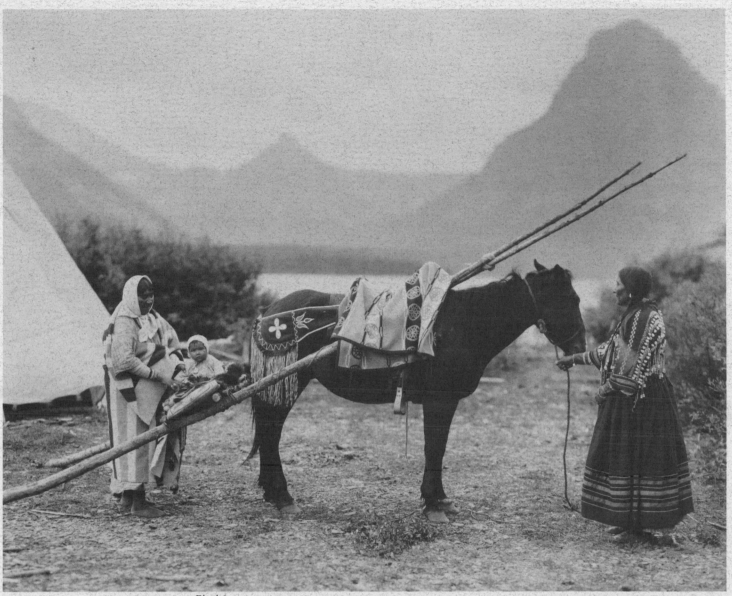

Blackfeet travois

The finest equipment belonged to members of Plains military societies. Each tribe had several of these fraternal groups, and every man aspired to membership in one of them. To achieve this, a young man had first to establish his competence as a fighter by taking part in several war parties. He then served a probationary period by accompanying the society on one or two forays. As a full-fledged member, he was expected to observe all society regulations and submit to society discipline. In some tribes, such as the Lakota, society membership was a lifelong affiliation. Other tribes, like the Blackfeet, ranked their societies by age: if a warrior lived long enough, he was expected to sell his membership in the junior society and buy into the next. Those who survived to old age eventually joined the prestigious Bull Society. Under still another system, the Arapaho established within each society ranks of membership designated by special garments and military equipment; one rose through these ranks by continued service and by counting additional coups.

The societies played several roles in tribal life. In battle, they served as shock troops, who were given the most dangerous assignments, and as military police, who controlled overambitious young warriors when an ambush was being set up. Domestically, they acted as civil police and as scouts and guards for a camp on the move. During the great

midsummer festivals, they played honorary roles. For example, the Blackfeet Crazy Dog Society, in full regalia, rode into camp singing and carrying aloft the fresh willow branches they had gathered to make the low walls of the Sun Dance lodge.

Periodically, a society danced publicly to entertain the tribe, with each member dressed in the regalia and carrying the weapons appropriate to his rank. Consisting of either single garments or whole ensembles, society regalia included some of the most famous Plains Indian artifacts, such as striking feather headdresses. These so-called "war-bonnets," probably originated by the Omaha and Lakota, were in most cases insignia reserved for the use of society officers. Parts of today's male dance clothing, such as the porcupine-hair headdress and dance bustle, were of similar origin. According to tribal tradition, the design of all military society regalia was revealed in a dream to the group's founder by a spirit mentor, who told him how to organize the society, what equipment to make, and how to use it. Thus, only authorized individuals were entitled to use the society regalia. With the extinction of the old societies, this practice has faded, and today all Lakota men are free to wear the bustles once restricted to members of the Omaha Society.

Military society equipment also included weapons for battlefield use. Narrative paintings frequently show men counting coups with a particular society lance (123) or wearing members' garb. Presumably these men were fighting in their official capacities, fulfilling the roles assigned by their leaders. One piece of society clothing, unique in the history of warfare, was the sash, used in several tribes and associated with a Dog or Crazy Dog society (103). Sashes could be worn only by individuals who had taken a solemn vow before battle never to retreat. Charging into combat, sash wearers dismounted and fastened themselves in place by pinning the end of the sash to the ground with a special wooden stake. Their determination to fight to the death frequently rallied their comrades. When circumstances required, however, a sash wearer could be released if a comrade pulled up the stake and struck him with a whip.

Art and the Circle of Humanity

Interaction between Plains tribes was sometimes hostile and even involved formal warfare, an exclusively male activity whose primary goal was individual glory. It was through military prowess that men established status and advanced themselves in civil affairs. As elsewhere in traditional Plains life, forms of art arose to support this activity and concern. The most significant is the narrative painting style developed to record, and thereby perpetuate, individual accomplishment in battle. As an art form with its own rules and conventions, narrative painting afforded Plains men their principal creative outlet. Perhaps because it gave more scope to creative talent than other art forms, narrative painting transcended its original purpose and stands today on its own merits as the ultimate artistic legacy of the Plains warriors.

The outermost circle encompassing the lives of the Plains people extended far beyond the limits of human vision into the mysterious world of *wakan*. Difficult to translate adequately, this Lakota word is best rendered in English as "that which is not understood." Natural phenomena that could not be comprehended or controlled were attributed to the powers who populated this sphere. The Plains people were able to approach and communicate with these awesome forces through religion, which thus touched almost every aspect of their lives. Their system of devotions was in large part personal and ranged from giving simple thanks before eating to seeking the aid of one's special spirit mentor at times when human efforts alone would not suffice. Unlike the darkly superstitious stereotype created by romantic authors, the devout Plains Indians held an optimistic world view and trusted in the benevolent intervention of the unseen powers in man's affairs. Their religious concerns, like their secular activities, led to the production of a considerable body of art.

Holy Visions

Basic to Plains religion was the belief that the world was filled with power that could reside in objects, animals, or even people. A personal relationship could, therefore, be established between an individual and a powerful being who would act as his guardian. At the approach of puberty, Plains youths prepared for this relationship by visiting a holy man for instructions in performing prayers and religious exercises that would bring them into contact with the spirit world. When the novice was ready, his guide led him to some remote spot, where he spent a two-to-four-day vigil completely alone. Boys were expected to pass this time in a place where wild animals or some other danger threatened. Less formal, but equally important, puberty rites for girls varied considerably from tribe to tribe and seldom involved a search for a spirit guardian.

During the vigil, the novice kept his mind turned toward all things *wakan*. He prayed frequently, fasted, and performed such exercises as singing holy songs, piling rocks into cairns, or dancing. If the powers were favorably impressed by the novice's sincerity and worthiness, one of them would speak to him and agree to act as his guardian throughout life. After giving specific directions for proper religious conduct, the power indicated that the vision was drawing to a close. Just at this point, as the novice began to rouse from his trance, the power itself appeared for the first time, usually in animal form.

During this religious experience, the novice was often shown an object which he was told to copy. It might be a garment decorated with various symbols and conferring certain benefits, or it might be a "medicine bundle," an assemblage of articles representing all he had seen. Boys were frequently told to reproduce something assuring magical protection in war, such as a shield or an amulet. Together with exact directions for making and using the object, the power issued restrictions that served as a test of piety. If these conditions were violated, the gift's inherent magic would be lost as it was in the case of the famed Cheyenne warrior Woqini, who owned a magic headdress that rendered him invulnerable in battle. Although its power had been demonstrated many times, when Woqini inadvertently violated the conditions of its magic properties by eating food which had been taken from the kettle with a metal utensil, his luck ran out. He died in battle the next day.

The visionary experience, the basis of all Plains religion, produced what has conventionally been called "dream" art, perhaps the most striking and imaginative of Plains visual art forms. Such art included clothing, tipi covers, shields, face painting, and various kinds of sacred paraphernalia. The designs on the two shields in this exhibition (124, 125) typify the subjects and bold painting style associated with dream art. The objects depicted probably refer to visions: a small bird whose flapping wings produced

thunder, a spectral bison cow whose magic tracks imprinted the earth. But these figures were merely representative of the complete vision, which only the participant knew in full and which he revealed to very few others, even in abridged form. Because the making of these objects was ordinarily private, we will never know the intellectual steps taken to translate a concept from the vision to its material embodiment. We can see by the results, though, that these dream objects, which should logically have been among the strictest and most conventional in their design, are actually the most free and creative works made by Plains artists. This apparent paradox is easily resolved in the context of Plains religious thought: since the objects were inspired, drawing their strength and vitality from the unseen powers that governed all life, they would naturally excel man's own limited conceptions. No wonder these objects were of the utmost significance to their owners.

Life-supporting Rituals

While most visions were given to Plains people for personal benefit, some conferred blessings on the entire tribe. The person who sought such a vision was usually instructed by his spirit guardian to gather into a sacred bundle specific materials which symbolized the events and persons of the dream, as well as the power inherent in them. The vision gave directions for the ceremonial opening of the bundle, and great good was expected to attend all those who were present at the ceremony.

The most important sacred bundles were thought to preserve the world and assure the continuity of the human race. Such bundles included those associated with the Sun Dance, the major Plains religious ceremony. Held in midsummer, it occasioned the largest gatherings of the year: whole tribes came together to enjoy the blessings bestowed by the ritual. Each tribe had sacred bundles reserved for use exclusively at the time of the Sun Dance. Those of the Crow and Kiowa contained holy effigies that personified the benevolent supernatual forces being propitiated. These effigies were heavily decorated with small, amuletlike, beaded pouches representing the prayers of individuals for life and health. The Blackfeet Natoas bundle held a sacred headdress and a full set of clothing for the central figure of the Blackfeet Sun Dance, the Holy Woman. Although the sacred objects in the bundles varied from tribe to tribe, all of them were decorated, almost excessively in some cases, for two purposes: to make them more effective and to show the dedication of tribesmen in seeking rapport with the spirit world. Plains people believe that the powers are always pleased with beautiful, carefully made objects, for these show the industry and devotion of mankind.

Besides the great palladiums concerned with general good, there were others with very specific goals. The Beaver Bundles of the Blackfeet, for example, were used to lure herds of bison close to camp and charm the animals so they would become easy prey. These bundles frequently contained handsome sculptures or paintings, often depicting the beaver spirits who first gave the bundles to man. Beaver Bundles also usually included fine pipes with carved stone heads, and the bundle keepers were entrusted with the cultivation of the sacred tobacco used for most tribal rituals.

Usually, however, the contents of sacred bundles are not so esthetically pleasing as vision-inspired objects like shields and tipi covers. The bundles are likely to contain a multitude of bird skins and tanned, undecorated hides, which, after years of use, become wrinkled and worn. Unappealing as they might seem to us, these venerable bundles were looked upon by the Plains people in the same light as medieval Christians regarded gruesome religious relics to which age and dessication added authenticity. Thus, Plains elders would argue that sacred bundles are intrinsically beautiful because of what they represent. Among these holy objects, however, are some which have unquestionable esthetic appeal to non-Indian eyes. In addition to carved and decorated pipes (130), sacred bundles might contain wooden or stone effigies of men and animals and even garments with vision-inspired decoration, like the Blackfeet Weather Dancer's shirt included in the

exhibition (129). The power resident in this garment helped its wearer ensure calm, clear weather during important ceremonies. The small horse effigy on the shirt, cut from rawhide and completely beaded in a very realistic style, is noteworthy for its vitality and shows that objects of visual interest can be found throughout traditional Plains culture.

Seeking the Past:
The Ghost Dance

Within the nomadic life patterns of the Plains people and the system of formal, intertribal warfare conducted according to codes of honor, it was possible for each tribal group to maintain itself and its sovereignty. Tribal existence became more precarious when the white men began to arrive in numbers, occupying more and more land and bringing organized troops of soldiers to wage annihilating battles. Within two decades the Plains tribes were subdued and confined to drab reservations. The final indignity came when their conquerors commanded these people to relinquish their traditional ways, forget their history and past glory, and become farmers. The Plains people turned in frustration to the visions of Wovoka, a holy man in far-off Nevada who had been visited by the ghosts of dead friends urging him to preach love and peaceful coexistence with the white race. Augmented by the visions of other holy men, who instructed the faithful to dance and sing magical songs, Wovoka's teachings provided a rallying point that led to the Ghost Dance movement. Some of its adherents believed that a tremendous whirlwind would sweep away the whites and bring back the great herds of bison and all the Indians who had died fighting for their lands.

Wovoka's gospel of harmony was viewed with suspicion by the United States Army leaders on the plains. General Nelson Miles even declared it a cover for armed rebellion. In 1890, when a kind of Ghost Dance fever swept through some of the Plains tribes, alarming white settlers, the army responded with an unprovoked massacre of some 200 Lakota adults and children at Wounded Knee, South Dakota.

Apart from its tragic outcome, the Ghost Dance movement is largely remembered for the revival of dream art it motivated. Dancers believed that wearing garments painted with vision-inspired symbols would hasten the Apocalypse. Some Lakota holy men even went so far as to proclaim that Ghost Dance clothing would render its wearers immune to bullets, a belief perfectly consonant with the traditional concept of dream art as divinely inspired and filled with benevolent power. Because of the cultural crisis that turned the Ghost Dance into an exceptionally fervent movement for some groups, the associated art became considerably more intense. Whereas older dream art had been marked by careful design and excellent workmanship, some Ghost Dance clothing was unquestionably made in haste. This is especially true of Lakota shirts and dresses, which, in almost all cases, were made of poor quality trade cloth and painted with commercial watercolors. The large natural forms depicted in bright colors on these garments suggest the heightened emotional state in which they were conceived.

In Oklahoma, the second important center of the Plains Ghost Dance movement, garments for the Dance were usually made of native leather, probably imported from tribes to the west, and painted with native and trade pigments. The effort the southern Ghost Dancers apparently took to obtain better materials reflects the difference between their experience and that of the Lakota. In the South, where the United States Army found nothing ominous in the movement, dancers could take time to assemble the proper dress. The more complex organization of the southern Ghost Dance movement itself supports this impression. Unlike the informal, evangelistic Lakota Ghost Dance movement, the southern Dance followed a defined structure based on that of the old military societies, in which one advanced through degrees of membership.

The southern garments reflect this order in their thoughtful compositions and color juxtapositions. Design elements tend toward abstract, geometric forms, particularly circles and Maltese crosses representing stars (138). The designs are usually drawn on a small scale, and large, central figures like those seen on Lakota garments seldom appear.

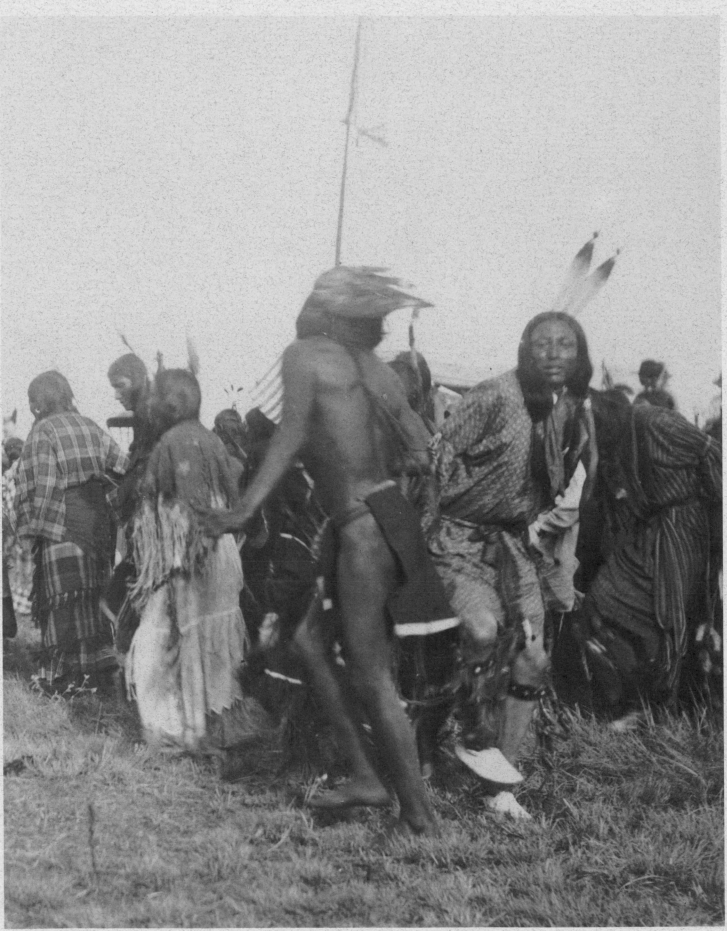

Arapaho Crow Dance, 1893

Within these limits, the southern Ghost Dancers developed distinguishable styles of tribal painting. The Southern Arapaho, for example, liked to paint entire garments in bold color combinations while the Kiowa preferred to leave large areas of natural white leather unpainted (137). Even taking tribal differences into account, southern Ghost Dance clothing reflects conservatism and patient expectation of the day of judgment.

A Gentle Way of Worship:
The Peyote Religion

A second religious movement of the late nineteenth century, one which actually preceded the Ghost Dance on the southern plains, spread far beyond the prairies and still exists today. It has been known by many names, but the one most widely used is that under which it has been incorporated in several states, the Native American Church.

Thousands of years ago, the native people of the far southern plains became aware of the beneficial healing qualities of the peyote plant (*Lophophora* sp.). Attributing to the plant the power to serve as an intermediary with the supernatural, they established a system of worship based on its use. In the 1880s, knowledge of peyote spread north to the Comanche, Kiowa, and Kiowa-Apache. The famous Comanche chief Quanah Parker was influential in disseminating peyotism to other tribes in Indian Territory.

Some members of the peyote religion, although aware of this historical account, prefer the legendary version of the discovery of peyote as more representative of their faith, which, like all Plains Indian religion, sees devotional objects and activities as gifts of the powers, presented to humanity for its protection and welfare. The traditional account tells of a woman and her child who were about to perish after being lost for several days in harsh weather. Following the directions of a mysterious voice, the woman picked a special herb which she and her child ate. Restored by its healing power and still obeying the voice, she returned to camp. A male relative to whom she confided this experience subsequently established the peyote rite among the southern Plains tribes.

Participants who take peyote in the context of native ceremonies are unanimous in describing their experiences as constructive. Messages and directions for coping with various situations are given, just as they were in the traditional Plains vision experience. In addition, participants often receive admonitions to live good lives and treat others with kindness. These themes of goodwill and benevolence have always been part of the dogma of peyotism and may have been taught to the first Plains users along with basic elements of ritual.

The ceremonies of the Native American Church, like those of earlier religious movements, led to the creation of a body of art. Ceremonial utensils, as well as jewelry and other badges of membership, make use of specific symbols that refer to peyote itself, the tipi where services are held, implements of worship like fans and rattles, and those birds thought to carry messages between mankind and the powers. Art associated with the peyote religion is notable for its wide, bright palette of colors. Colored feathers, both native and exotic, are used in fans, and wooden objects are often painted in several shades. The passion for color reaches its apex in beadwork, where virtually every available hue may be used in a spectrum or in an elaborate monochromatic series.

Today the Native American Church is incorporated in two dozen states and shows good prospect for growth and survival. Thus, the art forms created to serve it should continue to flourish and undergo further stylistic development.

The Sacred Arts of the Plains

Considering their view of religion and its preeminence in securing vital benefits for mankind, the nineteenth century Plains people undoubtedly considered their sacred arts the most important of all their creative undertakings. Certainly, some of the most vigorous and imaginative Plains art objects were made to serve religious functions.

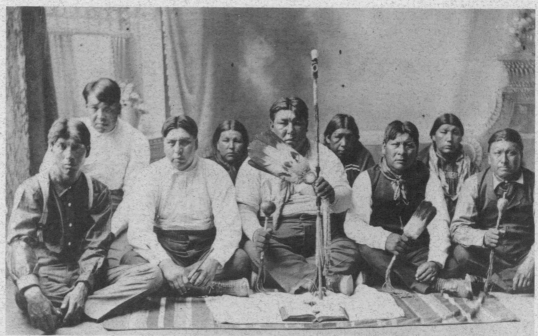

Omaha peyote meeting

Dream art is the paramount example. Particularly expressive and creative, it will very likely prove the most enduring of Plains sacred art forms. Although its quality is high and its significance great, very little sacred art survives. Holy objects were often buried with their owners or discarded to avoid others' being harmed by the magic power they contained. Moreover, this art was never produced in large quantity. Although he might need new clothing frequently, a warrior required only one shield for his entire military career.

In studying Plains sacred art, we quickly sense the dedication underlying its manufacture. Religious devotion and seriousness of purpose are expressed in superior workmanship and original design. While the Plains people took all their art seriously, they appear to have drawn on deep personal reserves in the service of their gods. In doing so, they stood in awe before mysteries they could not comprehend. In attempting to approach the unknowable, they were moved by the same desire for understanding that motivated Milton, Michelangelo, and other great western artists to create some of the world's finest artistic expressions. Let us consider the Plains people's aspirations and accomplishments in this light.

As we have seen, Plains Indian arts were functional and intimately involved with traditional life. The enforced changes of the late nineteenth century seriously undercut the basis of Plains art, and its production should presumably have vanished with the bison. Several factors, however, worked to extend its existence. The first was native determination to save as much of the old life as possible. Often practiced in secret, native religion survived although its adherents frequently gave up in despair or were converted to Christianity. As long as old warriors still lived, interest in their accomplishments was sustained. Social life, too, continued on a diminished scale in such events as festival dances. These remnants of traditional life supported some limited production of sacred and secular art.

Then a commercial market appeared to give new impetus to native arts. Collectors eager to buy valuable native artifacts motivated craftsmen to make copies for additional sales. The government also encouraged Native American artists to continue their work as a means of livelihood. In some quarters, such as the federal Indian Arts & Crafts Board, there was even an honest desire to preserve native artistic traditions. With commercial encouragement, Plains arts began to participate in the nonfunctional tradition of European art, for their purpose now became esthetic pleasure divorced from its original cultural context. The change from socially integrated art forms to "art for art's sake" had mixed results. Some kinds of art were so closely involved in their cultural roles as to be unadaptable. Thus, dream art died out because, to the native mind, it could only be practiced in the sacred sphere. Taking it to market would have brought supernatural vengeance upon its maker. Military art disappeared with the last warriors. Household arts changed and declined in response to the move from tipis to frame houses and the enervating bleakness of reservation life. It could be argued that those art forms which have persisted are still functional to some degree. Throughout the year, Plains people meet for traditional dances and social gatherings. Dance clothing, native jewelry, and horse equipment have important places in these events and continue to be made in quantity. Since these objects also have appeal to a non-Indian market, the artist's economic power has increased. On many reservations today, beadworkers or silversmiths are kept busy filling orders for tribesmen and trading posts alike. In those cases in which manufacture has continued uninterrupted, there has been a continuous development of style. Elements of traditional prereservation style survive in moccasins, for instance, despite changes in materials and design.

Since the middle 1970s, there has been a great surge of identity and pride among Native American people. A good part of their energy has been directed toward contemporary social and political issues, but they have also looked into the past to examine their ancestral culture. Some have learned their native language, others have embraced traditional religion, and still others have sought tribal elders as role models.

Although it has received less public attention, there has been a corresponding renewal of interest in traditional Plains art forms. We see increased production of dress clothing and similar forms which never died out, as well as revived production of tipis and horse equipment among tribes who had stopped making them altogether. Further, these objects are being made for functional purposes, just as they were in prereservation society. Although exact figures do not exist, it appears that more Plains art is being made today for tribal use than for sale to non-Indians. If this impression is true, it documents the swell of native pride in traditional art forms.

Within this revival, two interesting developments have occurred: a return to the oldest styles and the creation of new ones. Some Plains people have sought to go back to the earliest known prototypes and have been diligent in searching for them. They have talked to their elders, visited museums, and studied the pictorial records of nineteenth century observers like Bodmer. The results are frequently astounding. It is stunning, for

example, to see a correctly dressed 1830s Dog Dancer in the bright plains sunlight of today. Those who are involved in this return to early styles say their motive is to establish a point of "pure" tribal style which reflects little evident European influence and to build further artistic development on this base. But other Plains artists prefer to continue the course of nineteenth and twentieth century development, to move ahead from the present into the future. Those who take this point of view hope to create new styles to reflect contemporary Native American life by continuing the unbroken development of style that exists in such areas of Plains art as dress clothing. These two approaches are not antithetical nor do they represent factions. Rather, they are statements of artistic directions which show the vitality of Plains art today.

Whether Plains people return to the past for artistic inspiration, opt for fresh creation, or take a comprehensive dual approach, Plains art is today alive and healthy. It does not exist in precisely the same manner as traditional art of the nineteenth century, but this is as it should be. Human existence itself changes in response to the circumstances of life, and art must change as well if it is to continue to hold meaning. This is what is happening today on the plains. Although nineteenth century concepts of the individual, the family, and the world have changed over the years, analogous attitudes exist to sustain the individual on his path through life. Works created by Plains artists today relate, as they did in the past, to the world as their people see it. With this basic strength, Plains art will continue as a dynamic expression of those who make and use it.

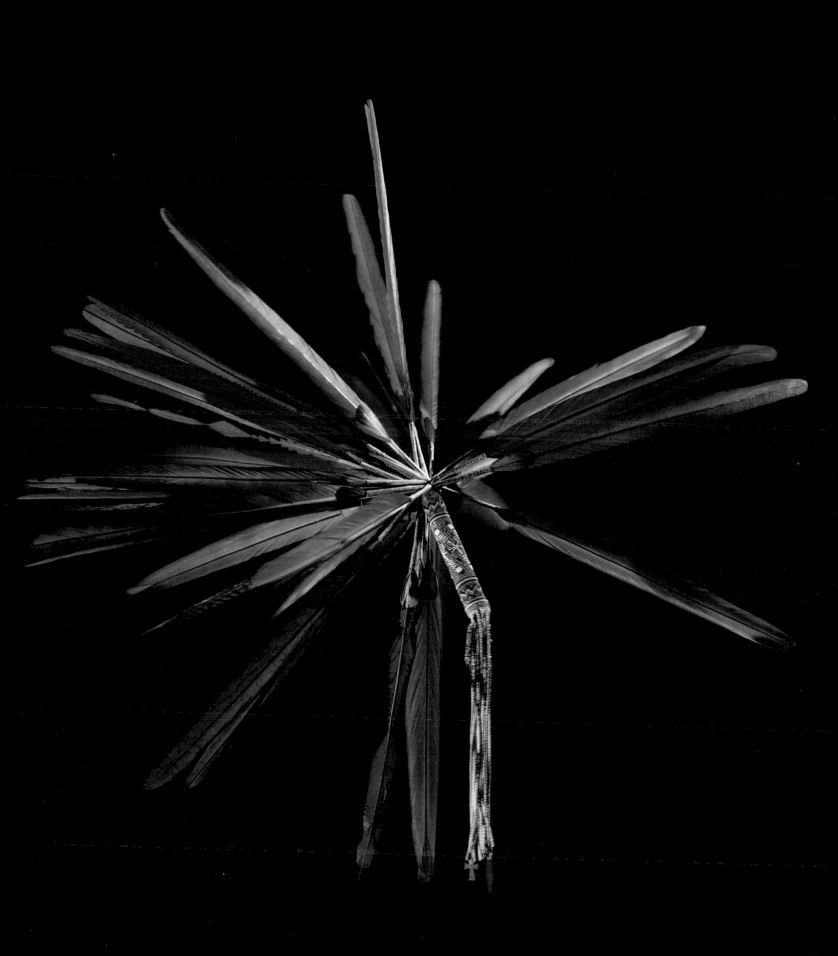

140. Ponca fan by Harry Buffalohead

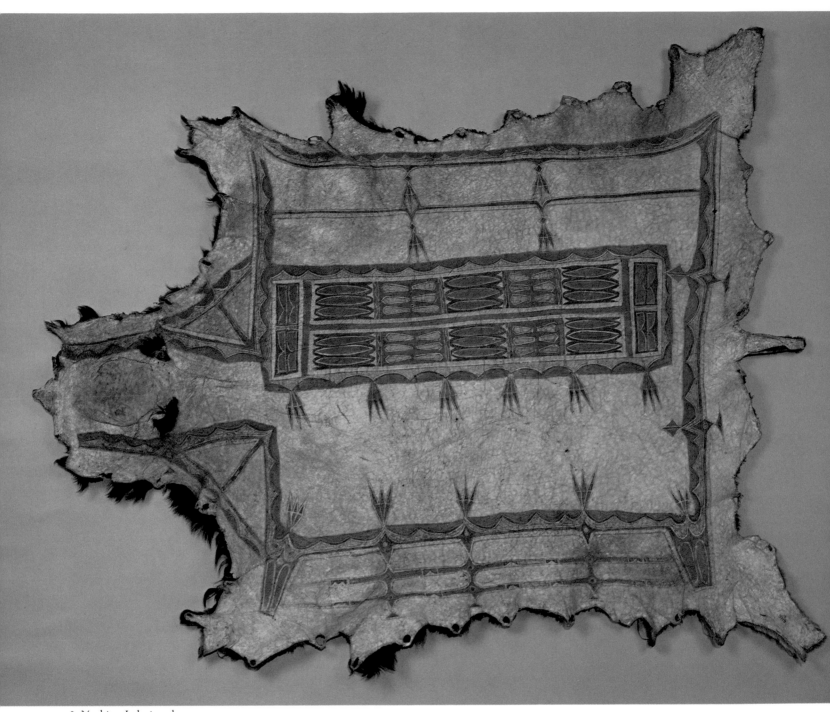

3. Yankton Lakota robe

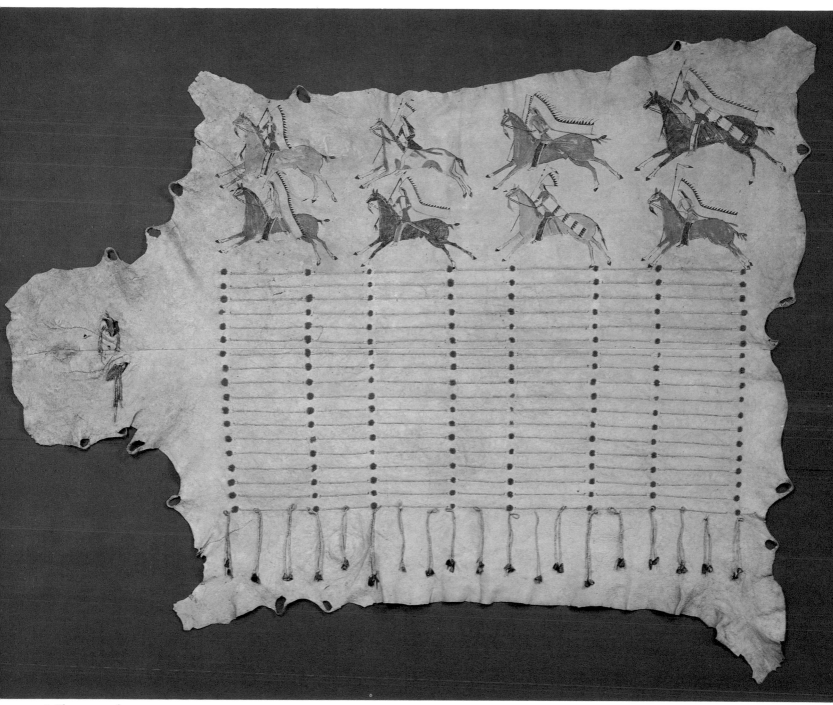

4. Cheyenne robe

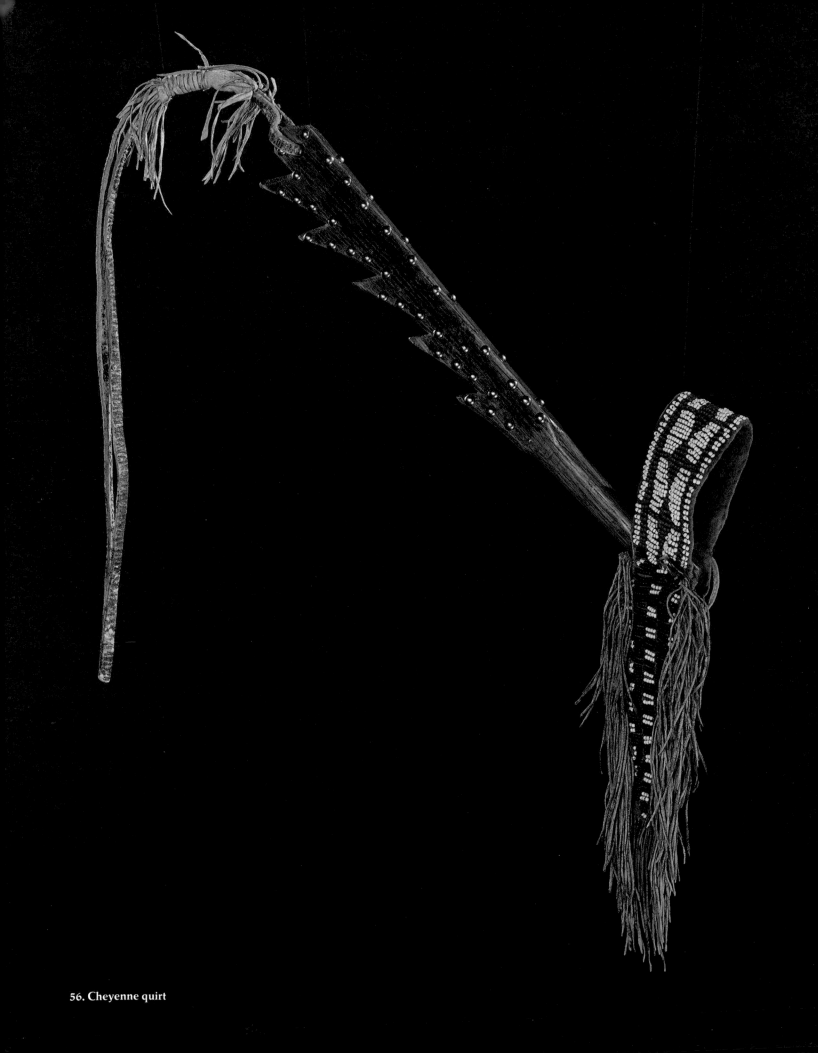

56. Cheyenne quirt

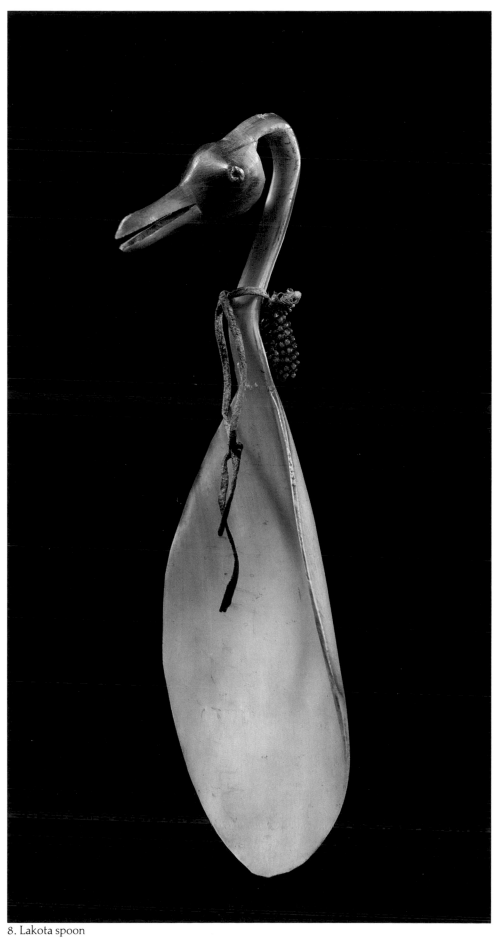

8. Lakota spoon

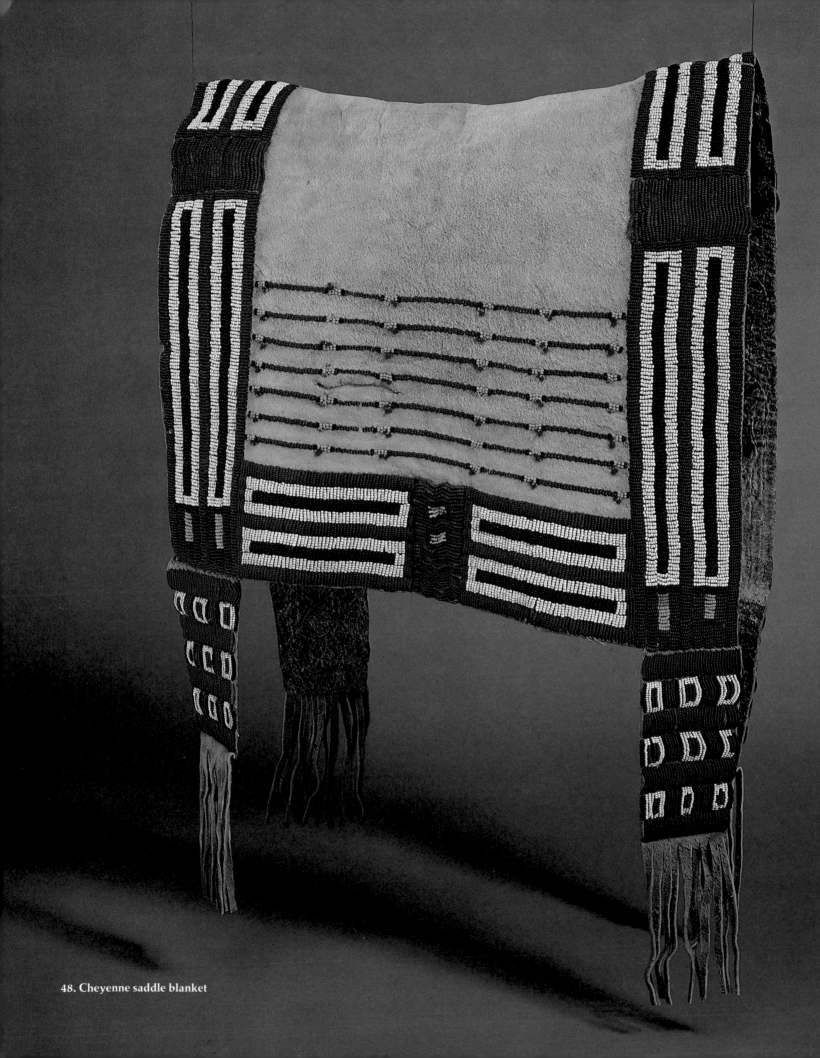

48. Cheyenne saddle blanket

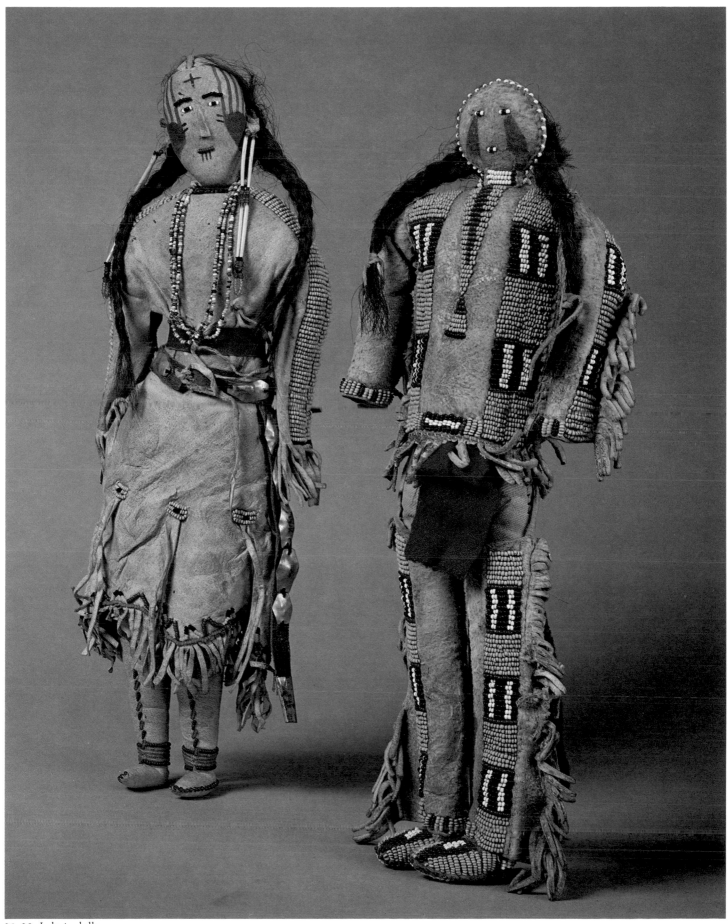

21, 22. Lakota dolls

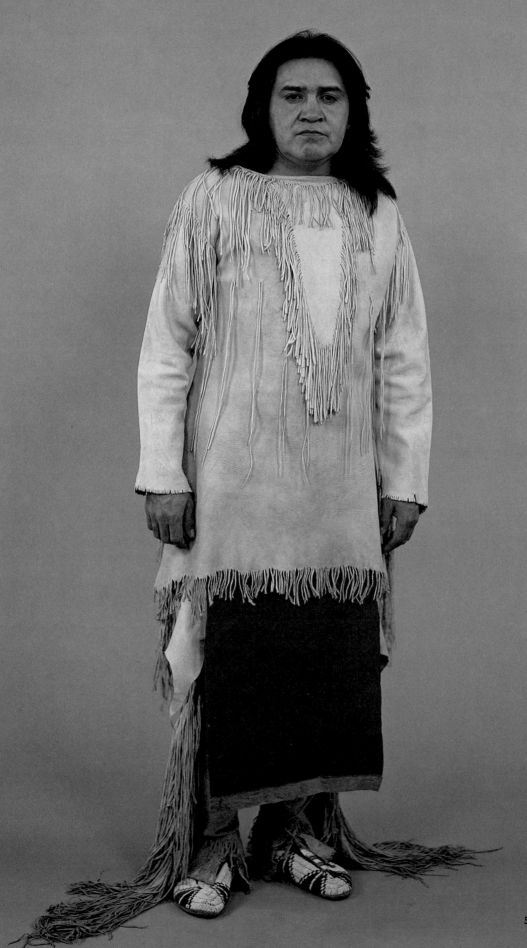

57. Arapaho man's clothing

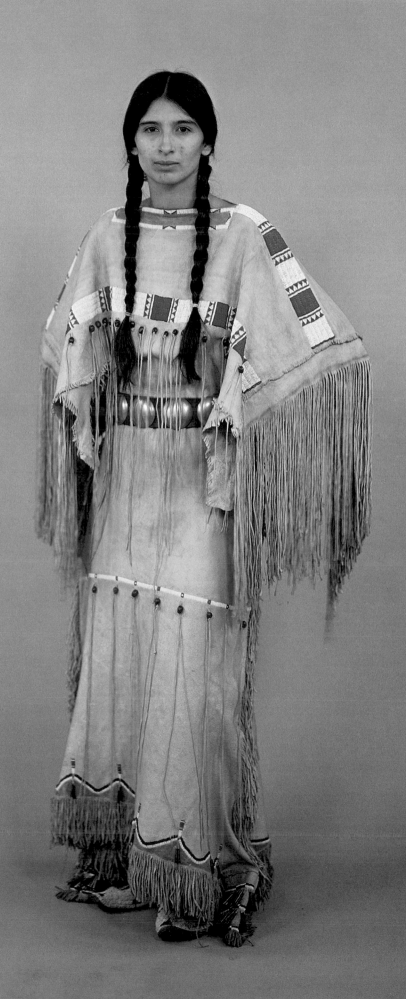

58. Cheyenne woman's clothing

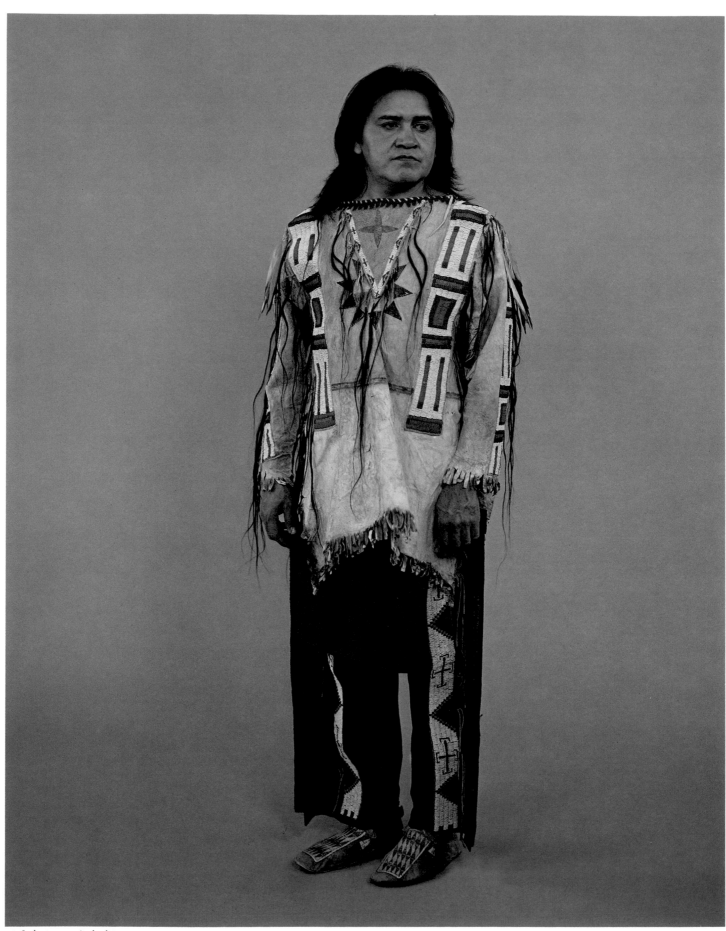

59. Lakota man's clothing

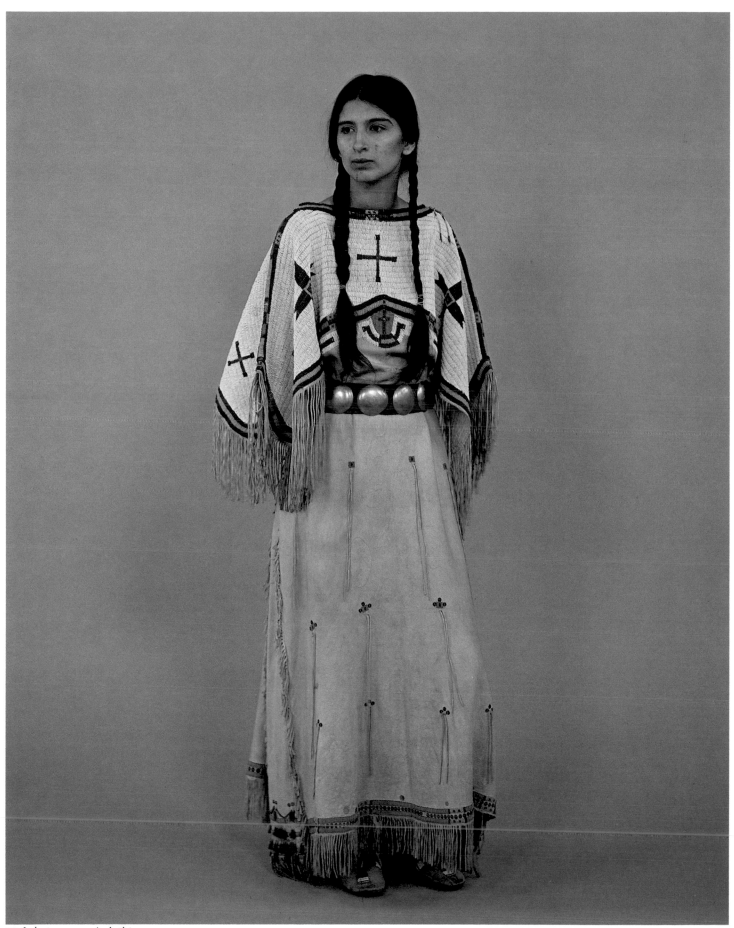

60. Lakota woman's clothing

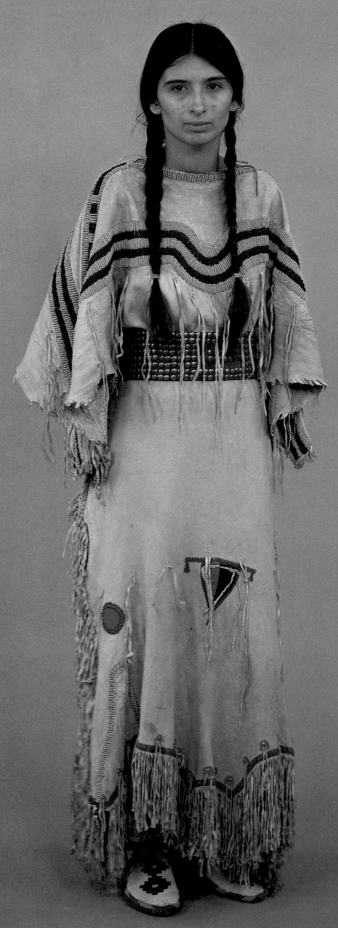

62. Blackfeet woman's clothing

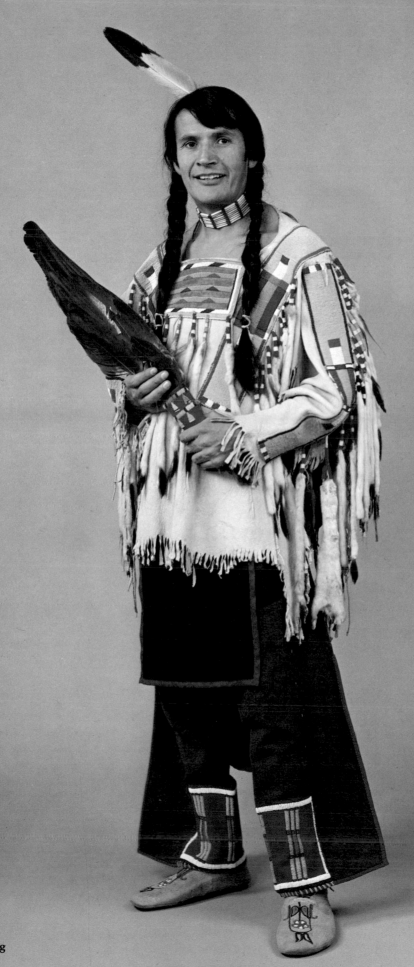

61. Crow man's clothing

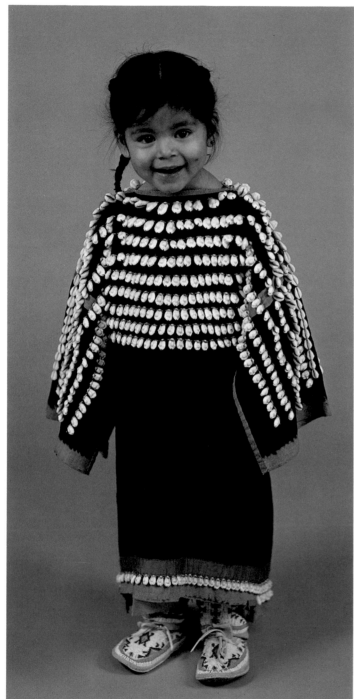

64. Cheyenne girl's clothing

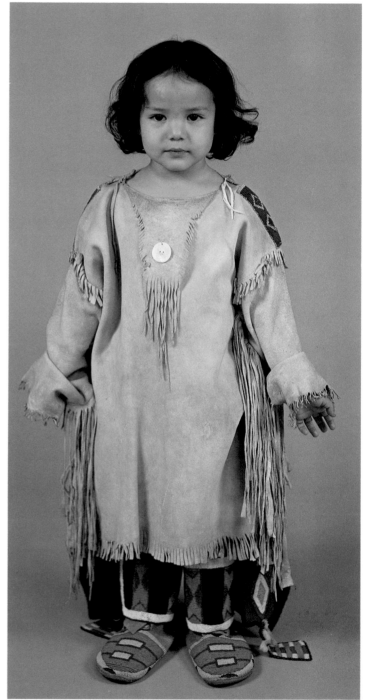

63. Crow boy's clothing

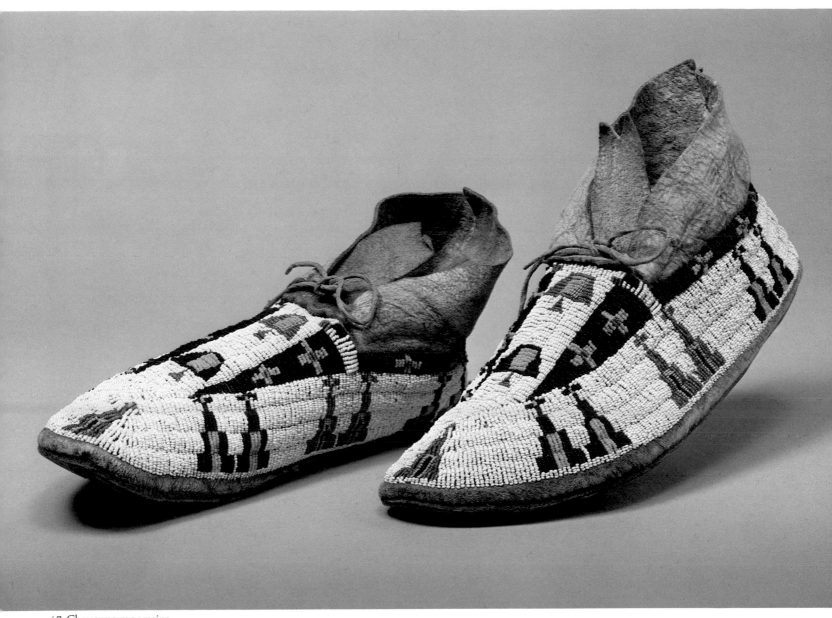

67. Cheyenne moccasins

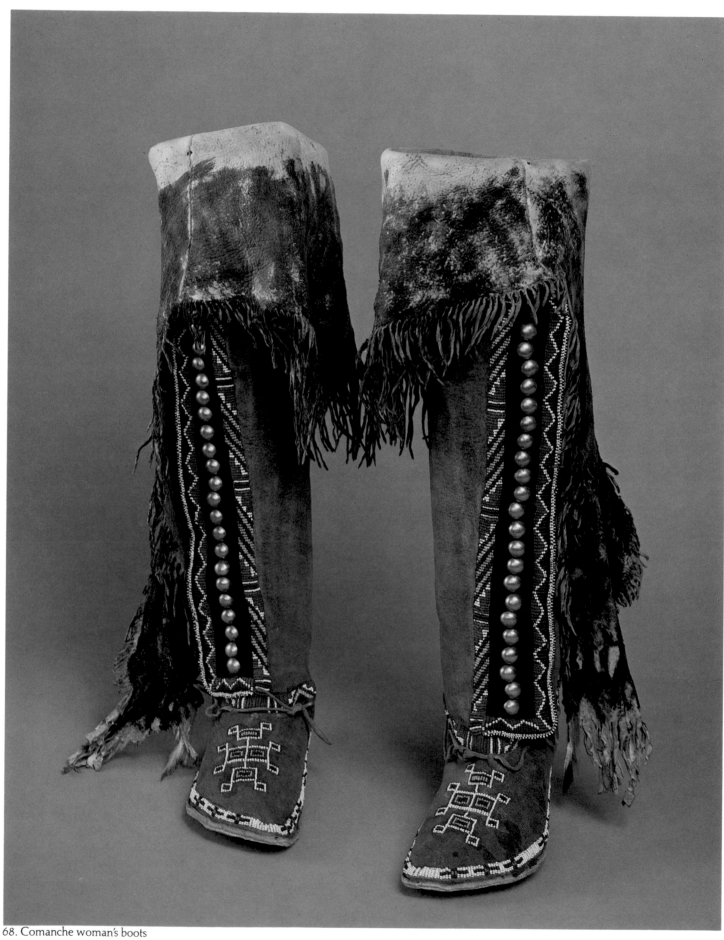

68. Comanche woman's boots

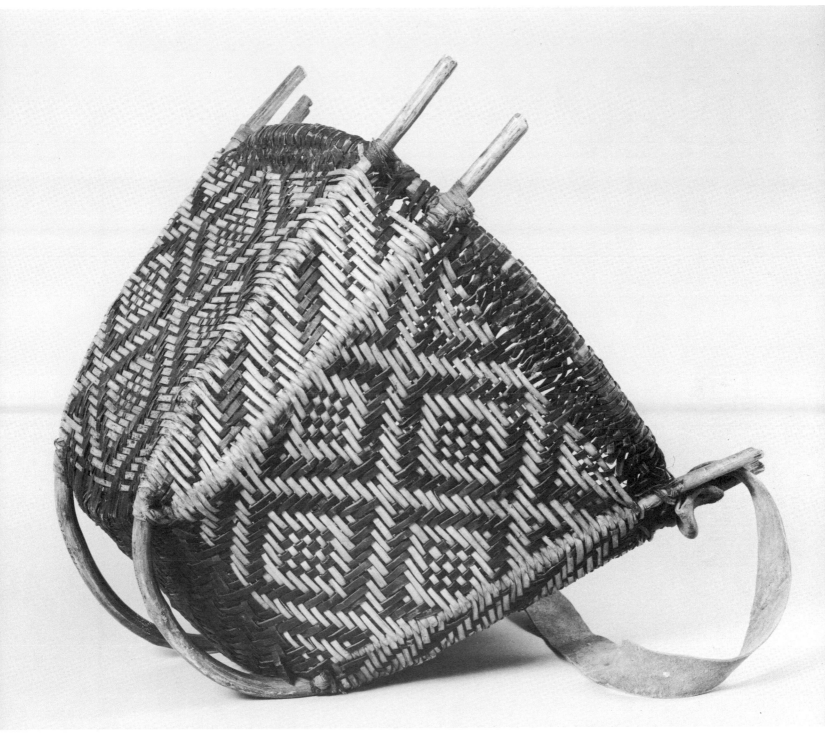

18. Hidatsa burden basket

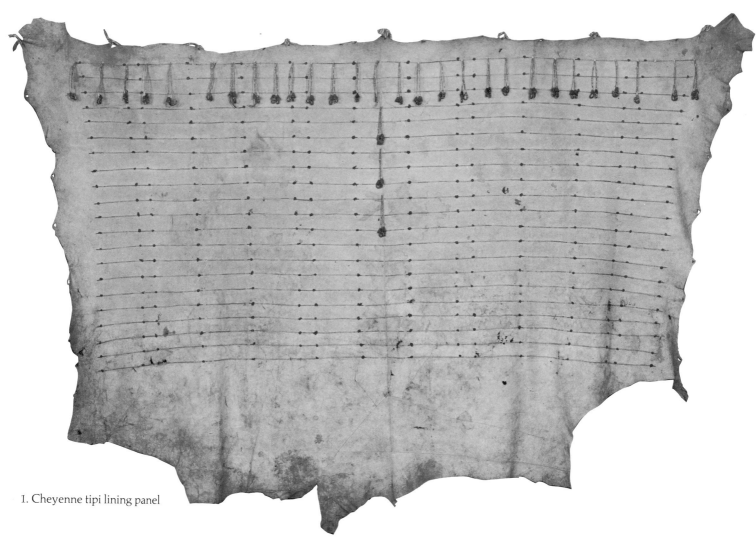

1. Cheyenne tipi lining panel

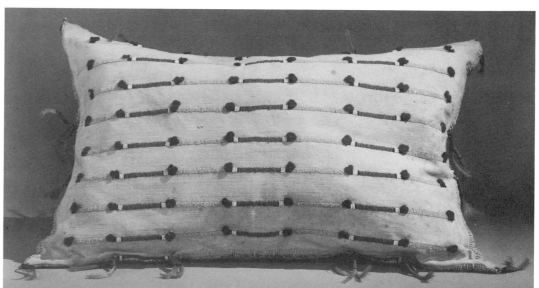

5. Cheyenne pillow

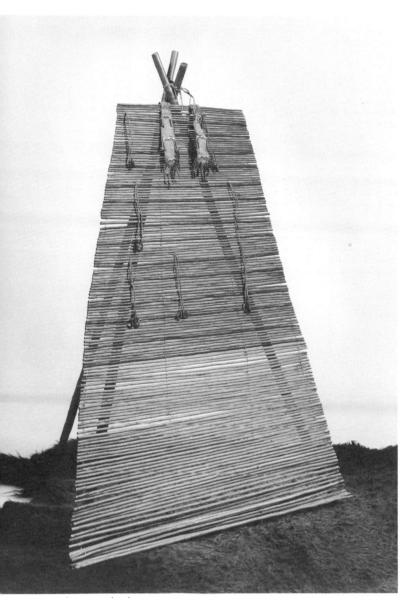

7. Cheyenne backrest

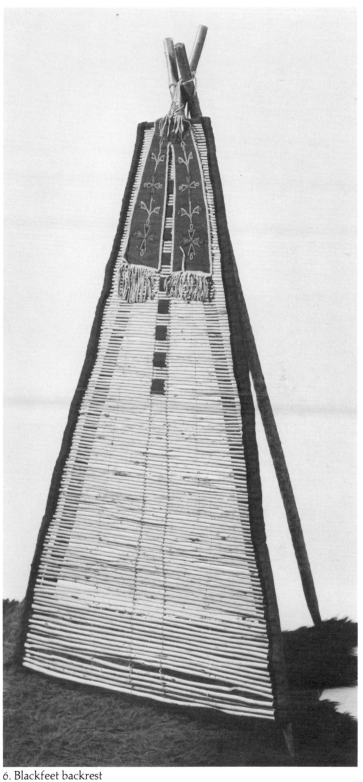

6. Blackfeet backrest

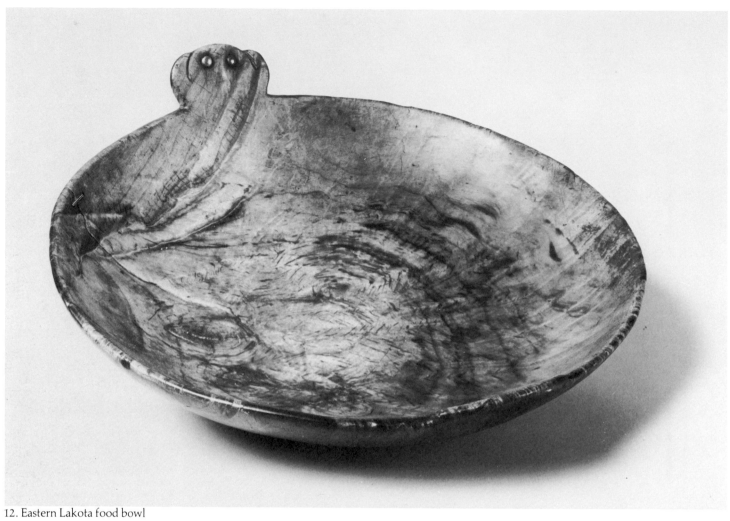

12. Eastern Lakota food bowl

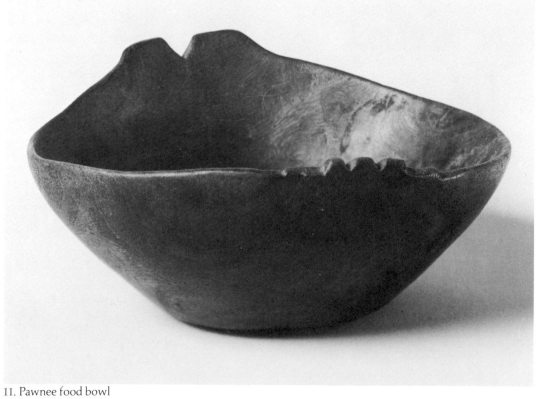

11. Pawnee food bowl

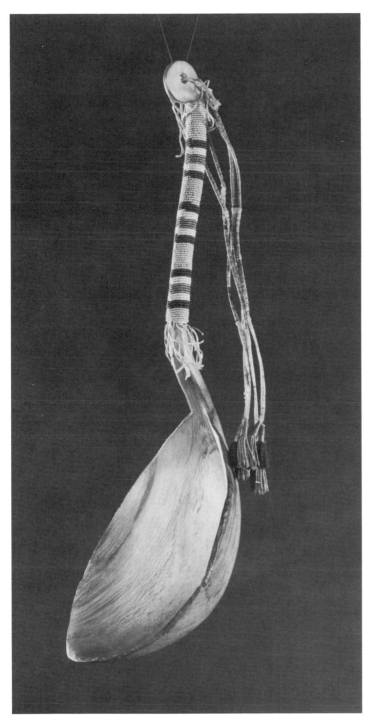

9. Lakota ladle

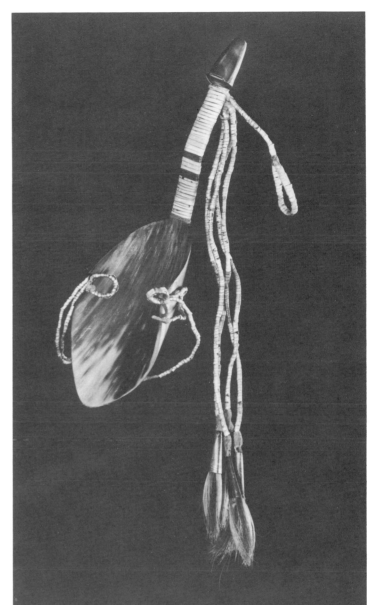

10. Arapaho spoon

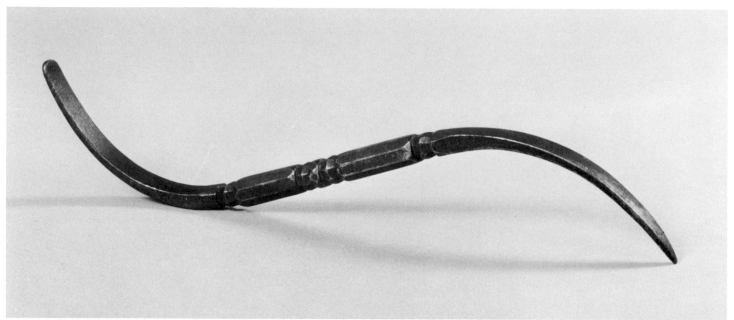

15. Lakota quill flattener

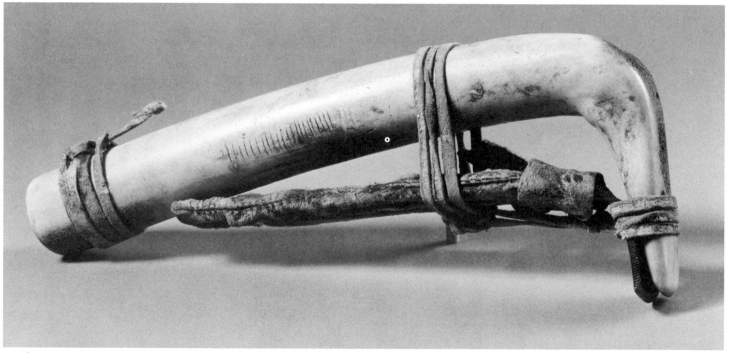

14. Cheyenne skin scraper

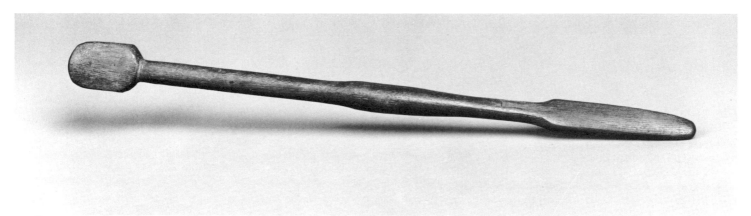

16. Cheyenne moccasin-turning stick

17. Arikara cooking pot

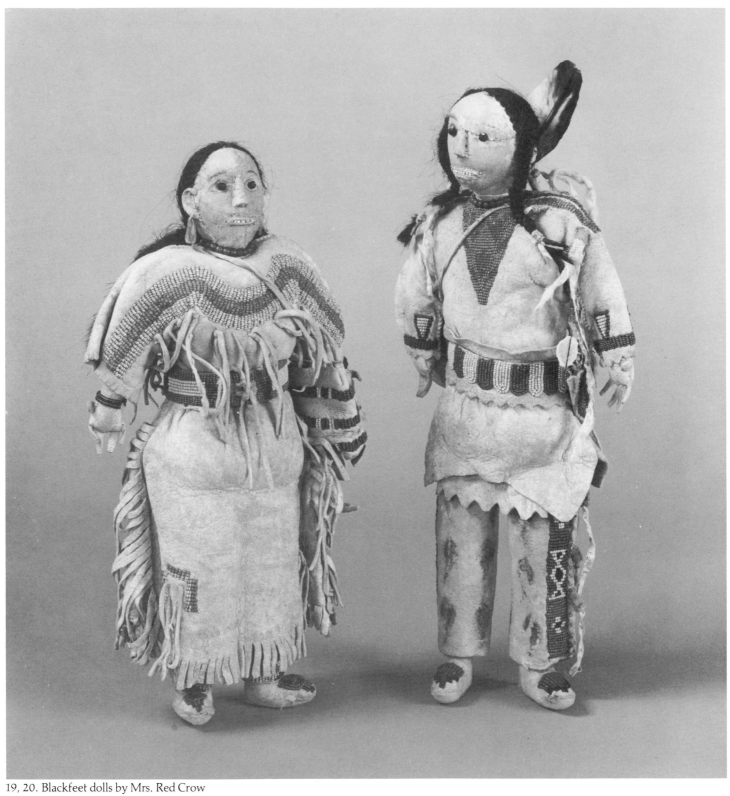

19, 20. Blackfeet dolls by Mrs. Red Crow

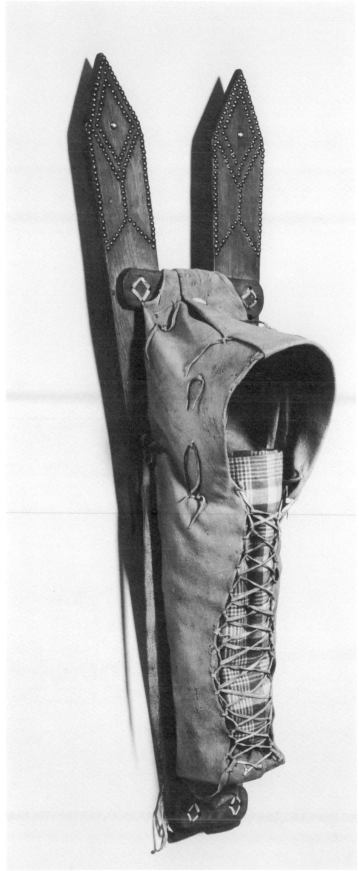

24. Comanche cradle

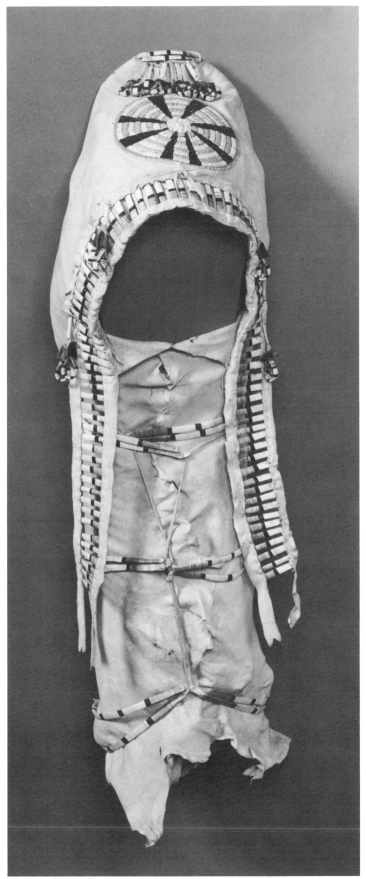

23. Arapaho cradle

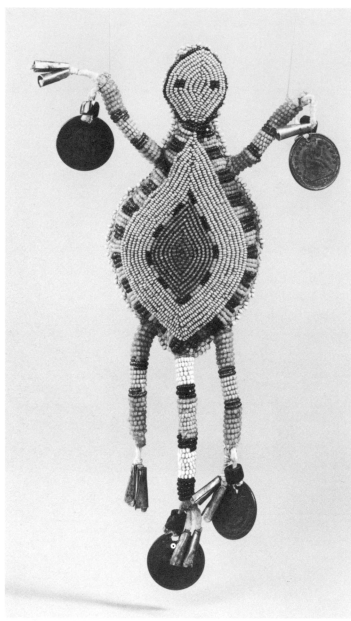

27. Lakota umbilical cord amulet

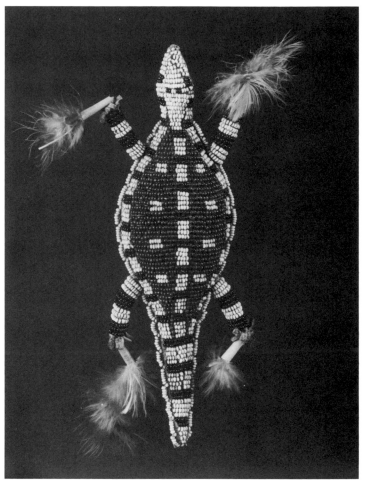

28. Lakota umbilical cord amulet

31. Crow baby's ball

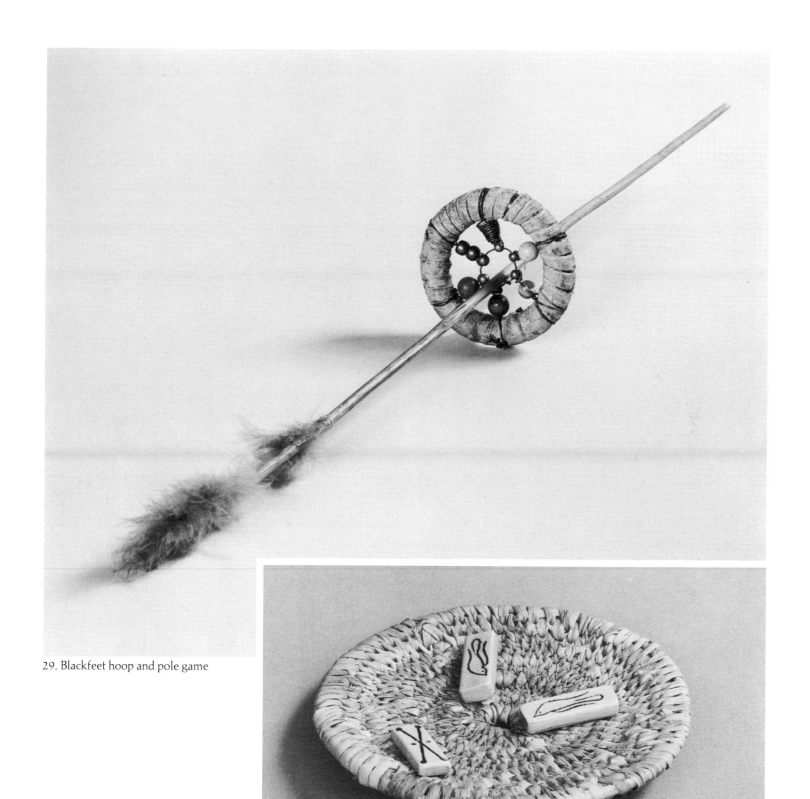

29. Blackfeet hoop and pole game

30. Cheyenne basket dice game

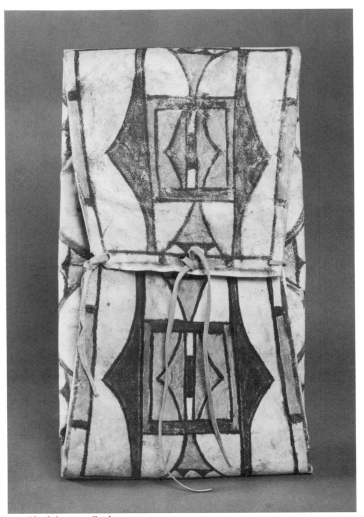

34. Blackfeet parfleche

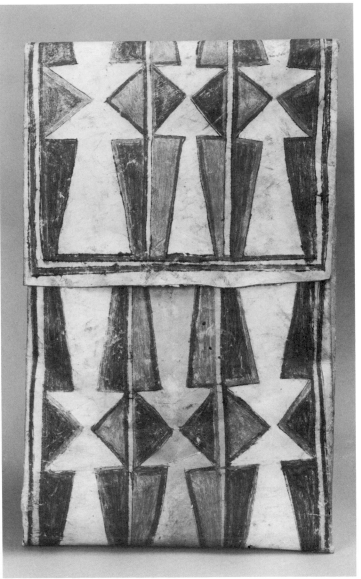

35. Arapaho parfleche

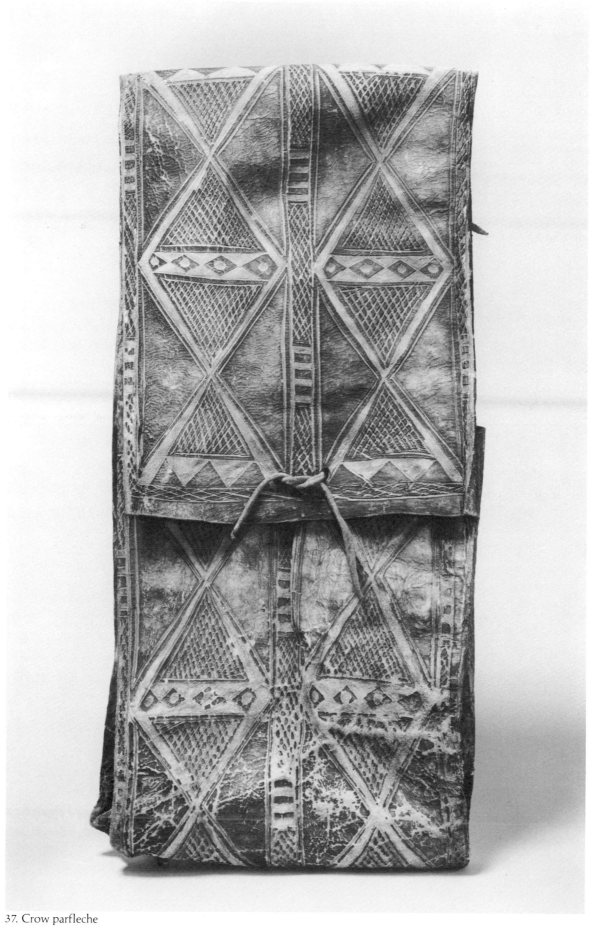

37. Crow parfleche

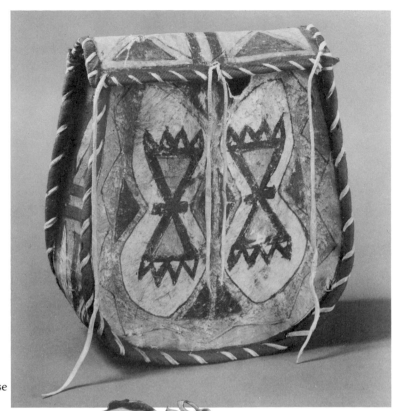

41. Lakota tool case

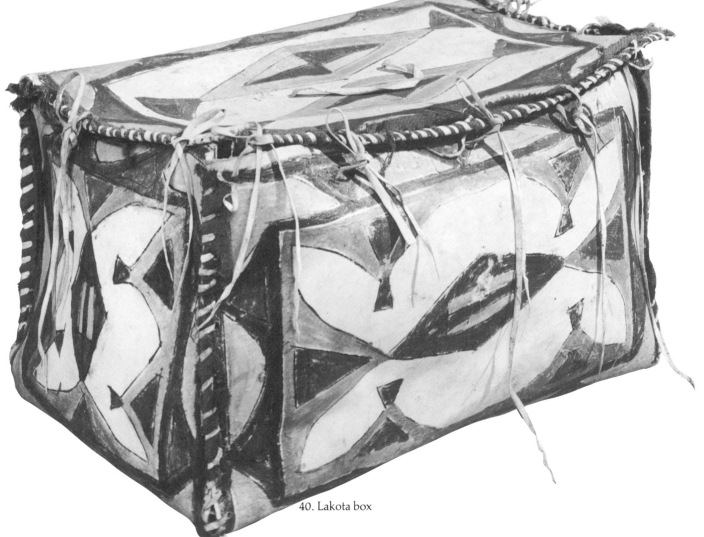

40. Lakota box

70

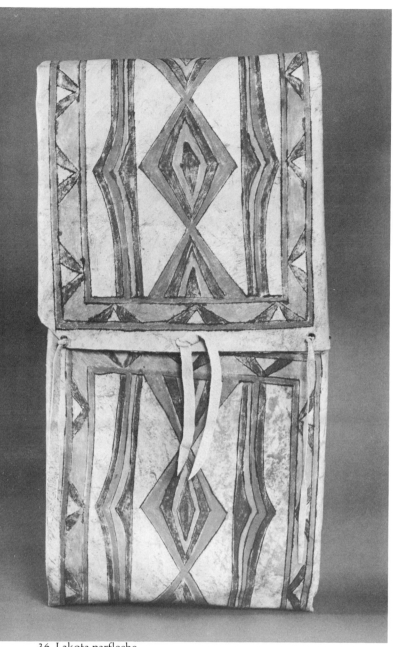

36. Lakota parfleche

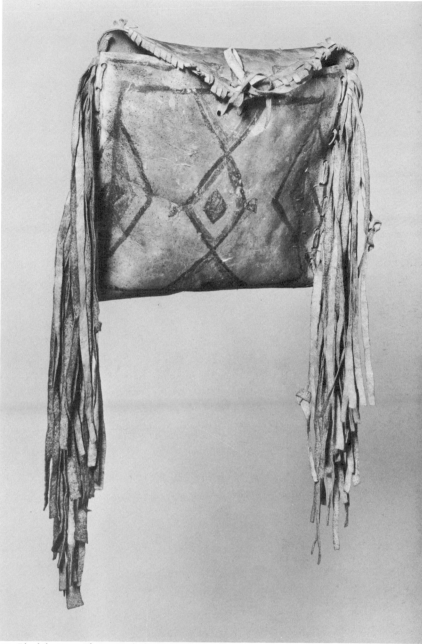

39. Blackfeet case for sacred objects

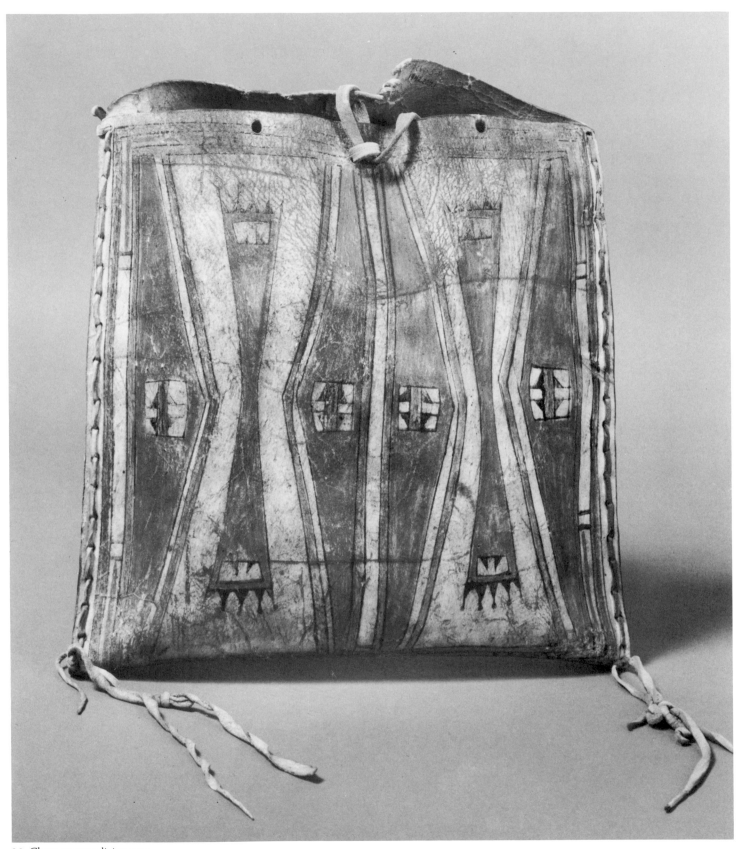

38. Cheyenne medicine case

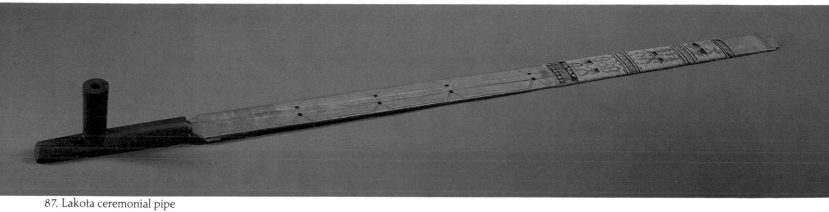

87. Lakota ceremonial pipe

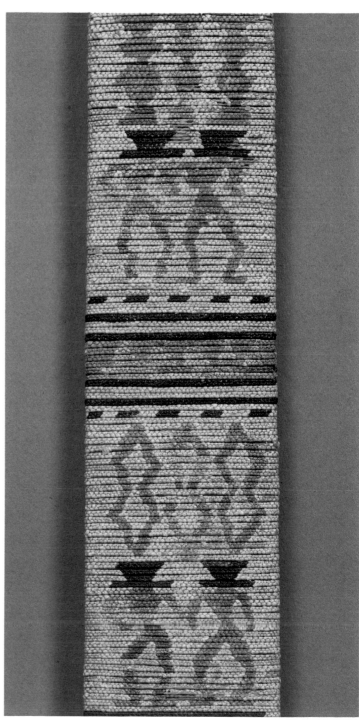

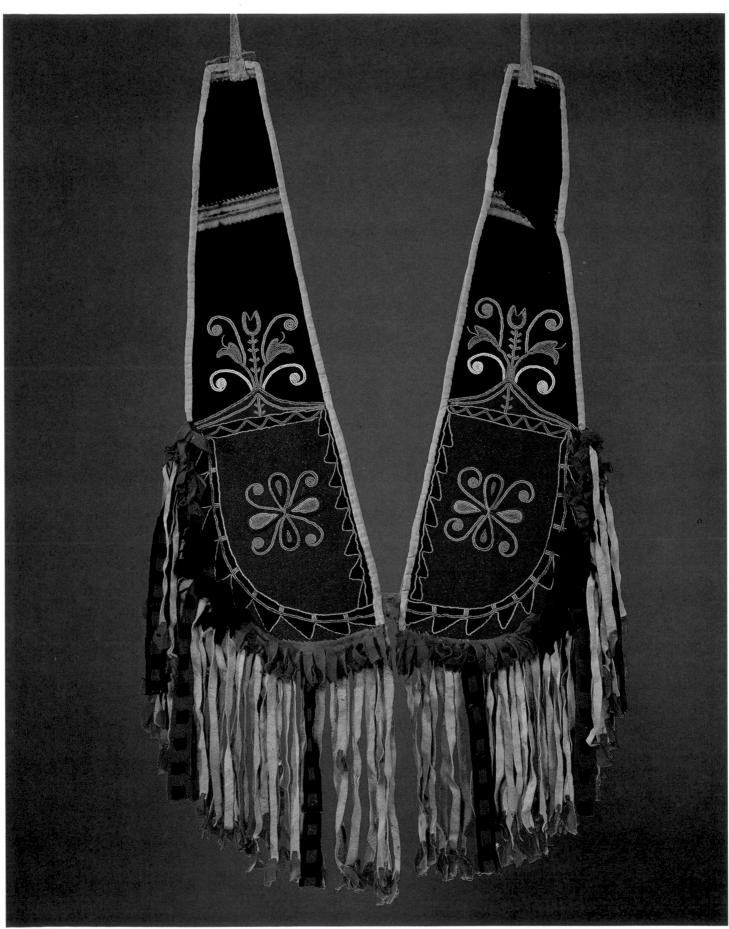

53. Blackfeet crupper

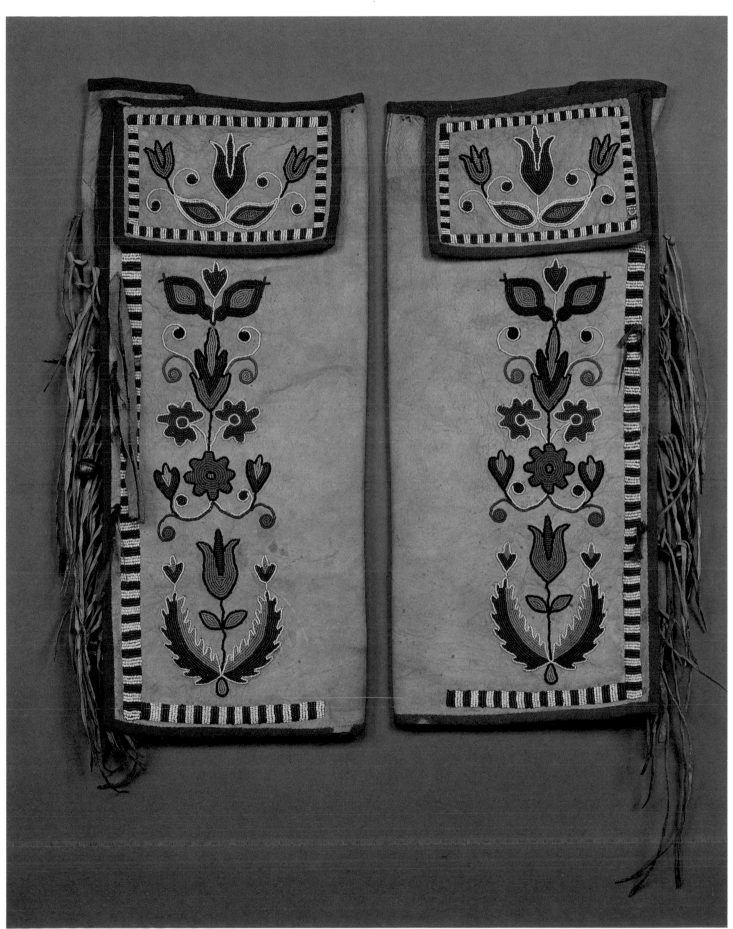

72. Eastern Lakota half-leggings

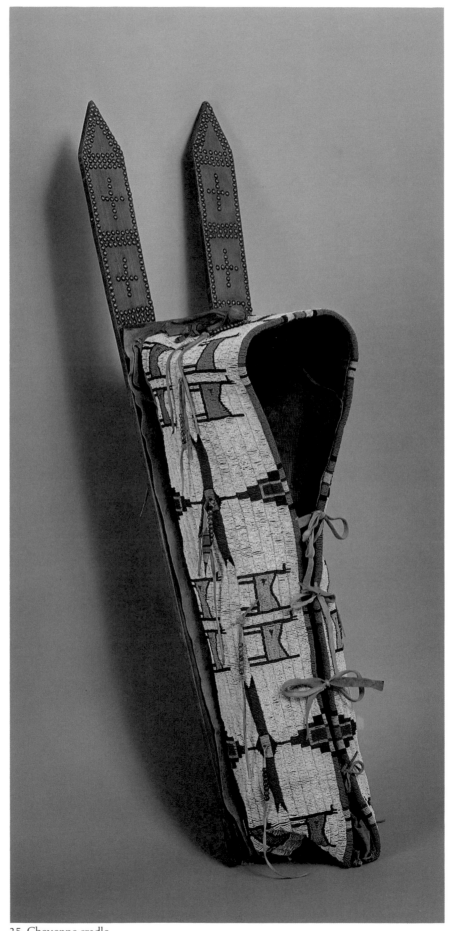

25. Cheyenne cradle

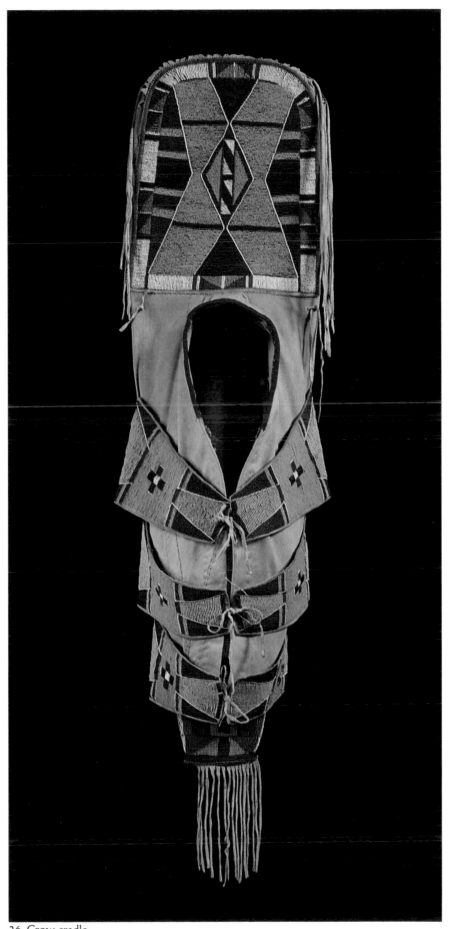

26. Crow cradle

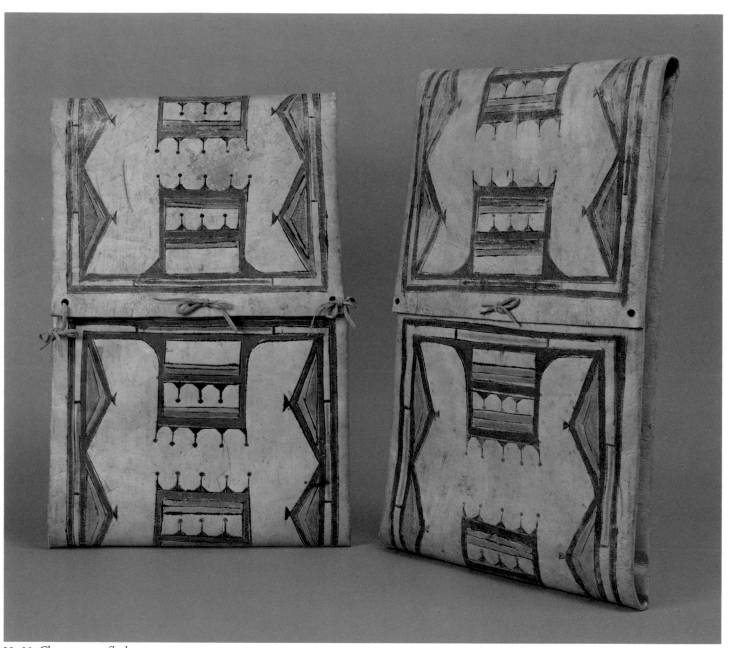

32, 33. Cheyenne parfleches

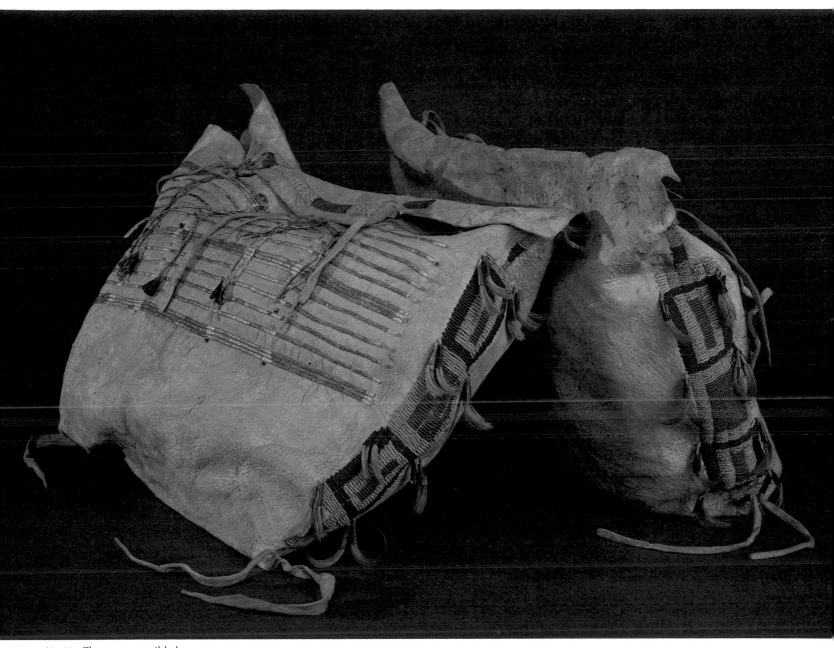

42, 43. Cheyenne possible bags

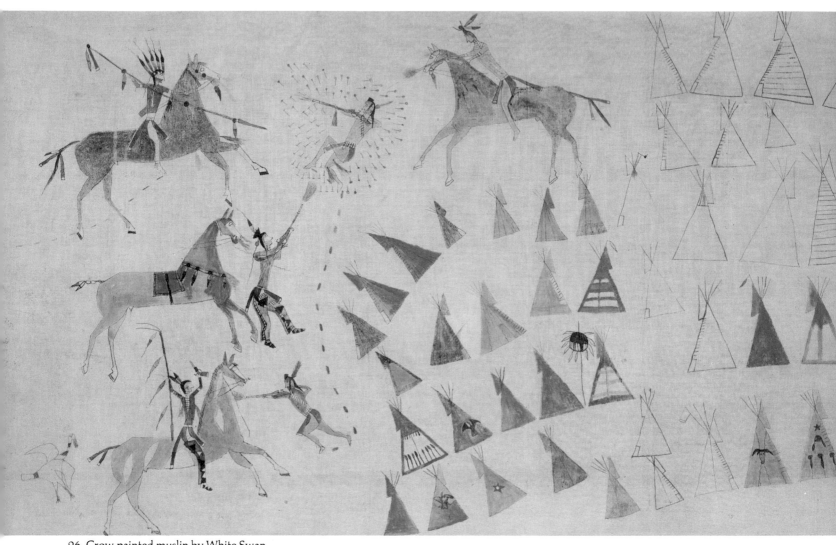

96. Crow painted muslin by White Swan

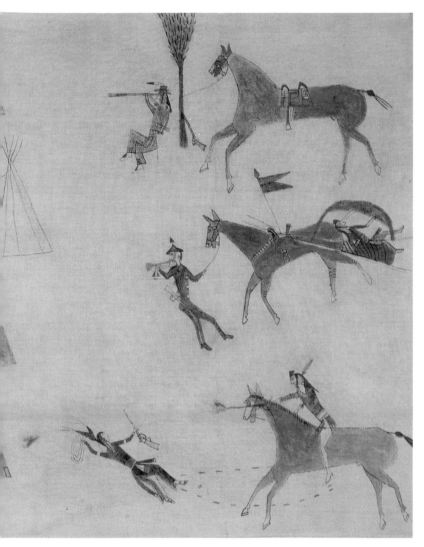
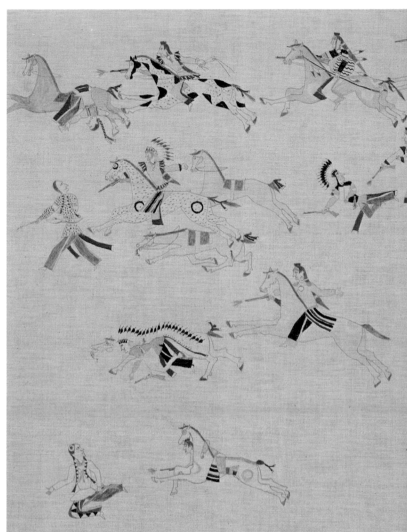

97. Cheyenne painted muslin by White Bird (detail)

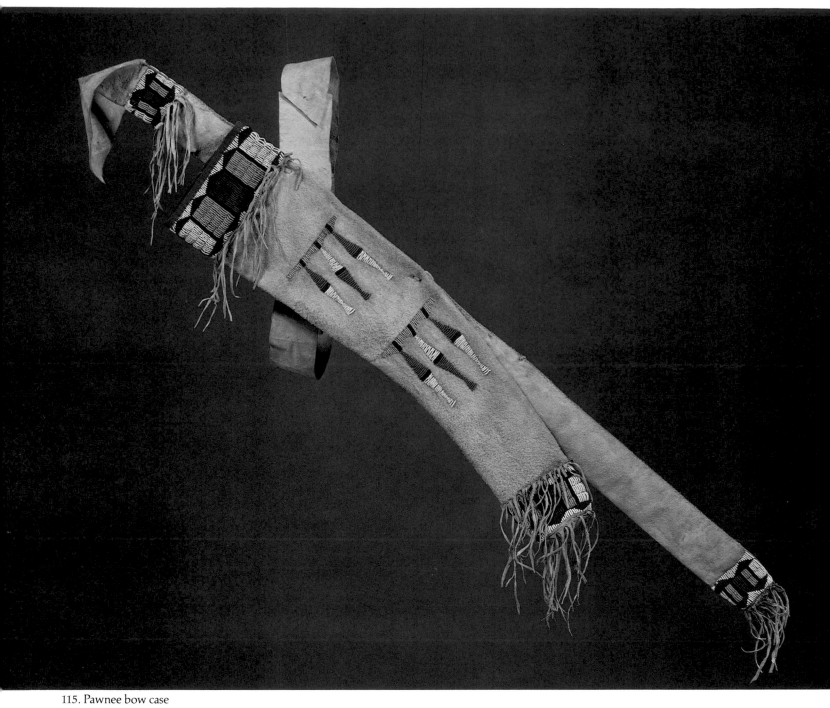

115. Pawnee bow case

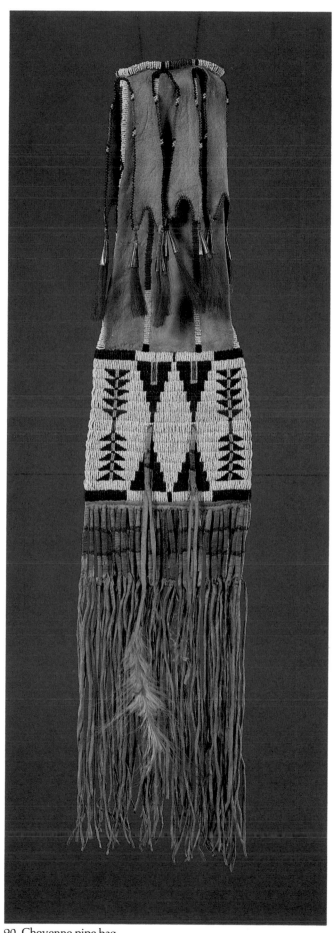

90. Cheyenne pipe bag

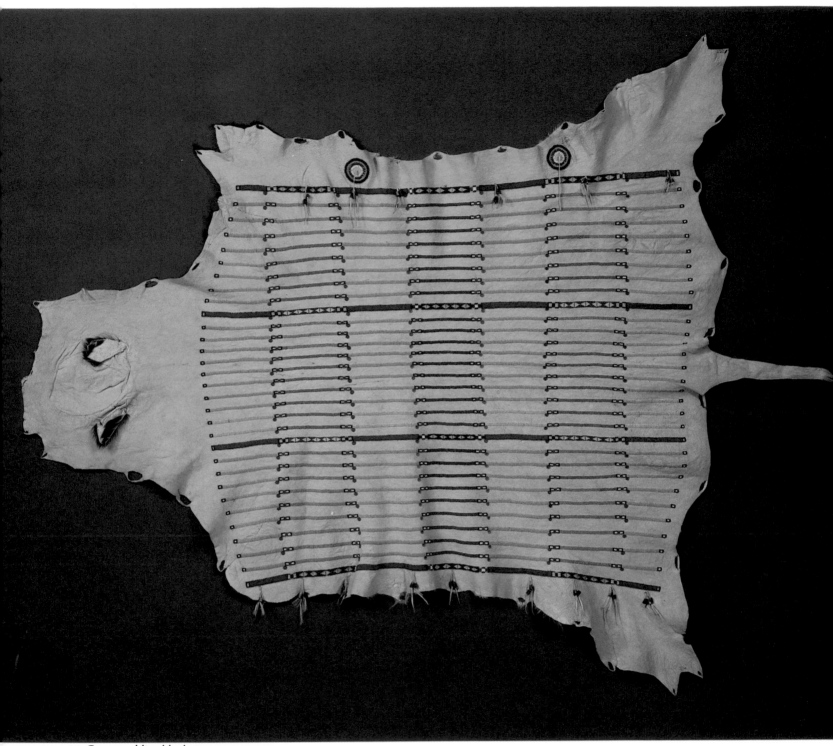

84. Crow wedding blanket

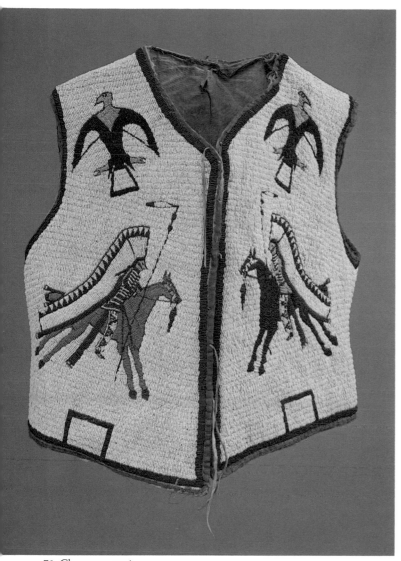

71. Cheyenne vest

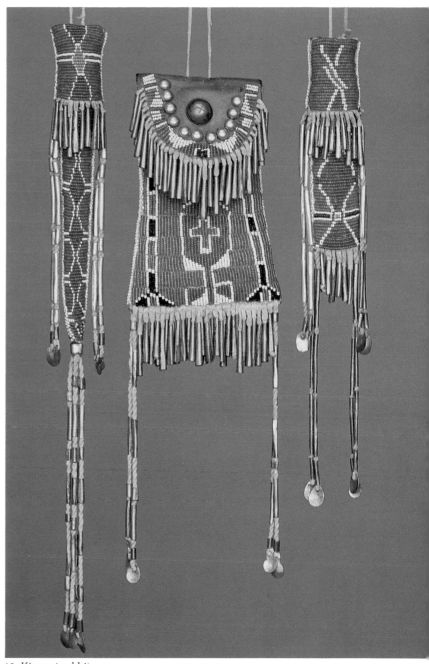

13. Kiowa tool kit

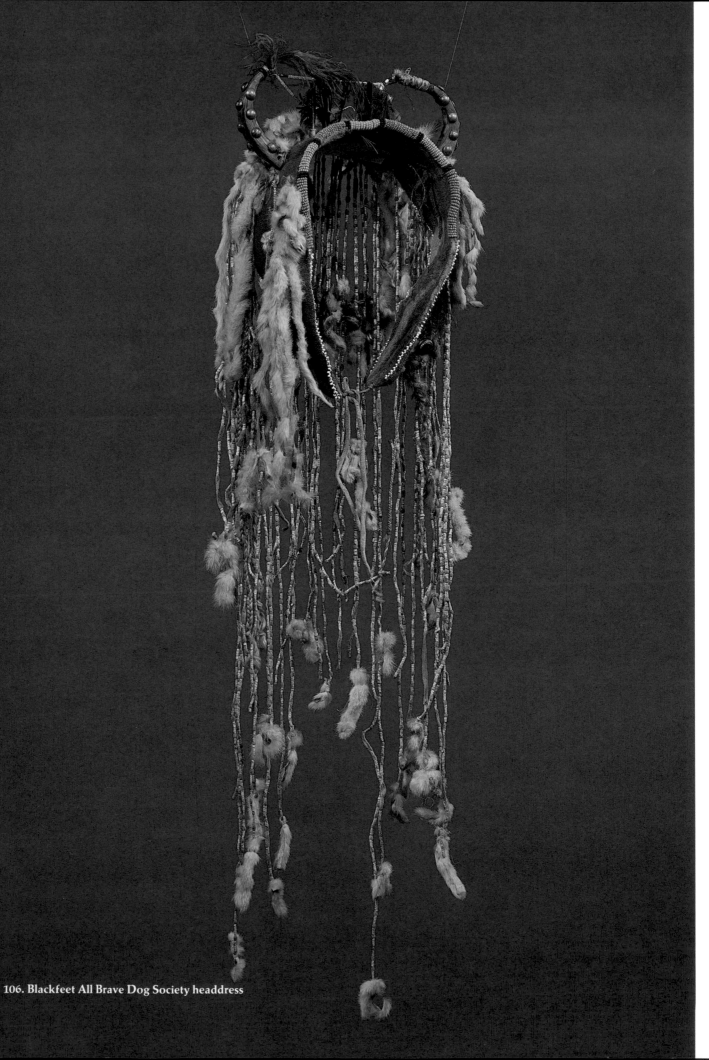

106. Blackfeet All Brave Dog Society headdress

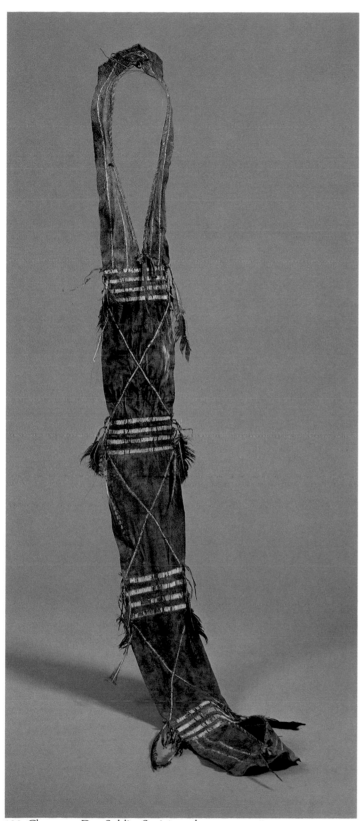

103. Cheyenne Dog Soldier Society sash

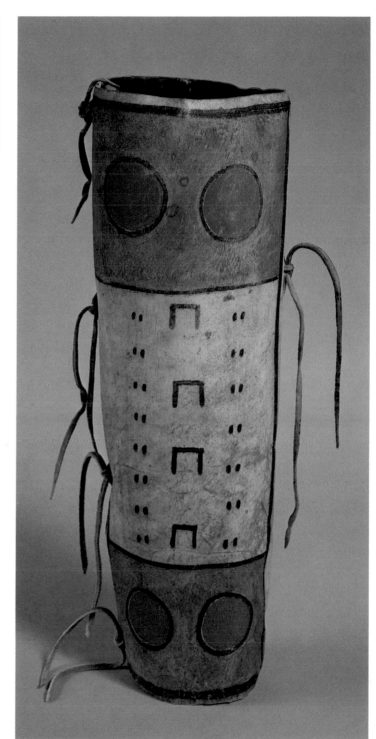

99. Crow war regalia case

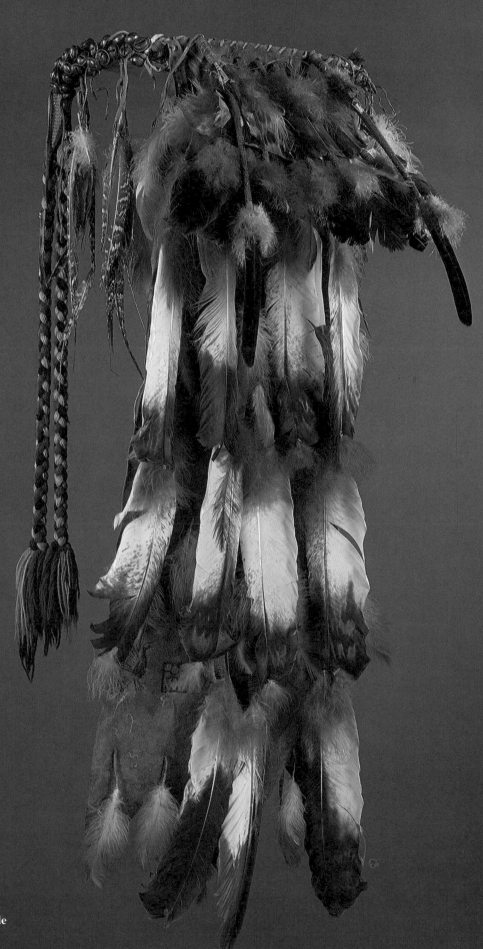

107. Crow dance bustle

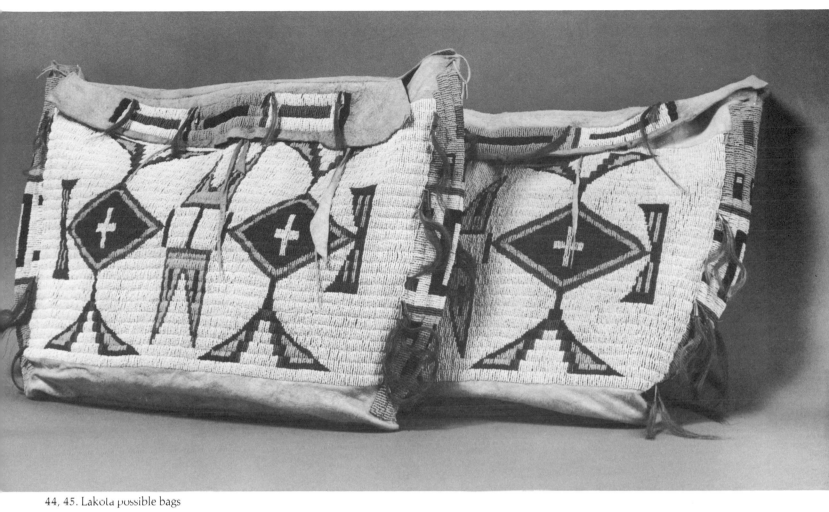

44, 45. Lakota possible bags

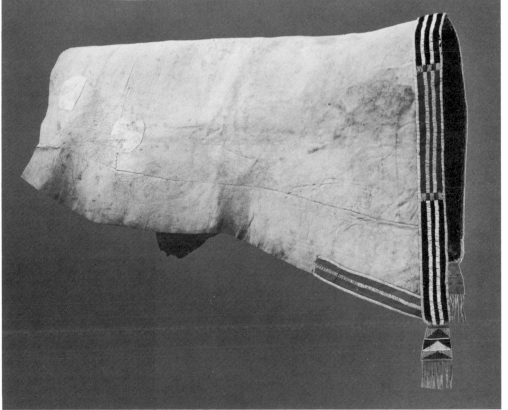

49. Crow saddle blanket

89

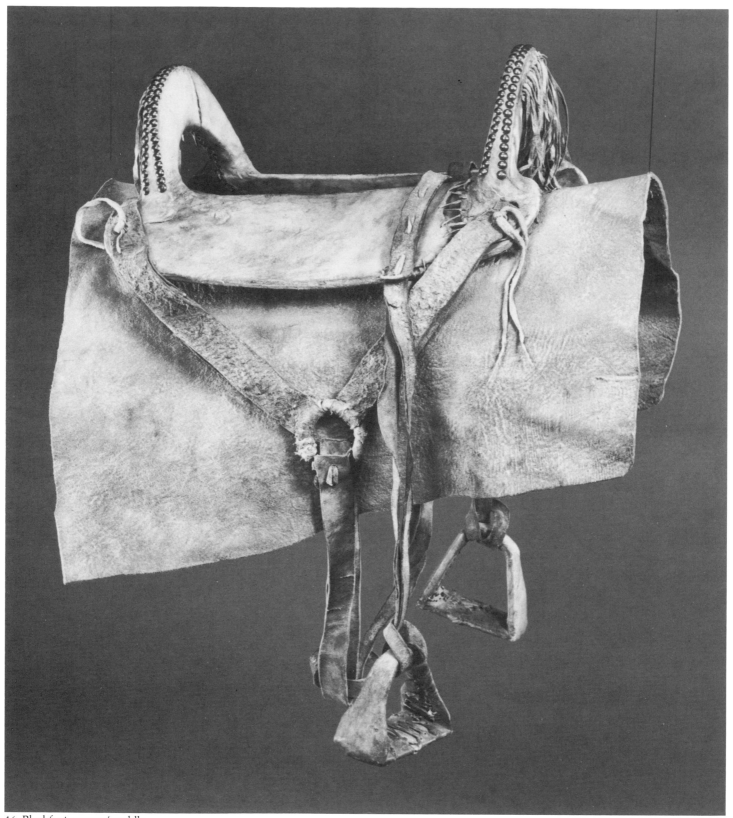

46. Blackfeet woman's saddle

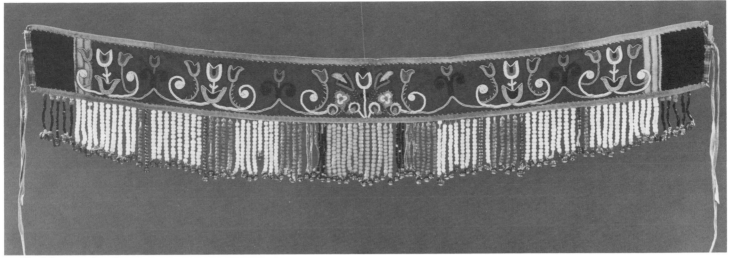

52. Blackfeet martingale

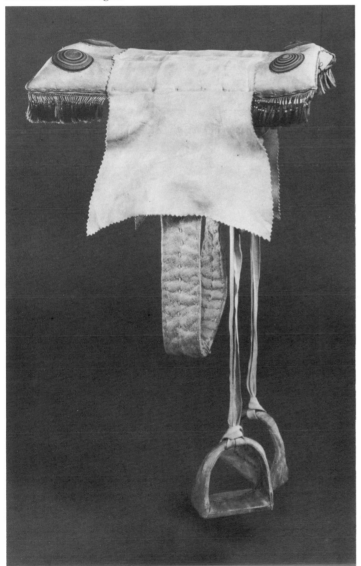

47. Plains Cree man's saddle

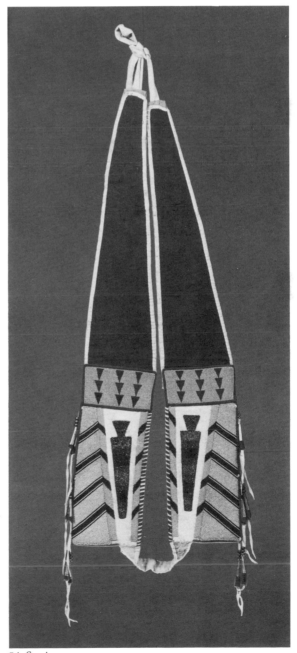

54. Sarsi crupper

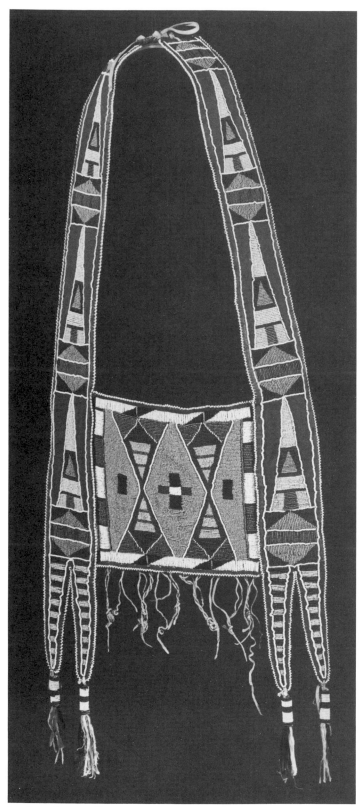

51. Crow horse collar

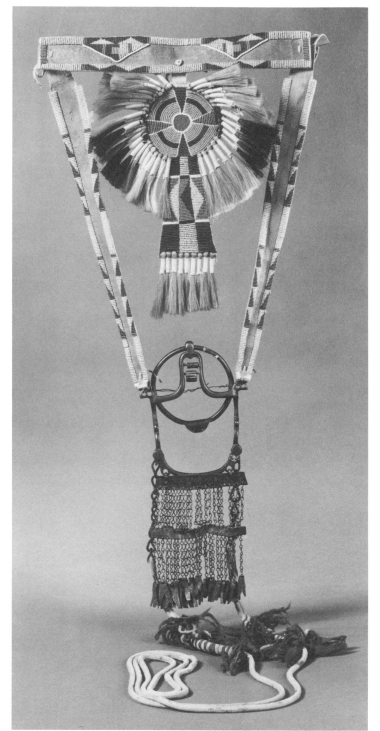

50. Crow bridle

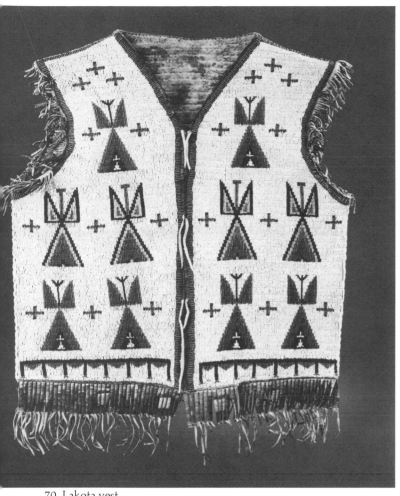

70. Lakota vest

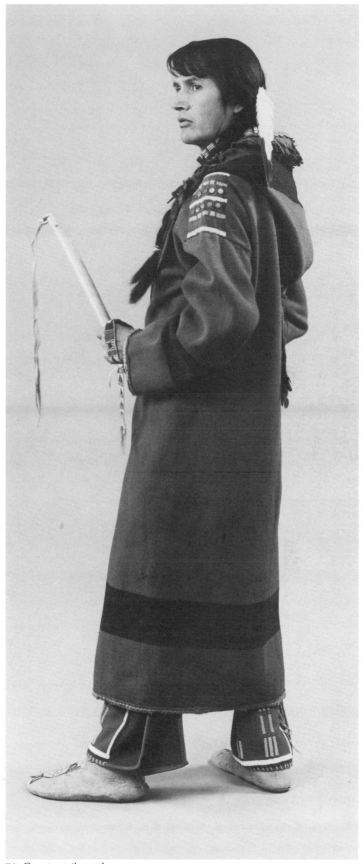

73. Capote, tribe unknown

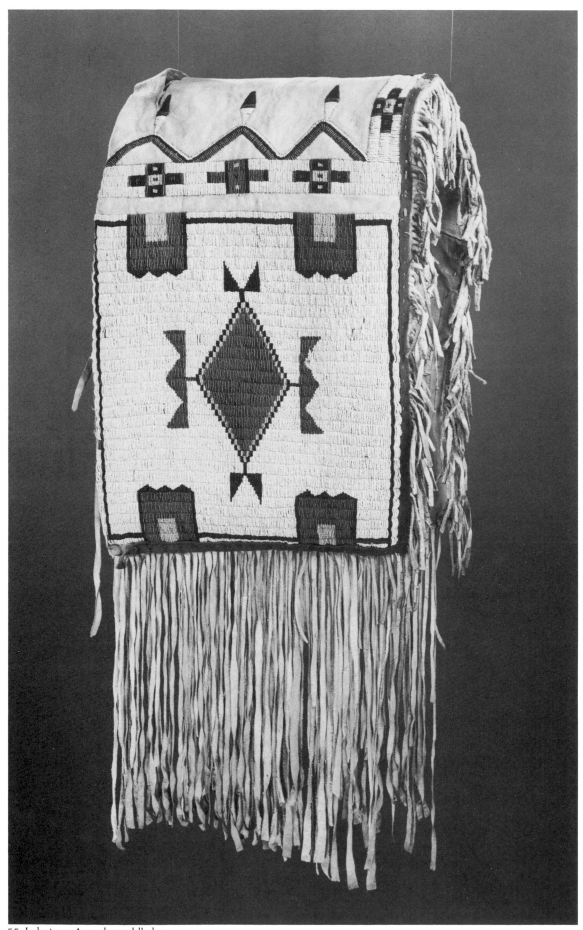

55. Lakota or Arapaho saddle bag

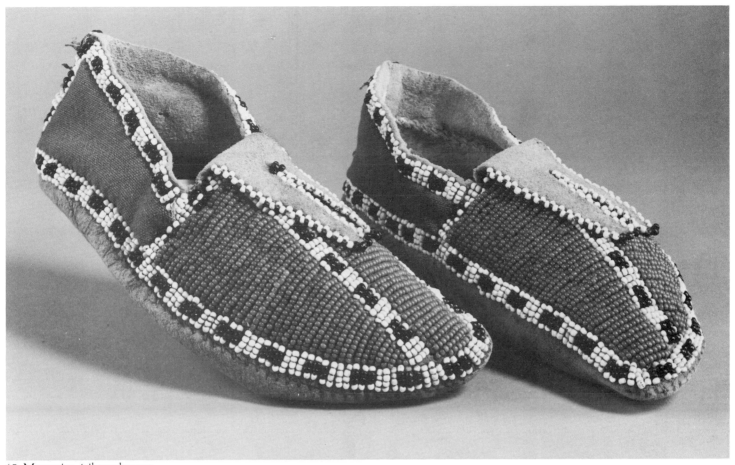

65. Moccasins, tribe unknown

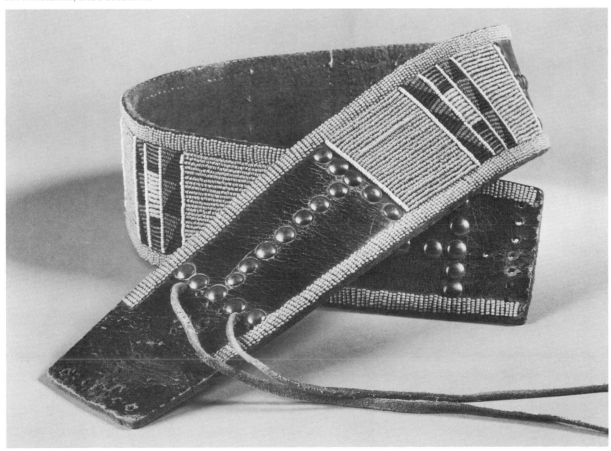

74. Arapaho belt

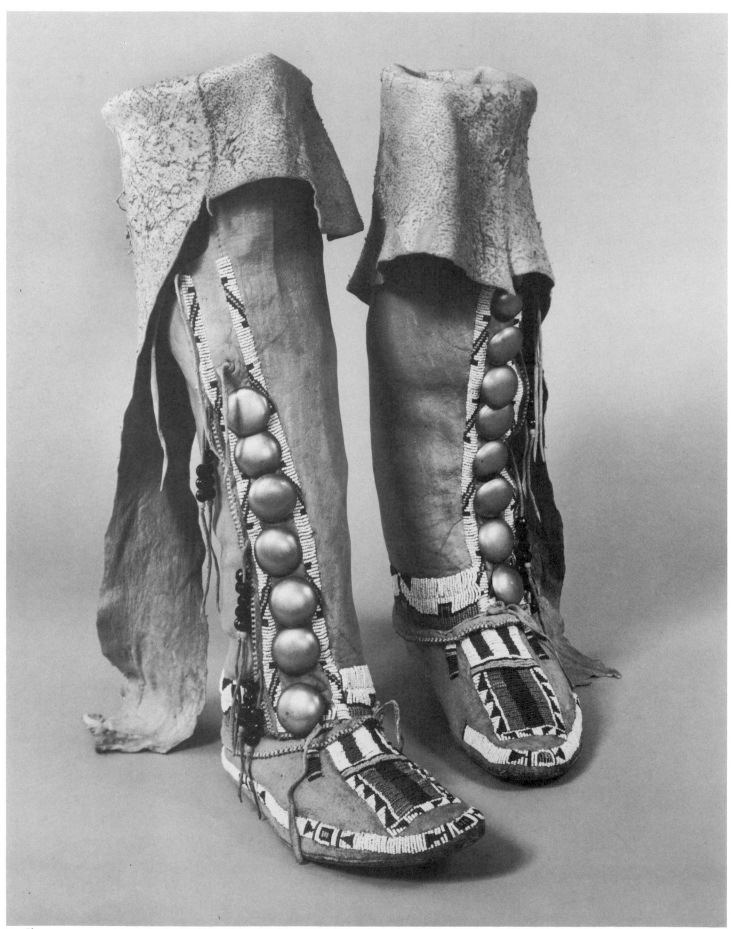

69. Cheyenne woman's boots

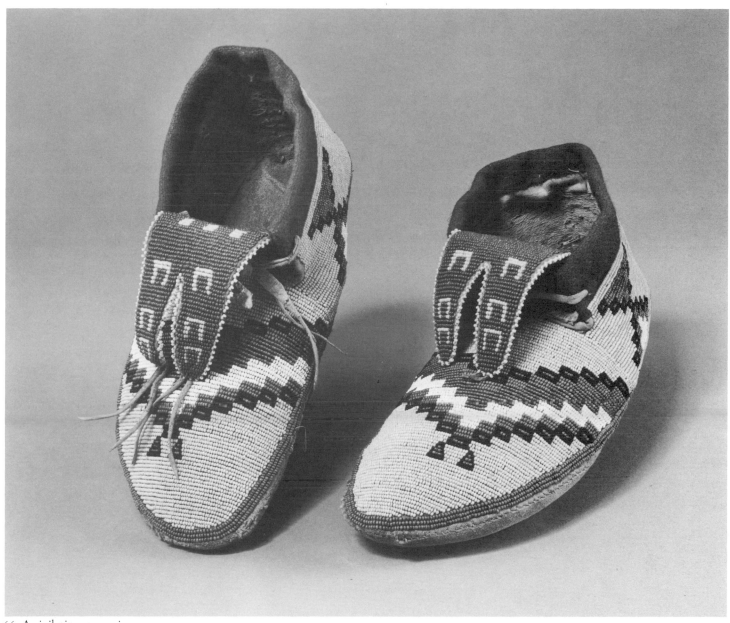

66. Assiniboine moccasins

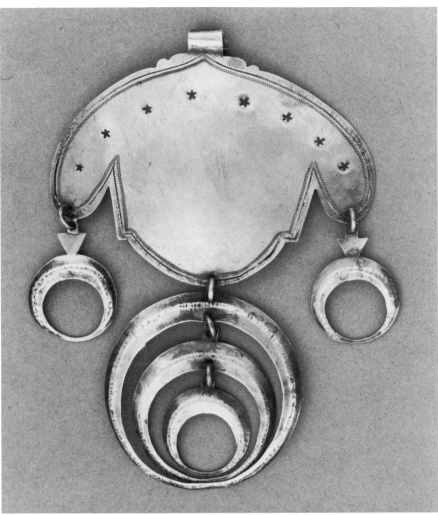

75. Shoshoni pectoral

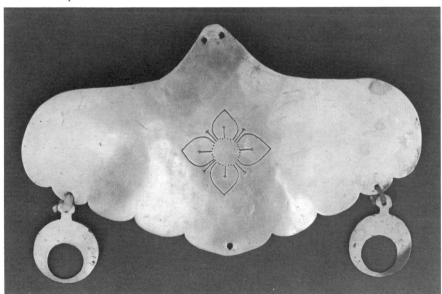

76. Central Plains pectoral

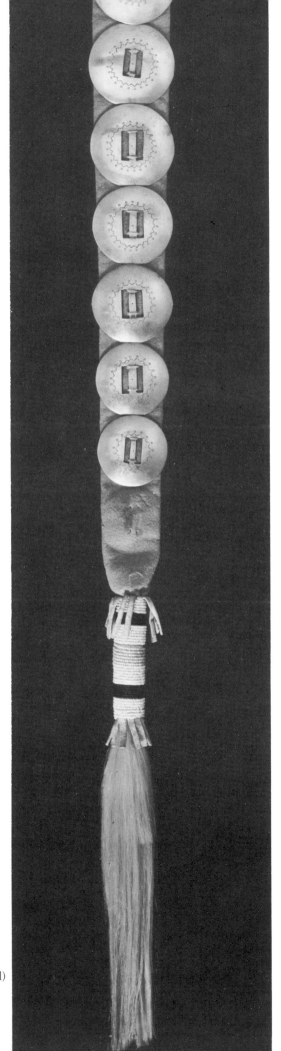

77. Kiowa hairplates (detail)

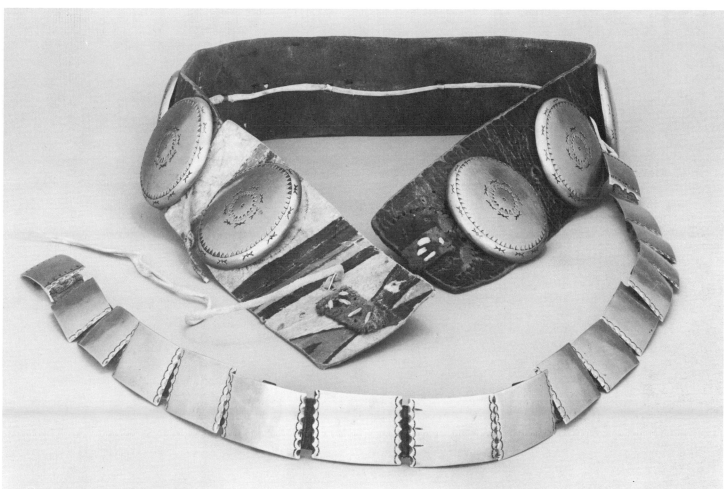

78. Cheyenne woman's belt

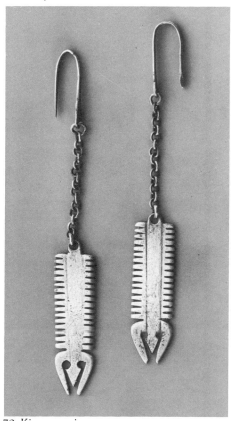

79. Kiowa earrings

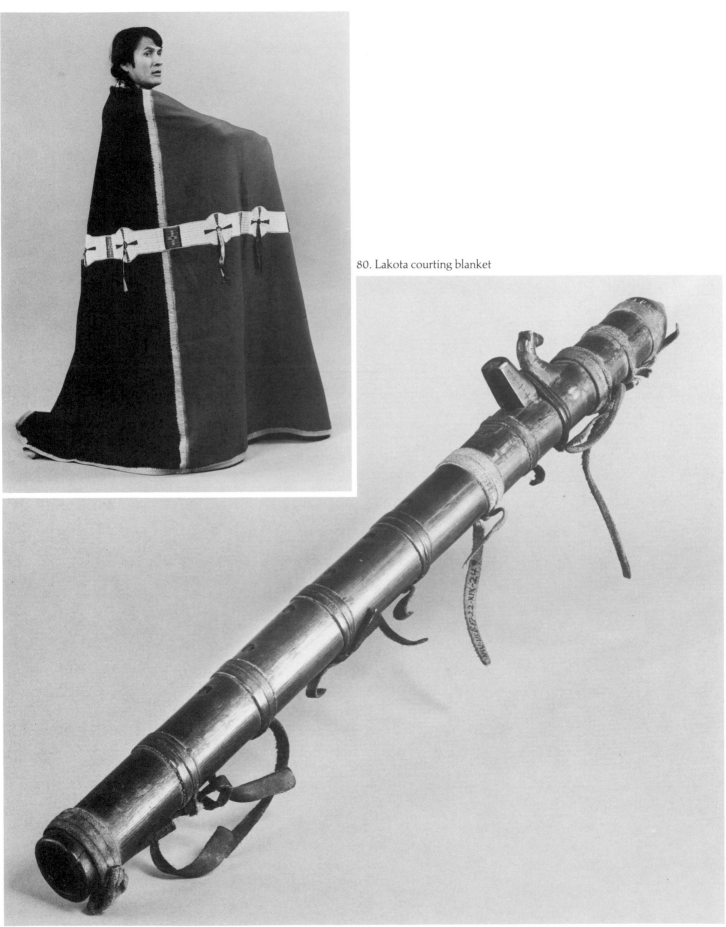

80. Lakota courting blanket

82. Fox courting flute

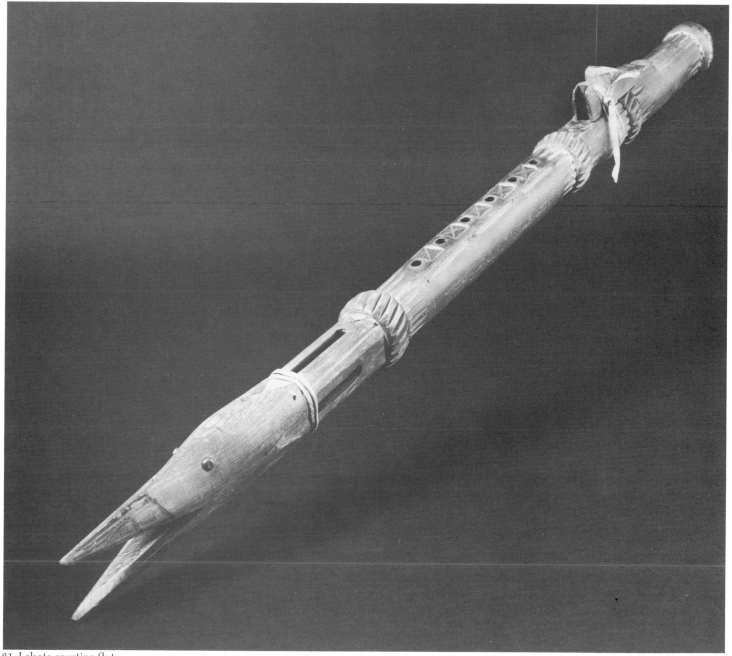

81. Lakota courting flute

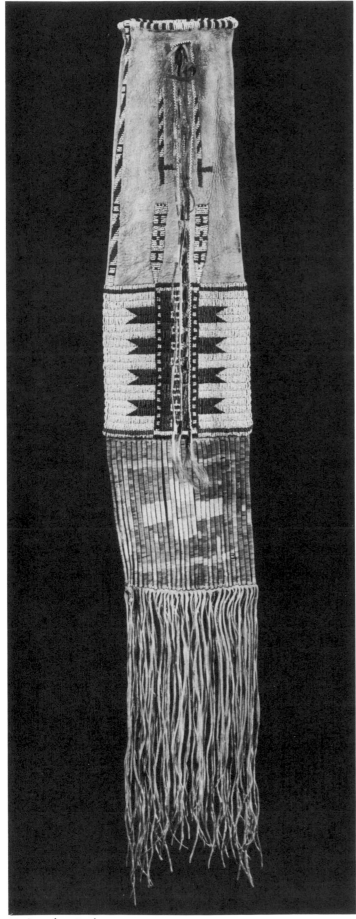

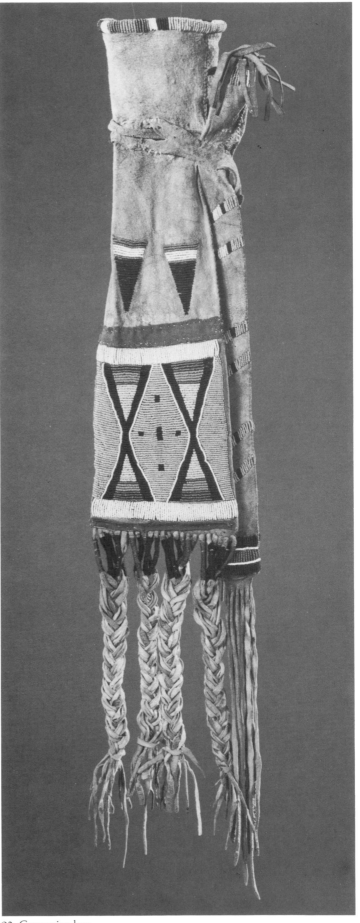

91. Arapaho pipe bag

92. Crow pipe bag

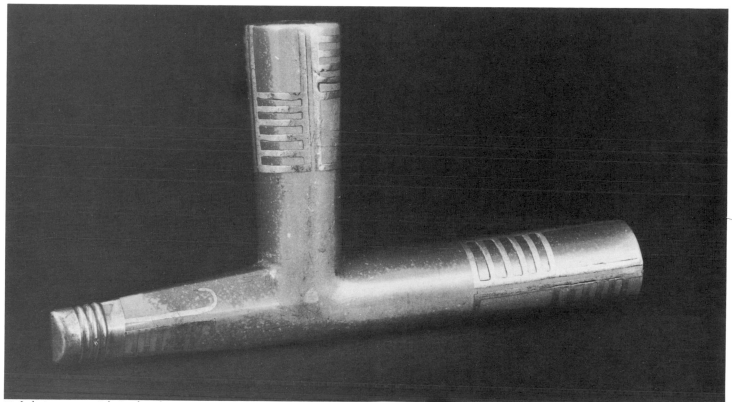

88. Lakota ceremonial pipe bowl

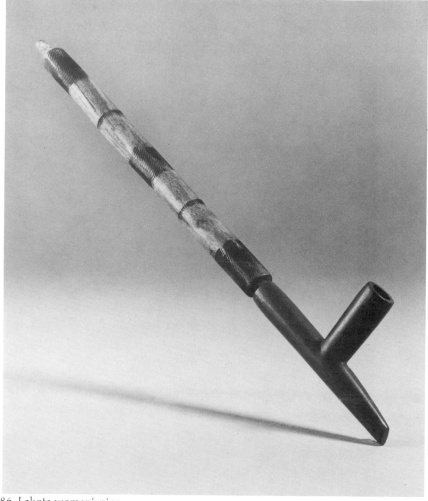

89. Lakota pipe tamper

86. Lakota woman's pipe

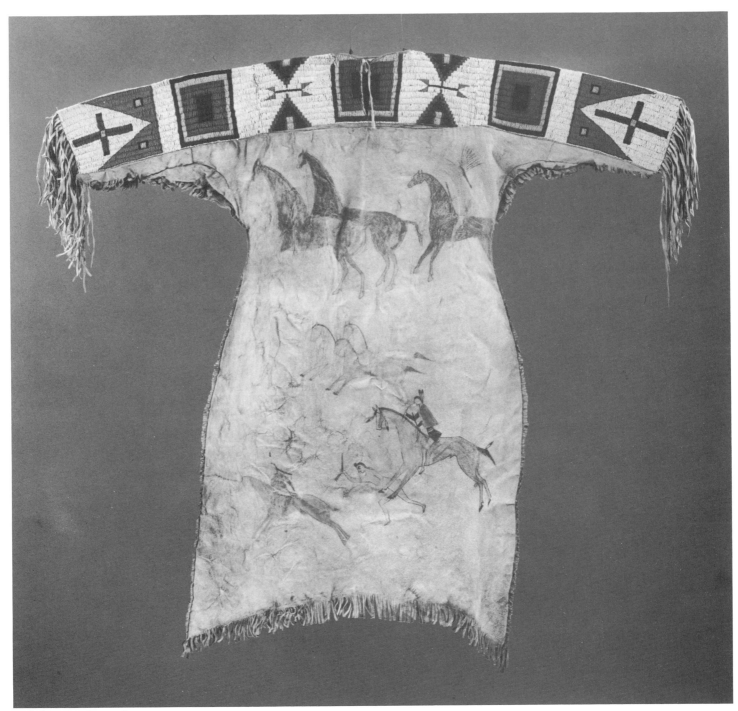

85. Lakota war honor dress

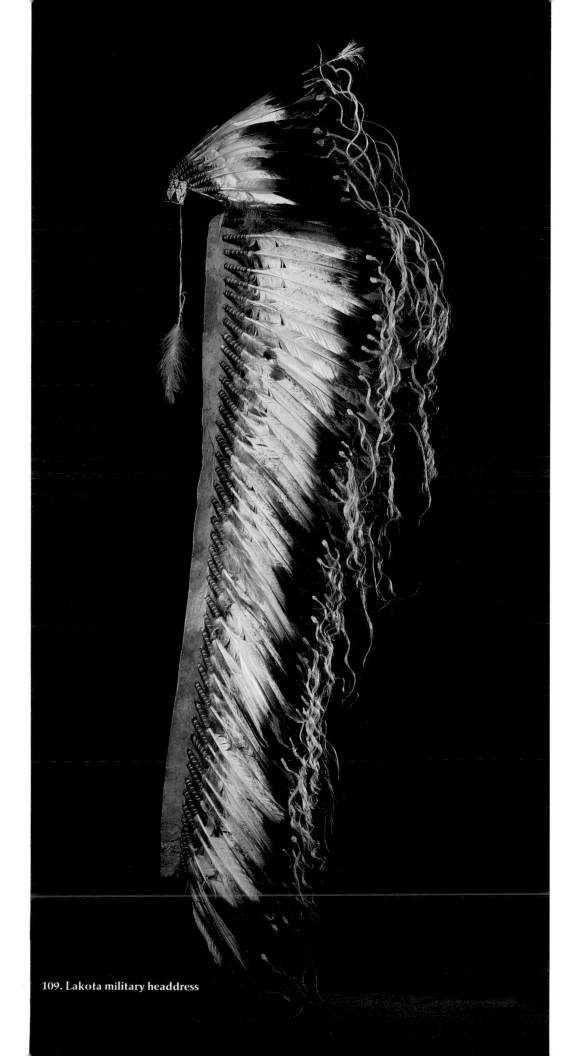

109. Lakota military headdress

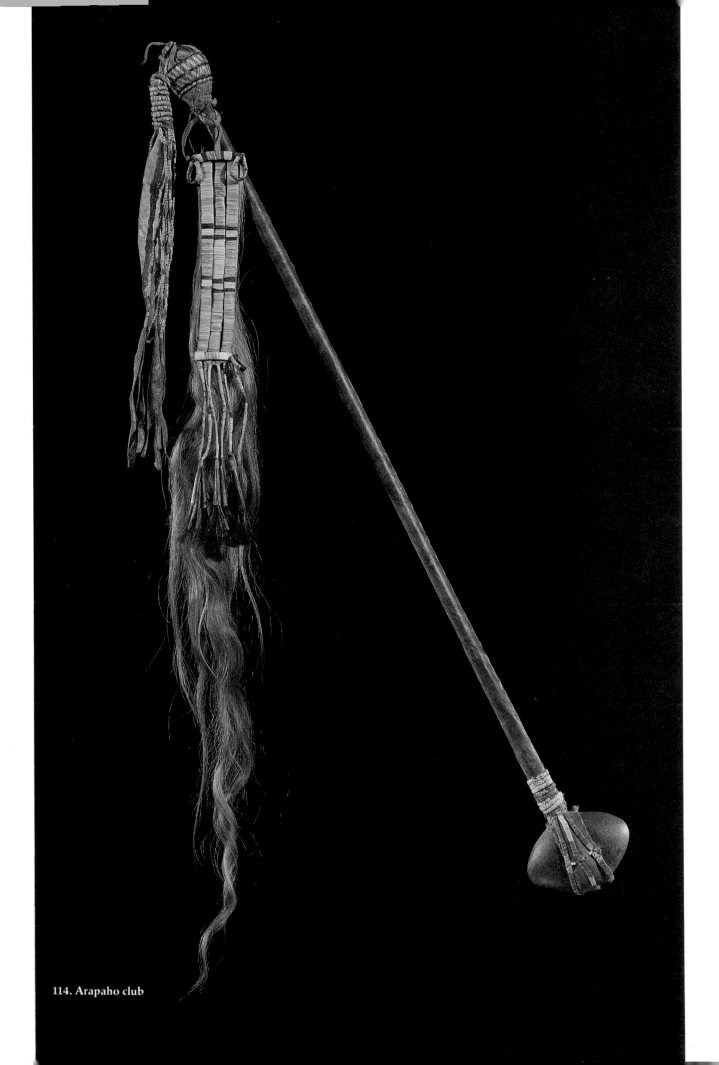

114. Arapaho club

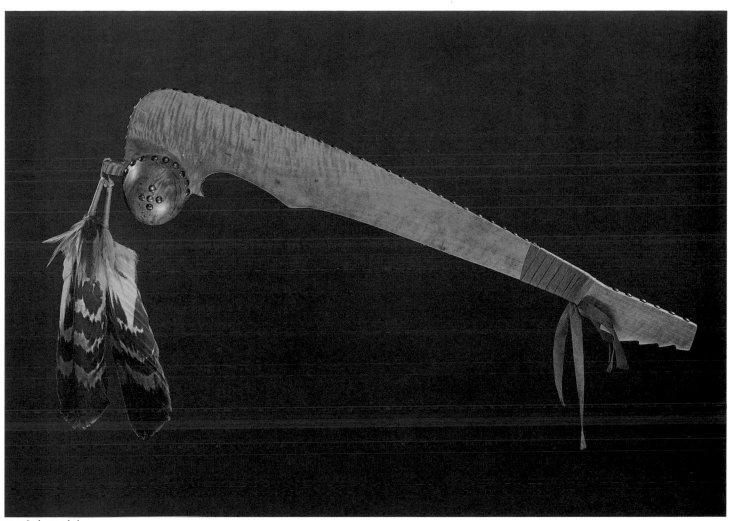

112. Lakota club

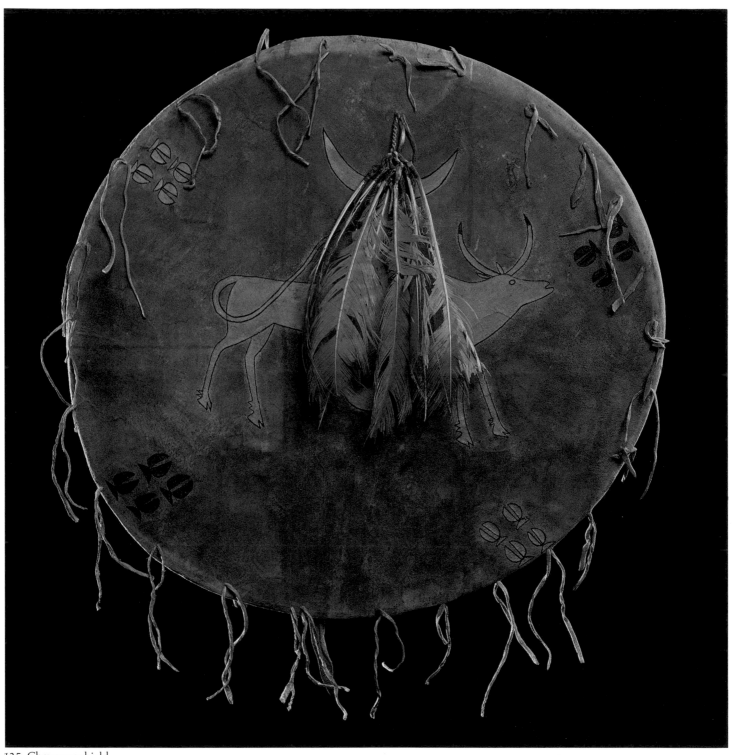

125. Cheyenne shield

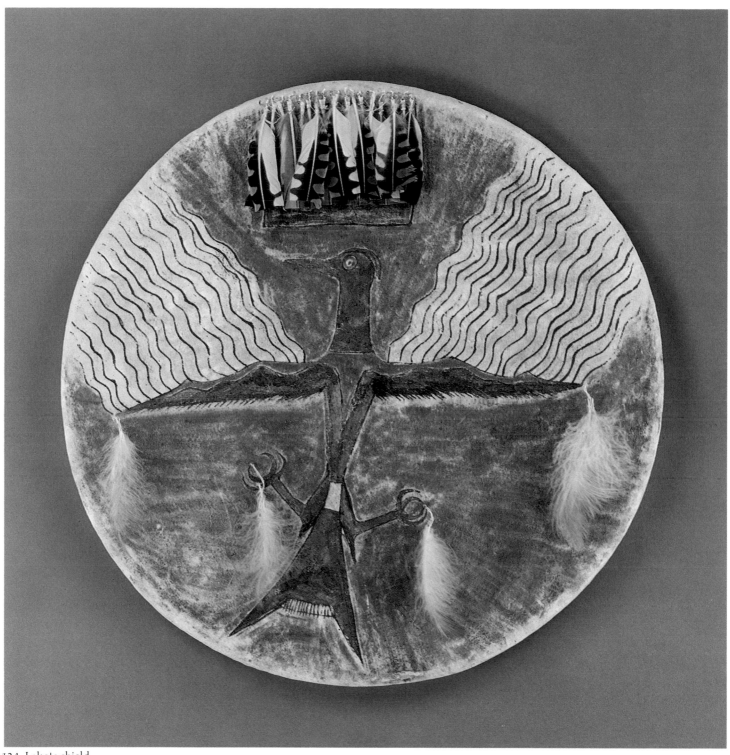

124. Lakota shield

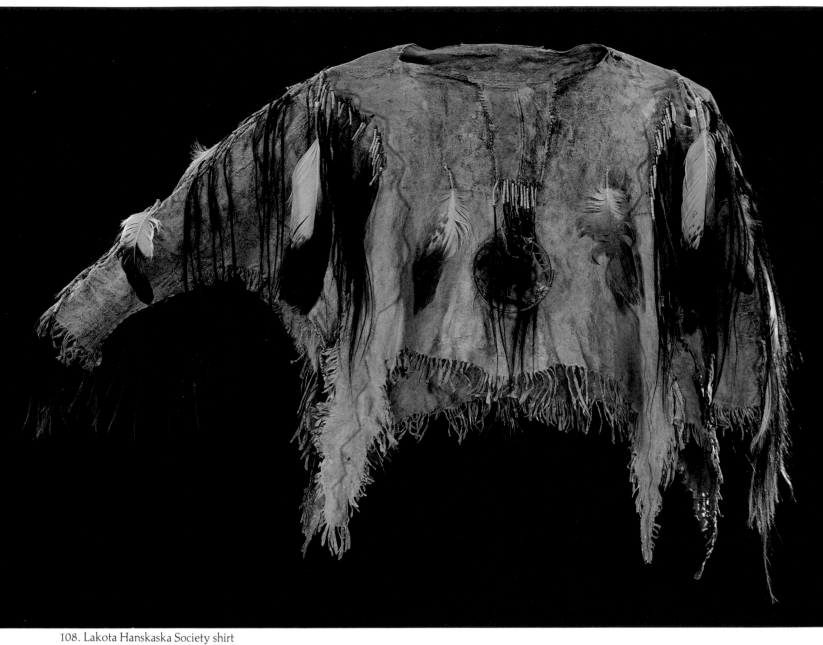

108. Lakota Hanskaska Society shirt

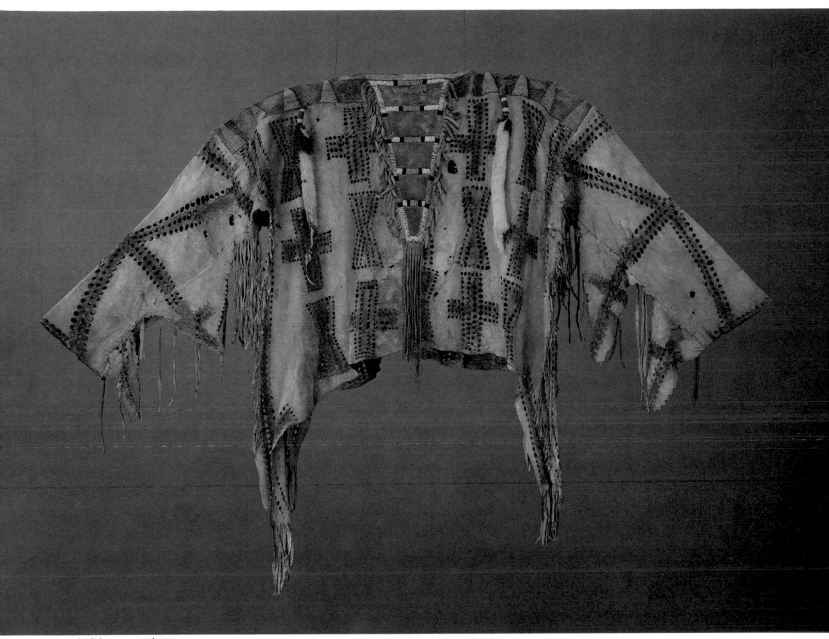

127. Blackfeet man's shirt

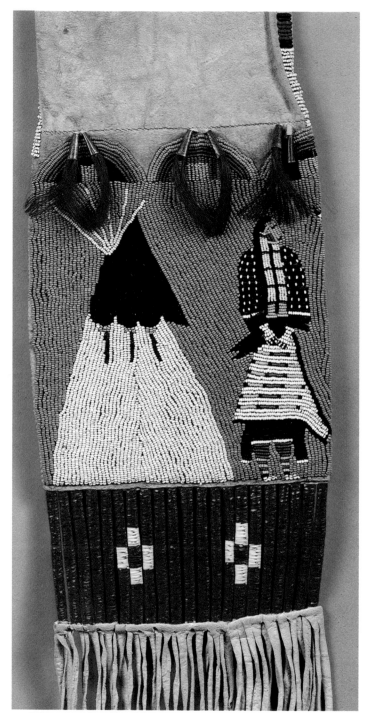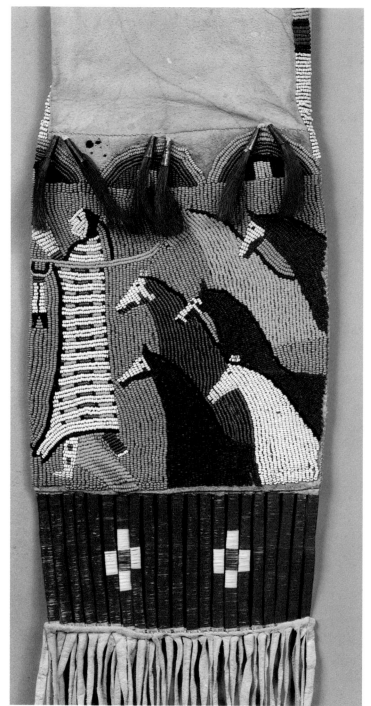

83. Lakota pipe bag (details)

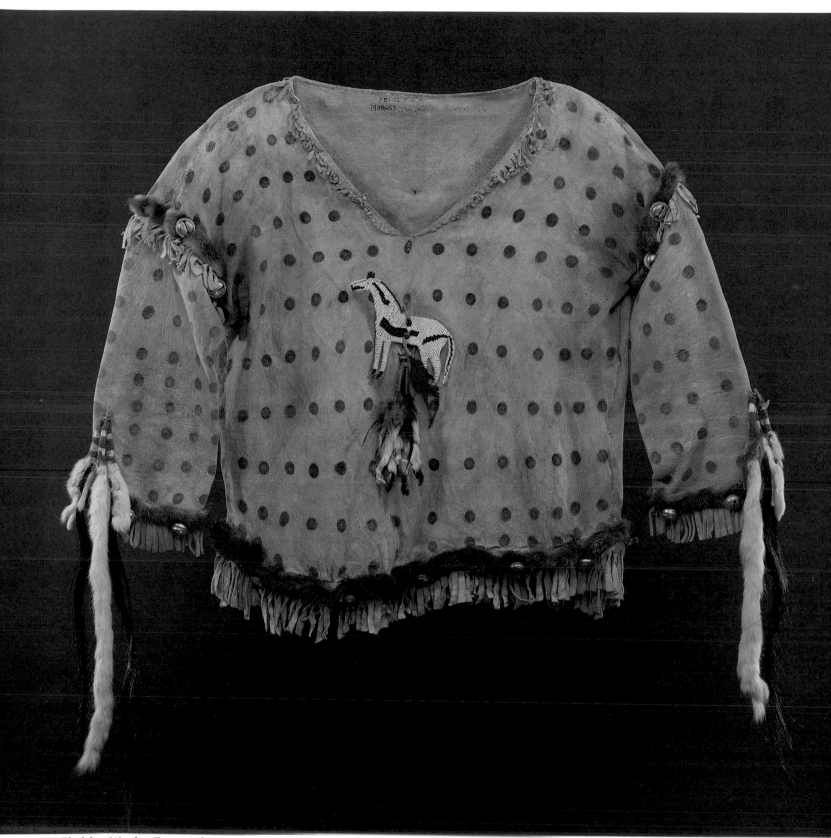

129. Blackfeet Weather Dancer's shirt

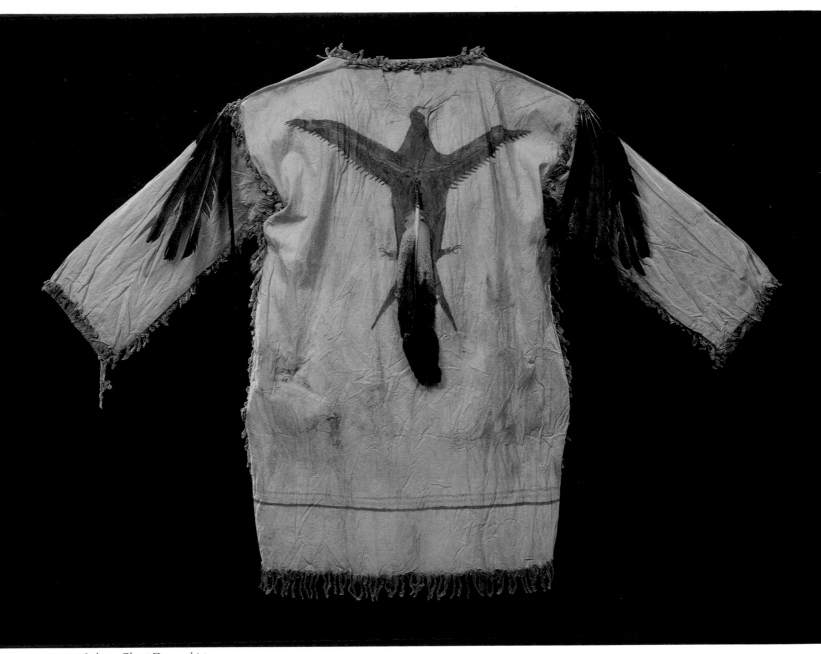

132. Lakota Ghost Dance shirt

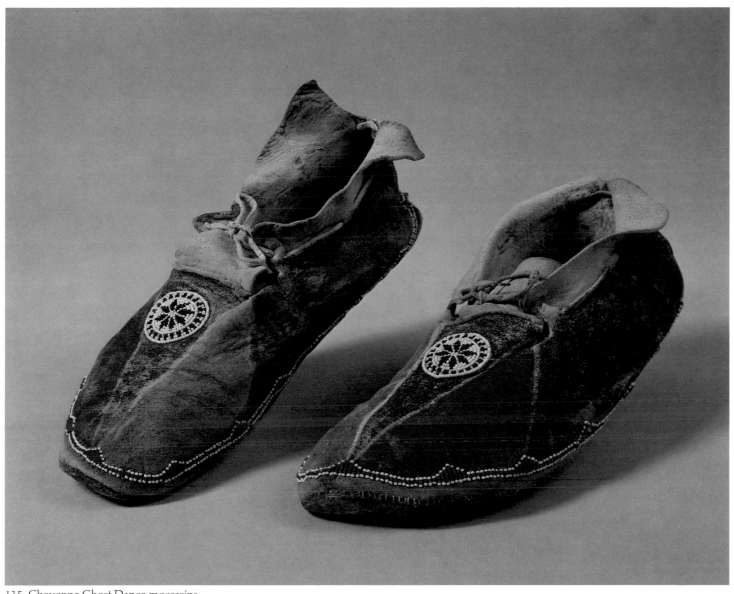

135. Cheyenne Ghost Dance moccasins

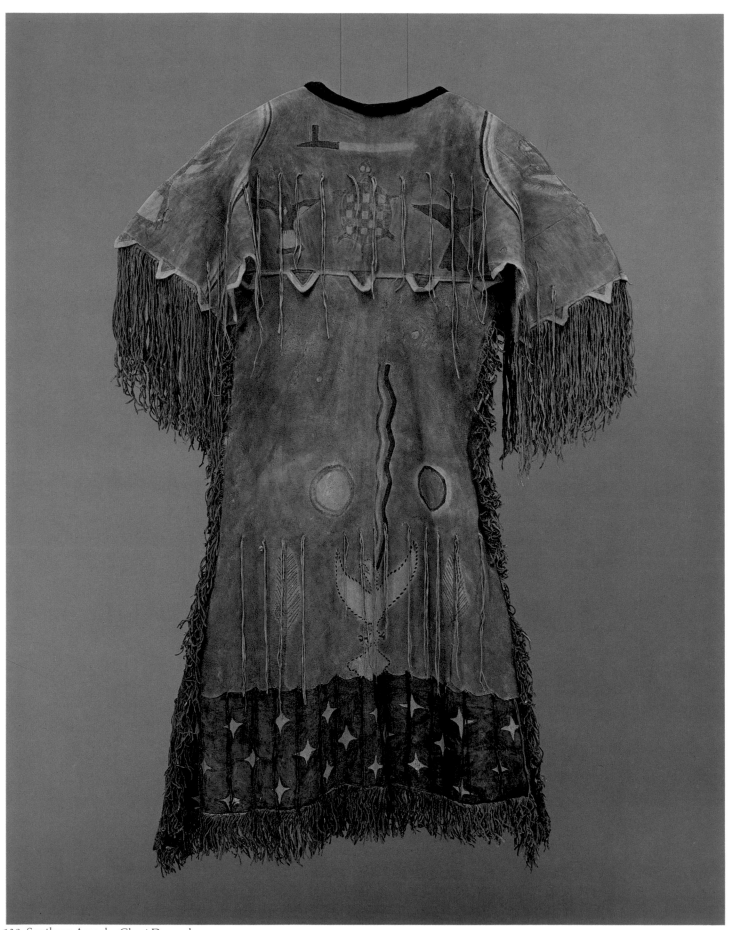

138. Southern Arapaho Ghost Dance dress

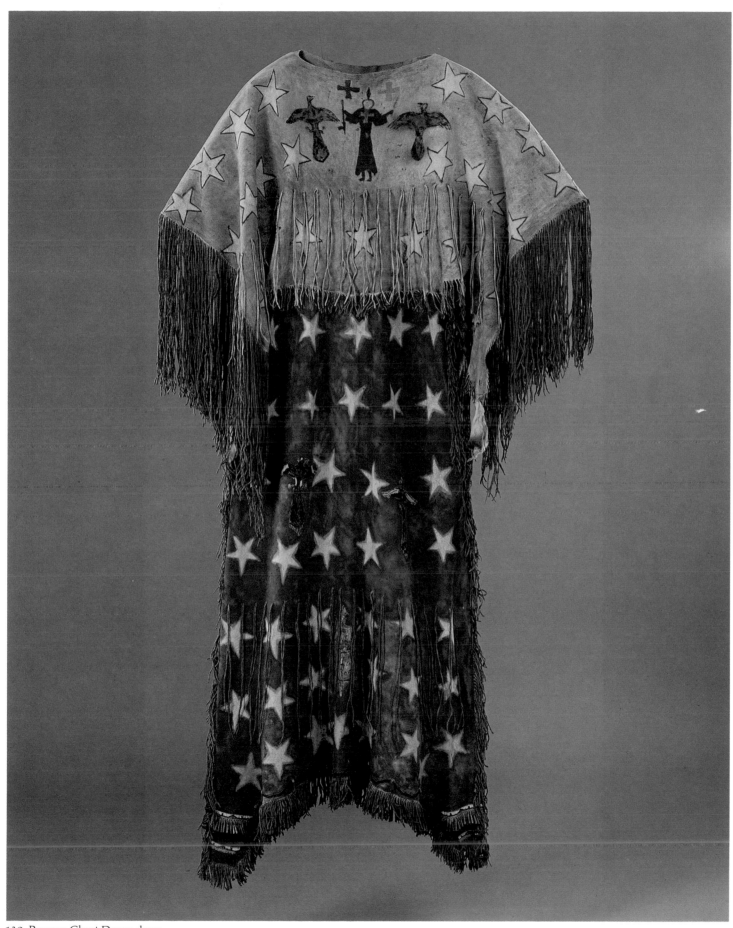

139. Pawnee Ghost Dance dress

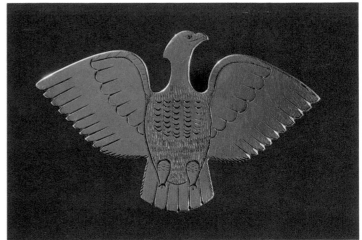

148. Osage tie slide

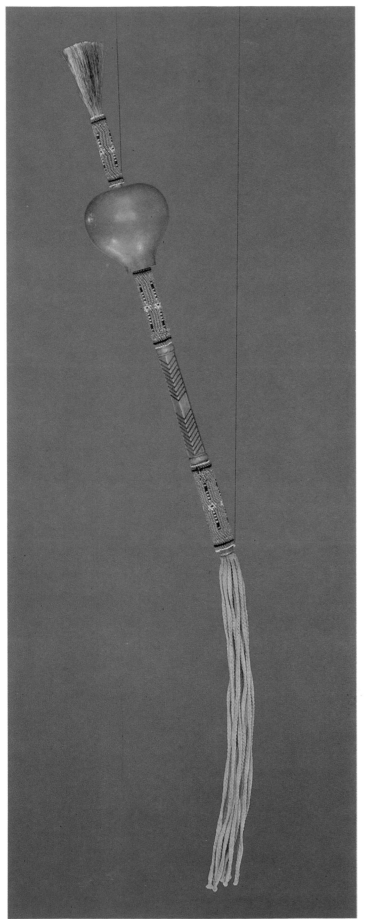

144. Comanche rattle

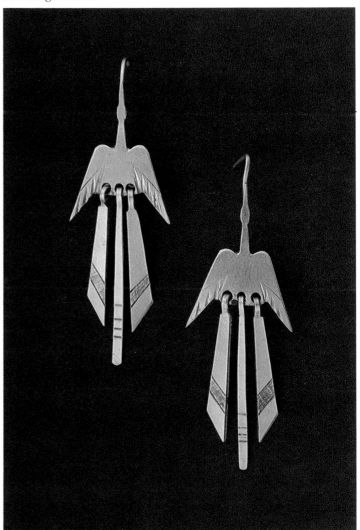

146. Kiowa earrings by Moses Boitone

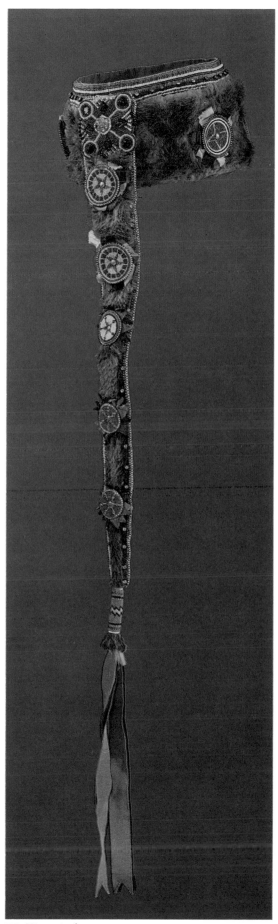

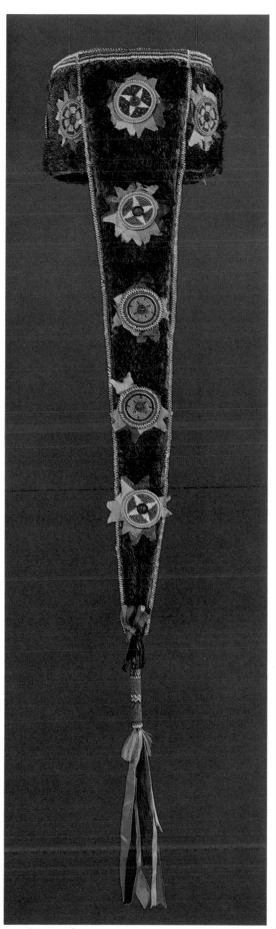

152. Kiowa turban

153. Osage turban

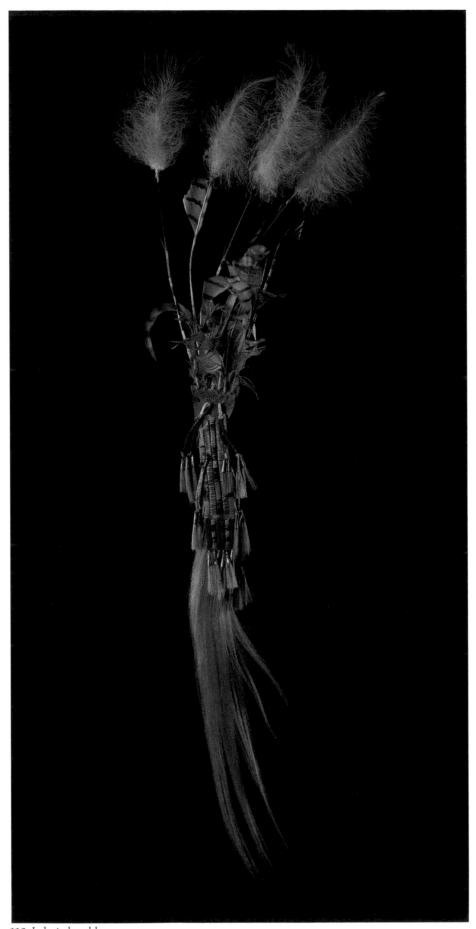

110. Lakota headdress

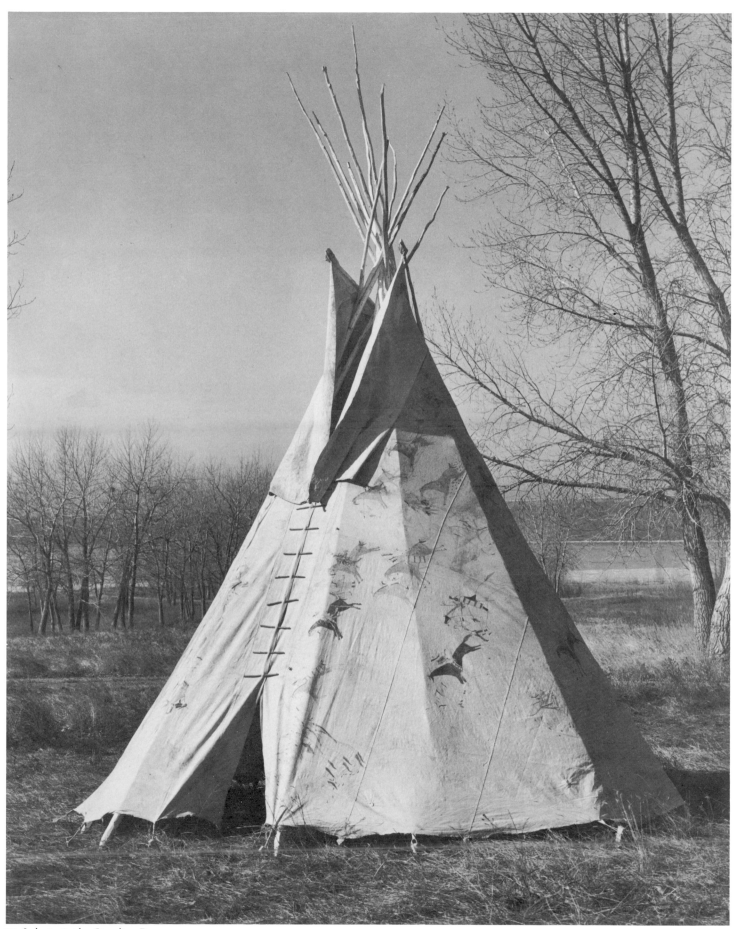

93. Lakota tipi by Standing Bear

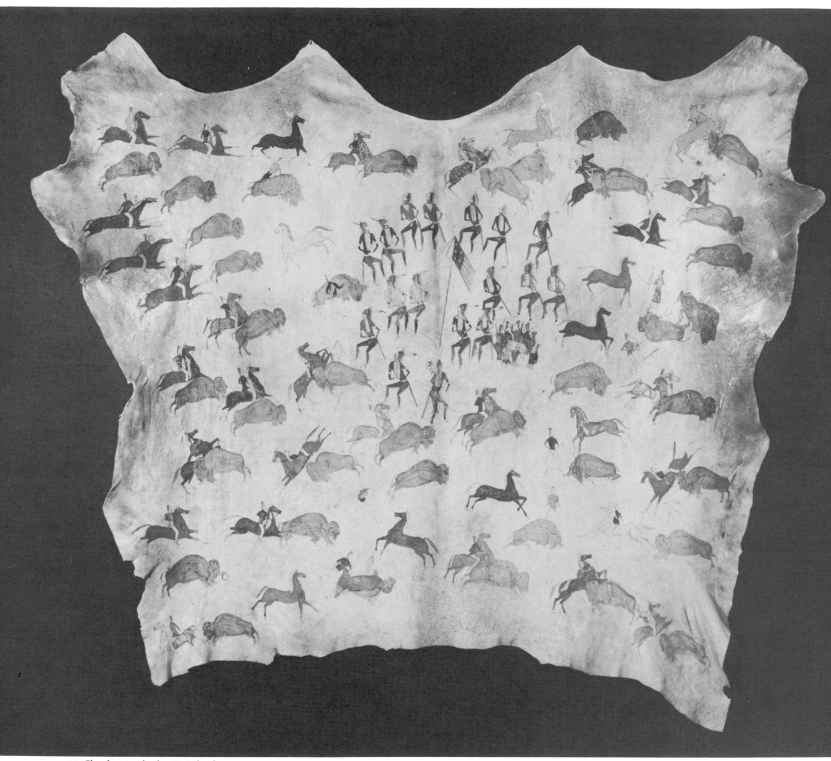

94. Shoshoni robe by Katsikodi

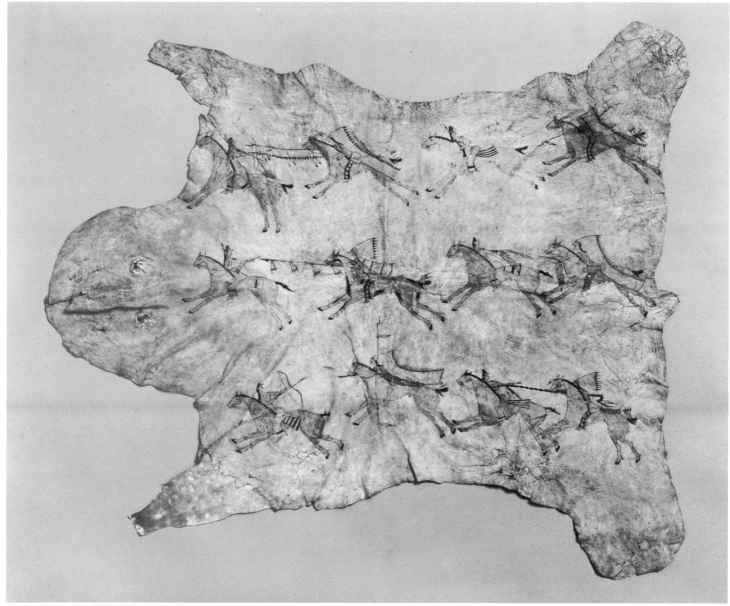

95. Lakota painted skin

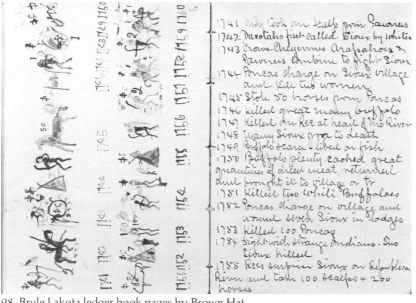

1741 Only took one scalp from Pawnees
1742 Dacotahs first called Sioux by whites
1743 Crows Cheyennes Arapahoes & Pawnees combine to fight Sioux
1744 Poncas charge on Sioux village and kill two women
1745 Stole 50 horses from Poncas
1746 Killed great many buffalo
1747 Killed one Ree at head of Mo River
1748 Many Sioux froze to death
1749 Buffalo scarce lived on fish
1750 Buffalo plenty. cached great quantities of dried meat, returned and brought it to village or tr
1751 Killed two White Buffaloes
1752 Poncas charge on village and wound seven Sioux in lodges
1753 Killed 100 Poncas
1754 Fight with strange Indians. Two Sioux killed
1755 Rees surprise Sioux on Republican River and take 100 scalps & 200 horses

98. Brule Lakota ledger book pages by Brown Hat

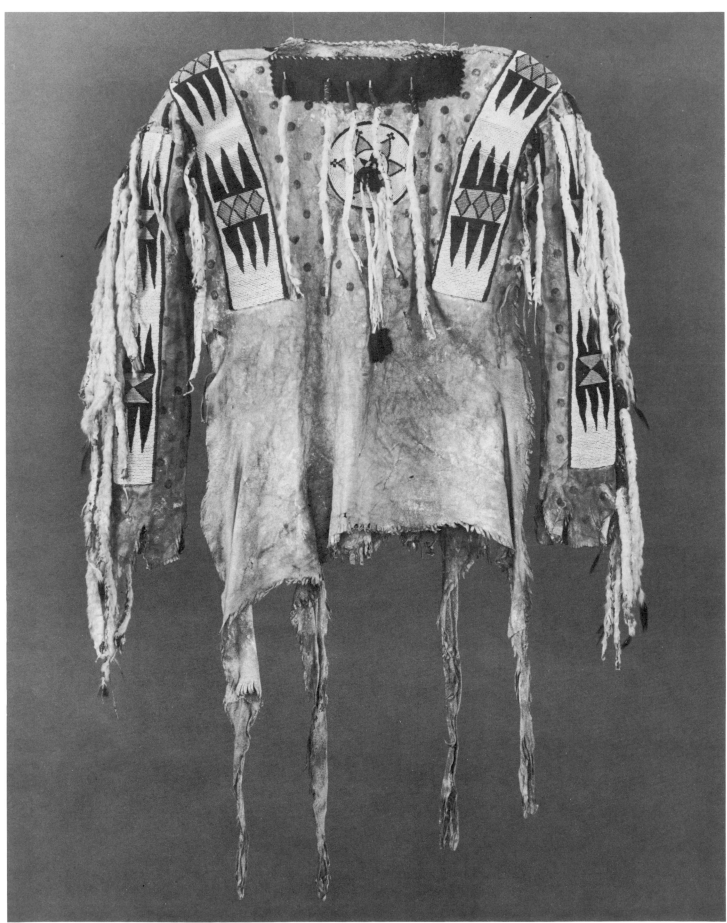

102. Blackfeet military shirt

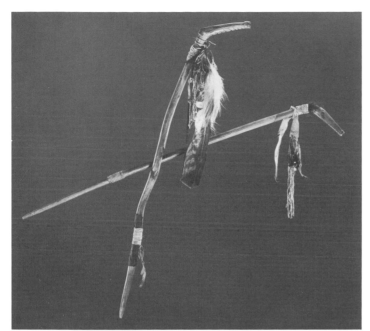

104, 105. Arapaho Tomahawk Lodge sticks

123. Lakota lance by Big Snake

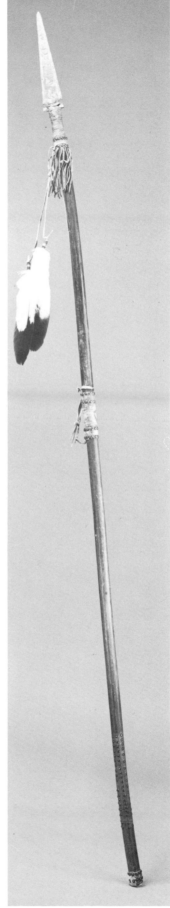

121. Salish lance

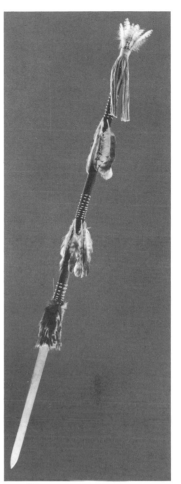

122. Kiowa spear

125

100. Crow picket pin

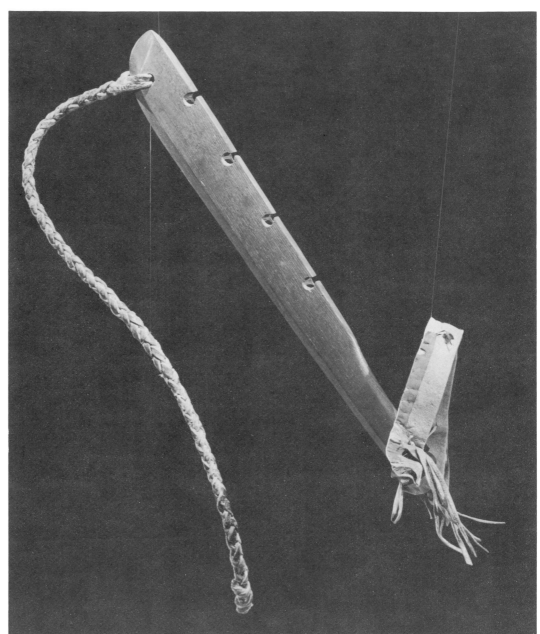

113. Comanche club

131. Arapaho dream necklace

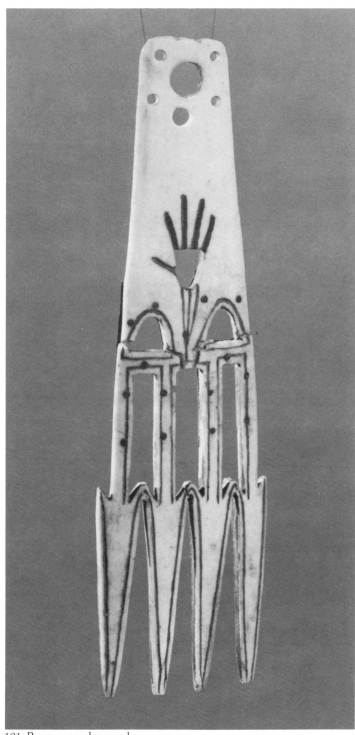

101. Pawnee roach spreader

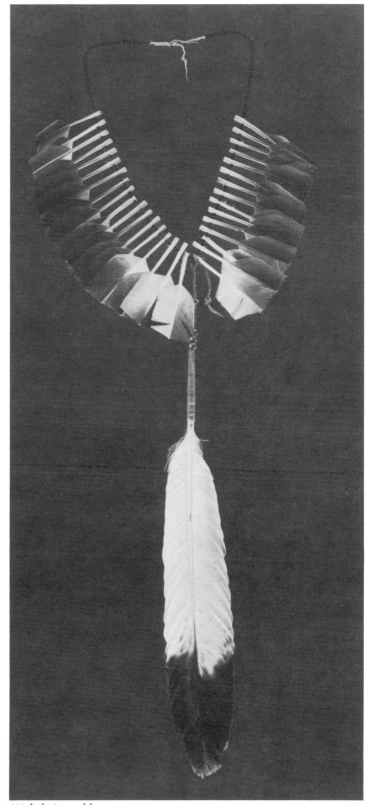

111. Lakota necklace

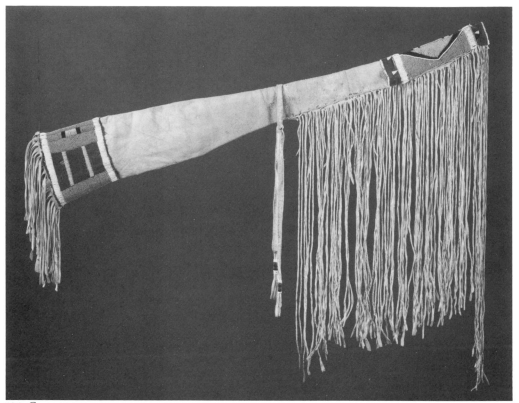

120. Crow gun case

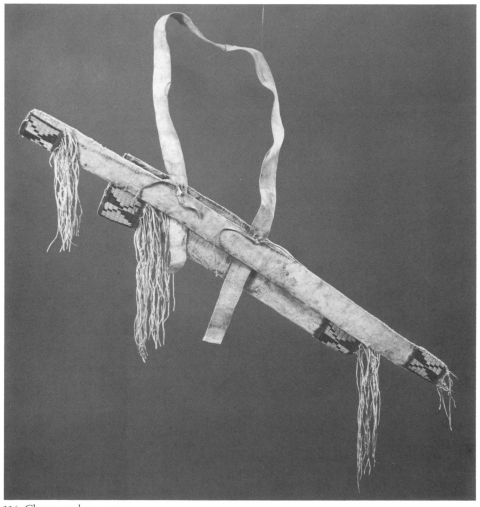

116. Cheyenne bow case

128

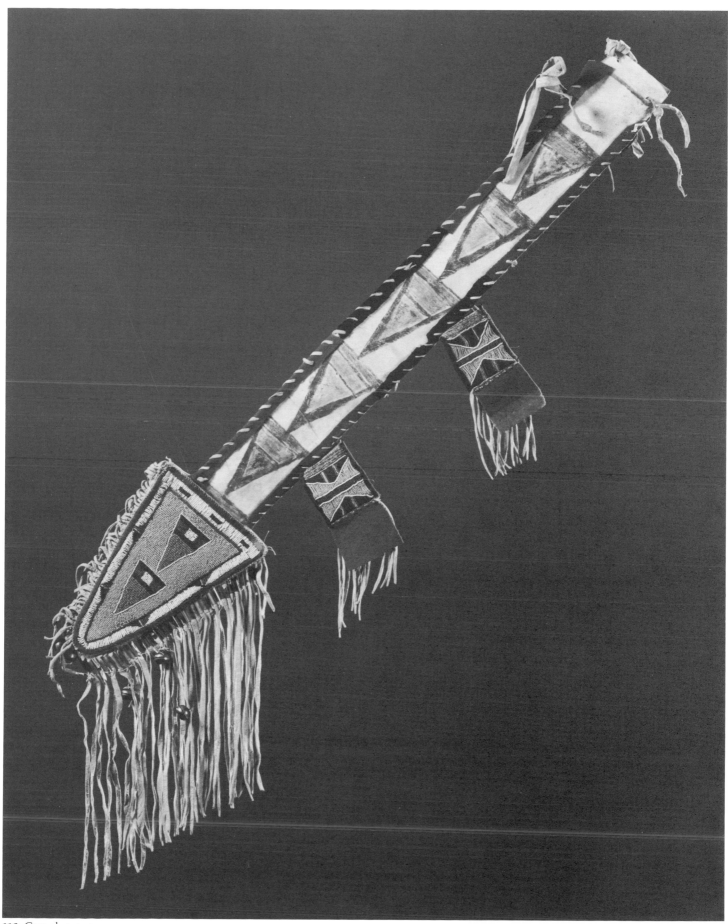

119. Crow lance case

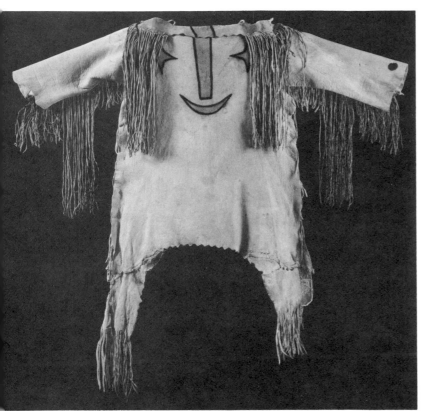

136. Kiowa Ghost Dance shirt

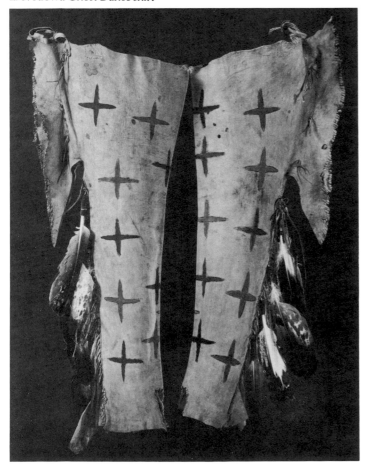

126. Pawnee man's leggings

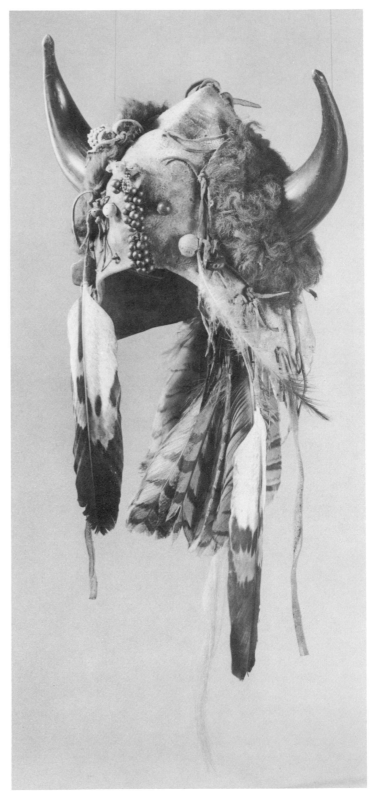

128. Plains Cree buffalo catcher's hood

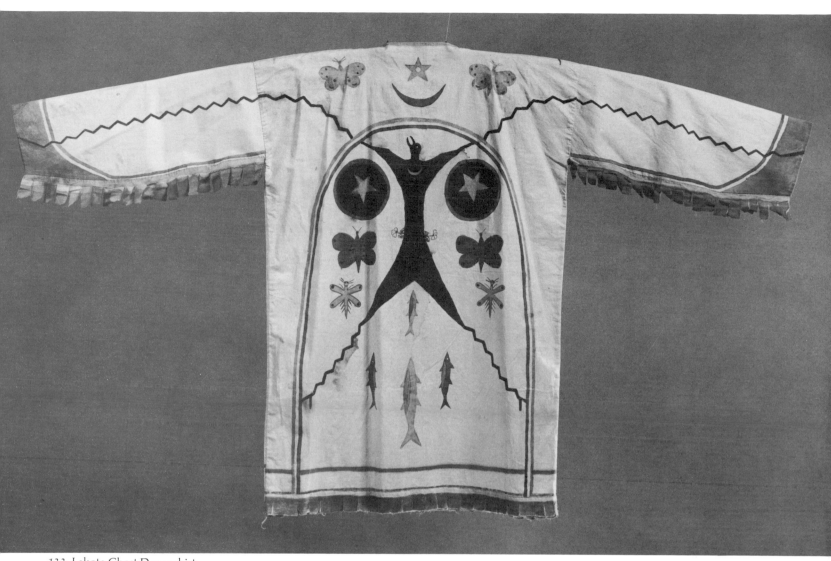

133. Lakota Ghost Dance shirt

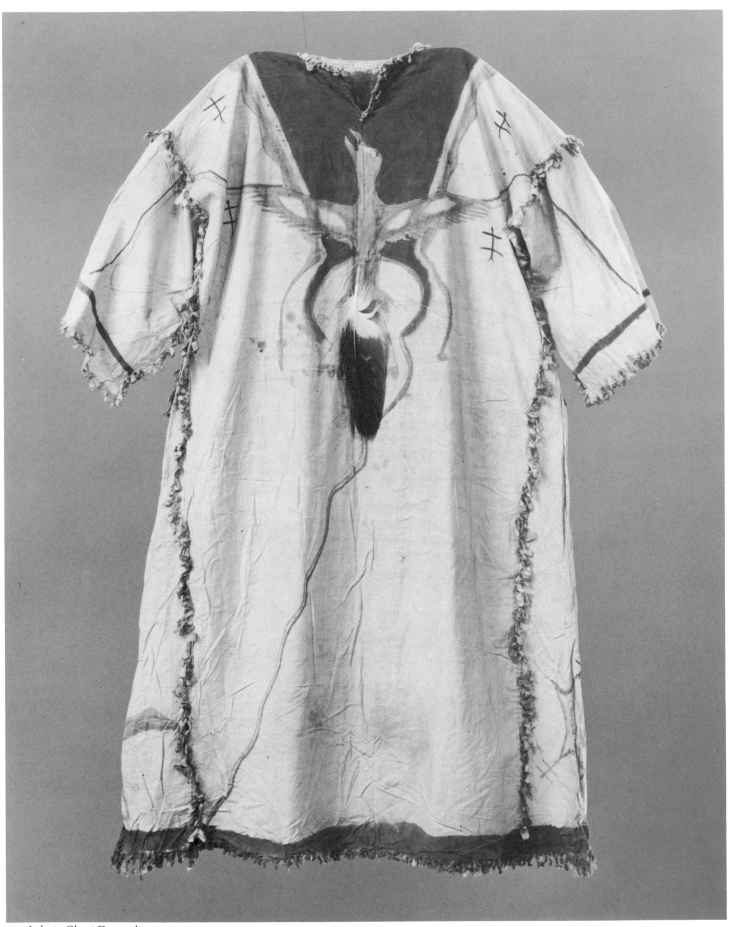

134. Lakota Ghost Dance dress

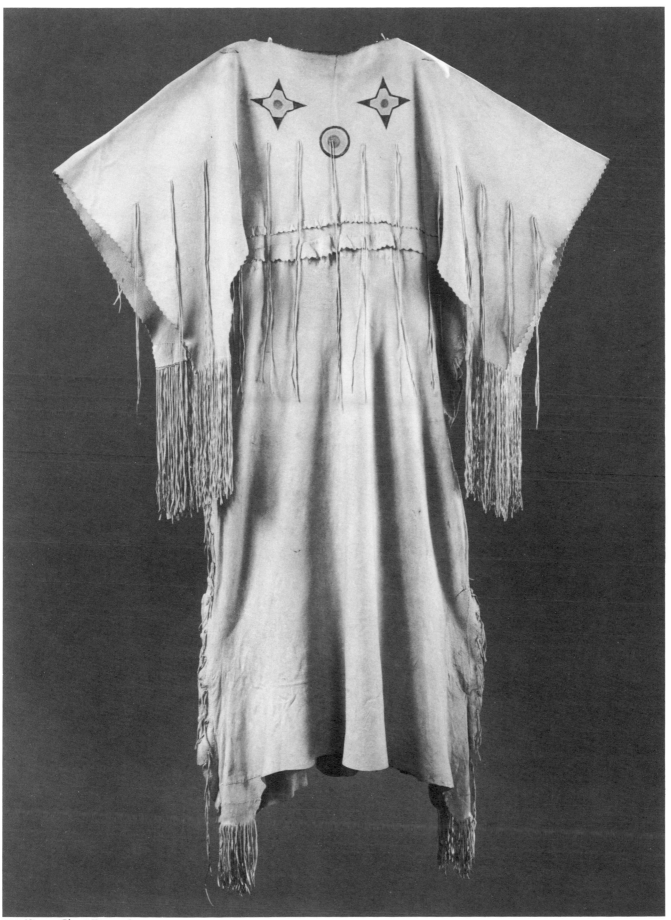

137. Kiowa Ghost Dance dress

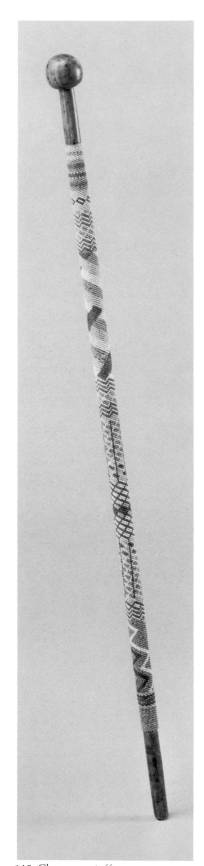

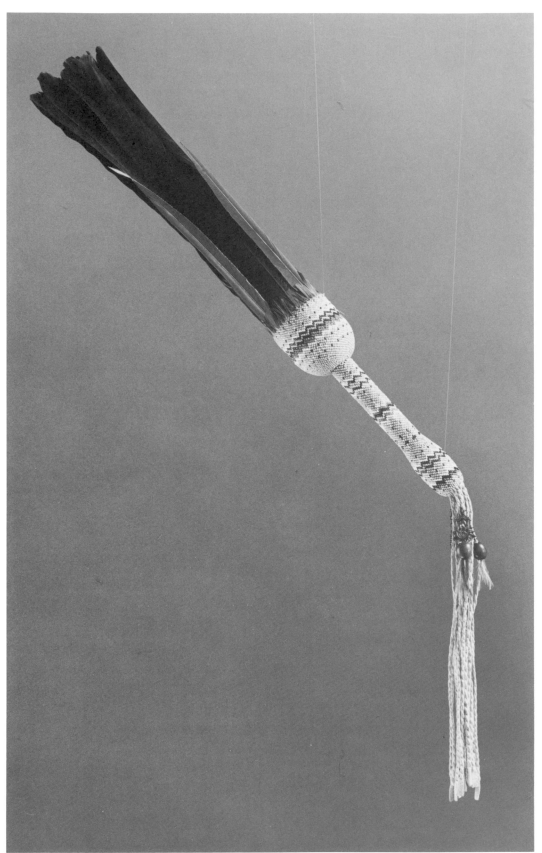

145. Cheyenne staff

142. Kiowa fan

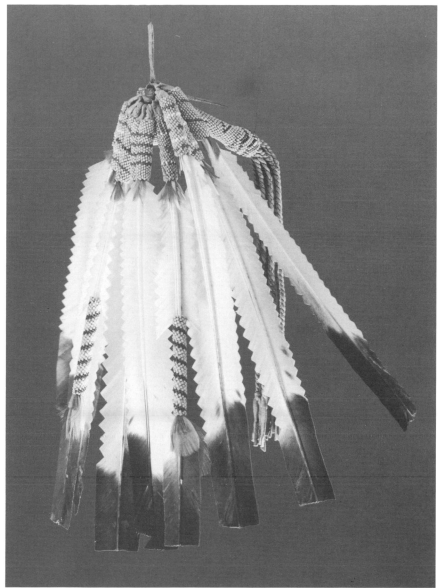

141. Cheyenne fan

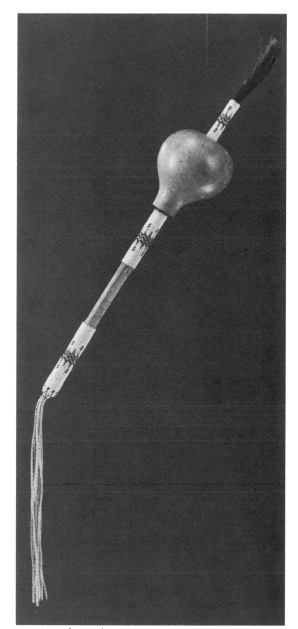

143. Arapaho rattle

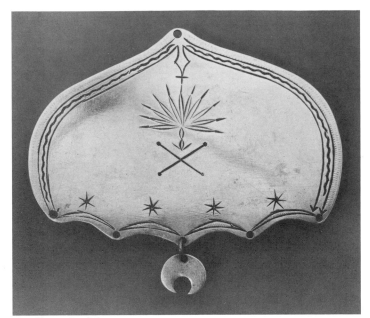

149. Osage tie slide

150. Kiowa tie pin

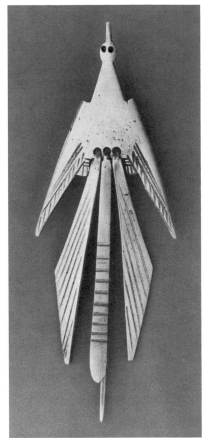

151. Tie pin, tribe unknown

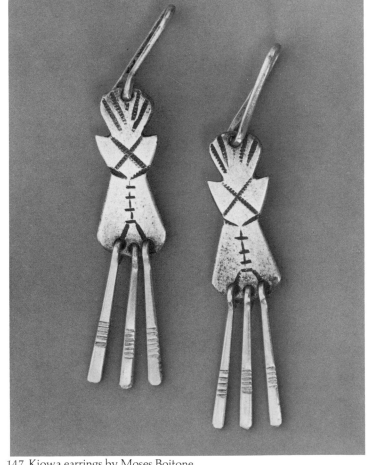

147. Kiowa earrings by Moses Boitone

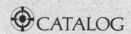
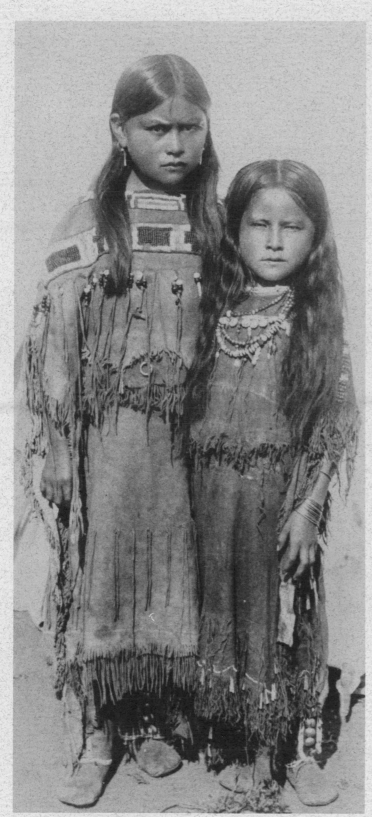

Chief Quanah's daughters, Comanche

1. *TIPI LINING PANEL*, Cheyenne, 1850s
Bison leather, native fibers, bison dewclaws, 2.37 x 3.39 m.
Gift of Royal B. Hassrick and museum exchange. 1957.203. *Illus. p. 58*

Although other tribes painted their tipi linings, the Cheyenne and
Arapaho preferred embroidered decoration. The native plant fibers in
this example are an unusual embroidery material, which, prior to 1850,
was sometimes used to supplement quillwork. To line the lower portion
of a normal-sized tipi required four or more panels like this one. Together
they formed a decorative horizontal band that effectively foiled the
dominant verticality of the tipi poles.

2. *ROBE*, Blackfeet, 1880s
Bison leather, native paint, 2.11 x 2.21 m.
1939.67. *Not illus.*

Because it was intended primarily as bedding, this robe was simply
finished with yellow paint made from crushed bison gallstones. Robes
which also served as clothing, like the following example, were more
elaborately decorated.

3. *ROBE*, Yankton Lakota, 1870
Bison leather, native and commercial paint, 1.73 x 1.98 m.
Gift of the family and friends of Natasha Congdon. 1980.352. *Illus. p. 42*

Leather robes intended to be worn as clothing were decorated by both
men and women, although custom restricted women to painting in a
geometric style and men to a figurative one. Both men and women
sometimes wore clothing decorated by the opposite sex. Worn and
painted only by women, this geometric "box and border" pattern is
thought to symbolize the bison, with each motif representing a different
portion of the animal. The compositional elements apparently derive
from an archaic Plains style, which survived in the nineteenth century
only on bison robes and certain rawhide objects. This example is painted
with white, red, and yellow native pigments and a powdered blue paint
introduced by traders.

4. *ROBE*, Cheyenne, 1870s
Elk leather, native paint, quills, deer toes, horsehair, 1.75 x 2.1 m.
1931.28. *Illus. p. 43*

Robes decorated with battle scenes were customarily worn by men and
occasionally by the wife of the warrior whose adventures were
depicted. While women in most Plains tribes conventionally used only
nonrepresentational geometric designs, it was a male prerogative to paint
narrative military scenes. Here, the unusual combination of painting
with the women's craft of embroidery suggests that a woman was
responsible for at least part of the decoration. Plains artists, like their
European counterparts prior to the development of photography, often
drew horses moving at an impossible "flying gallop."

5. *PILLOW*, Cheyenne, 1892
Canvas, beads, cloth, tin, horsehair, 36 x 61 cm.
1959.139. *Illus. p. 58*

Both the Cheyenne and Arapaho had women's guilds which held the
exclusive right to apply sacred embroidery to certain articles, including
tipi furnishings. When beads supplanted quills as a medium, these
women continued to work their designs in the four traditional colors
which symbolized the cardinal directions (23). In the 1890s, it became
fashionable for a Cheyenne woman to commission from a guild
member a tipi cover and lining, two pillows, and a bedspread as
wedding presents for her daughter. Some conservative families maintain
the custom today.

6. *BACKREST,* Blackfeet, 1885
Willow rods, native paint, cloth, beads, 173 x 91 cm.
1938.321. *Illus. p. 59*

Backrests provided comfort for family members and were always part of the hospitality offered to honored visitors. The tall, narrow shape of this example is typical of all Northern Plains tribes, but the decoration is uniquely Blackfeet. Patterns on the painted willow tripod which supports the backrest were created by stripping away portions of the bark.

7. *BACKREST,* Cheyenne, 1880
Willow rods, paint, leather, beads, quills, 1.41 x 1.09 m.
1938.332. *Illus. p. 59*

Central and Southern Plains people preferred a relatively broad shape for their backrests, which they decorated with groups of painted rods and quill-wrapped leather pendants. The Cheyenne continue to make backrests today although the Lakota and Arapaho no longer produce them.

8. *SPOON,* Lakota, 1870s
Cow horn, native paint, beads, leather, 20.3 cm. l.
1951.313. *Illus. p. 45*

The spreading bowl and recurved handle of this spoon were achieved by boiling the fresh horn in water until it was pliable enough to bend into the new shape. The finial was carved after the horn had dried. Spoon finials carved as birds' heads were a Lakota fashion in the 1870s, and, since the extant ones are remarkably similar, they may represent the output of a few craftsmen who knew each other's work.

9. *LADLE,* Lakota, 1880
Bighorn horn, beads, quills, leather, horsehair, 46.5 cm. l.
1937.287. *Illus. p. 61*

Plains women used decorated ladles like this one to serve meat and vegetable stews to honored guests at formal meals. The ladle has been elegantly shaped and handsomely ornamented with beadwork.

10. *SPOON,* Arapaho, 1890
Cow horn, quills, leather, 21 cm. l.
Gift of Mrs. Harry English. 1951.360. *Illus. p. 61*

Because the placement of the quillwork would have made this utensil virtually unfunctional as a spoon, it was probably used by an honored guest at a formal meal to hold bits of grilled meat intended to be eaten with the fingers. Normally, quilled decoration was applied only to a spoon's handle.

11. *FOOD BOWL,* Pawnee, 1860s
Cottonwood, 16.5 cm. diam.
1938.362. *Illus. p. 60*

Small bowls for everyday use were carved with rim projections which served primarily to identify the owner. By keeping to a simple form, the carver has emphasized the decorative quality of the richly convoluted wood grain.

12. *FOOD BOWL,* Eastern Lakota, 1840s
Maple(?), brass tacks, 40 cm. diam.
1938.365. *Illus. p. 60*

Large dishes like this were used as serving platters for informal entertaining and as food bowls for honored guests at formal meals.

Although the practice was prevalent in the Great Lakes region, among Plains tribes only the Eastern Lakota carved elaborated rim projections, which may have represented the owner's personal spirit mentor. Like the maker of the Pawnee bowl (11), the carver has taken pains to bring out the natural beauty of his material.

13. *TOOL KIT,* Kiowa, 1880
Leather, beads, metal. Left case, excluding pendants, 19.5 cm. l.
1937.41. *Illus. p. 85*

For important occasions, Kiowa women wore decorated versions of everyday tool cases attached to their belts in the same spirit that nineteenth century American women wore lace aprons when entertaining guests. These containers held a sewing awl, flint and steel for starting fires, and a whetstone. Representative of prereservation Kiowa embroidery, the bold, decorative figures are beaded in nearly complementary colors outlined in white.

14. *SKIN SCRAPER,* Cheyenne, 1850s
Bison femur, leather, metal, 33 cm. l.
Gift of Royal B. Hassrick. 1953.493. *Illus. p. 62*

Over the centuries, the design of the skin scraper used by Plains women was refined until the tool could clean either side of a hide to velvetlike smoothness with maximum efficiency. The small incised lines on the handle of this scraper suggest that its owner kept count of the hides she had cleaned.

15. *QUILL FLATTENER,* Lakota, 1860s
Iron, 28 cm. l.
Gift of Frederic H. Douglas. 1954.363. *Illus. p. 62*

After being sewn to leather, porcupine quills were pressed flat to make a smooth surface. Originally, Plains women used bison-horn tools for this task, but trading posts began offering metal implements in the late 18th century. This example appears to have been a mason's jointer adapted by its Indian purchaser for flattening quills. Iron was used sparingly on the plains, mostly for cutting tools like knives and arrowheads.

16. *MOCCASIN-TURNING STICK,* Cheyenne, 1895
Hardwood, 19 cm. l.
1949.3658. *Illus. p. 63*

The stiff rawhide soles and soft leather uppers of Plains footwear were sewn together inside out and then turned with a stick like this one. Although Plains men did comparatively little work in wood and metal, the forms they designed in these media were attractive as well as functional.

17. *COOKING POT,* Arikara, late 19th century
Unglazed pottery, 20 cm. h.
Anonymous gift. 1977.52. *Illus. p. 63*

At one time, most Plains tribes made simple pottery like this cooking vessel. Commonly of globular shape with ring handles for suspension over a fire, their wares were hand built and decorated, if at all, with bands of incising below the rim. As Plains groups took up nomadic life, they abandoned pottery as impractical although a few conservative families continued to practice the art into the late nineteenth century. In the last three decades, some Plains tribes have produced ceramics commercially, but these contemporary wares, wheel-thrown and finished with vitreous glazes, are unrelated to traditional Plains pottery.

18. *BURDEN BASKET,* Hidatsa, 1870s
Willow bark, ash rods, 44.5 x 43.8 cm.
1938.610. *Illus. p. 57*

Like pottery, basketry was once practiced by most Plains tribes but
was given up with the change to nomadic life, although simple coiled
gaming trays were still being made in the nineteenth century (30). The
most elaborate Plains baskets were produced by the Hidatsa and their
neighbors along the Missouri River. This example, used to carry garden
produce, shows a pattern called "clouds," one of several designs used in
Hidatsa plaiting.

19, 20. *PAIR OF DOLLS,* Mrs. Red Crow, Blackfeet, 1920s
Leather, cloth, beads, rawhide, ermine, human hair, steel, bone.
Female, 36.2 cm. h., male, 38.3 cm. h.
1946.313, 311. *Illus. p. 64*

These dolls were made by an elderly woman as replicas of a pair she
had received in childhood from her grandmother. Details of clothing,
hairdress, and weapons conform exactly to those of the prereservation
1870s period. Like their full-scale counterparts, the man's shield has a
removable leather cover, his sheath holds a miniature bone-and-steel
knife, and the woman's pouch holds diatomaceous earth used by the
Indians to clean soft leather. The Blackfeet call such figures "real dolls,"
meaning they were of the highest quality and therefore betokened great
esteem for the child to whom they were given.

21, 22. *PAIR OF DOLLS,* Lakota, 1880
Leather, cloth, beads, human hair, quills, metal, paint.
Female, 36.9 cm. h., male, 34.3 cm. h.
1946.318, 317. *Illus. p. 47*

The careful detail and fine workmanship of these dolls indicate that the
girl who received them was warmly loved. Their condition suggests that
the child realized their importance and took good care of her beautiful
toys. The female doll's face painting connects her with the legendary
White Buffalo Calf Maiden, a benevolent holy woman revered for
bringing religious instruction to the Lakota.

23. *CRADLE,* Arapaho, 1870
Leather, quills, wood, deer toes, 86.4 x 28 cm.
1939.336. *Illus. p. 65*

Quillwork produced by a guild of Arapaho women who held exclusive
rights to decorate certain objects was thought to be sacred and beneficial
to the recipient (5). On cradles, these decorations symbolized prayers
for the health and well-being of any child who slept in them. The disc
on the hood of this example represented the infant's brain and called for
unfailing wisdom throughout his life. Sacred quillwork was limited to
four colors which signified the cardinal directions: red (east), white
(north), black (west), and yellow (south).

24. *CRADLE,* Comanche, possibly 1860s
Leather, native paint, Osage orange wood, brass tacks, silver buttons,
rawhide, 116 x 39 cm.
1948.208. *Illus. 65*

Plains cradles were made in "soft" and "hard" forms. The soft Arapaho
example (23) required that the infant be either held or laid down in a
safe place. This hard Comanche cradle was reinforced with a protective
rawhide lining and supported on a wooden frame so that it could be
carried on the mother's back or leaned against a tree or tipi. The simple
adornment of the cover and frame typifies Comanche decorative art
prior to the 1880s. Like their neighbors on the southern plains, they
preferred painted to embroidered leather.

25. *CRADLE,* Cheyenne, 1875
Leather, rawhide, beads, Osage orange wood, brass tacks,
cloth, 105 x 26 cm.
1949.61. *Illus. p. 76*

The beaded horses on this cradle symbolize the maker's hope that
one day the boy for whom it was made would own a substantial herd.
The evenly stepped, triangular figures exemplify the mature style of the
Cheyenne, who shared with Central Plains tribes a preference for motifs
of dark or medium value on a white field.

26. *CRADLE,* Crow, 1890
Wood, leather, canvas, beads, 84 x 30 cm.
1938.52. *Illus. p. 77*

The colors, motifs, and especially the composition of the beadwork
on this cradle characterize the mature geometric style of the Crow.
The cradle's form, however, suggests influences from Plateau tribes to
the west, who commonly used a flat backboard decorated at the top,
otherwise unknown on the plains. The foot panel and three pairs of tie
straps are apparently a Crow invention.

27. *UMBILICAL CORD AMULET,* Lakota, 1860s
Leather, beads, coins, 17 cm. l.
Gift of Mrs. Gerald Hughes. 1959.143. *Illus. p. 66*

At birth, a Plains child's umbilical cord was packed in soft material like
bison wool and placed in a special decorated amulet. This example must
have been made for a girl because the turtle, which it represents, was
thought to have power over women's procreative functions. Normally
rare in Lakota beadwork, the overlay technique—long strands of
couched beads—has been used here to achieve small, curving shapes.

28. *UMBILICAL CORD AMULET,* Lakota, 1880s
Leather, beads, feathers, 20 cm. l.
Gift of the Estate of Helen Mills. 1940.40. *Illus. p. 66*

Amulets like this lizard-shaped one, made to hold a boy's umbilical cord,
were first attached to the child's cradle and later to his best dress clothing.
His preserved umbilical cord was believed to protect a child during his
growing years.

29. *HOOP AND POLE GAME,* Blackfeet, 1875
Metal, rawhide, wood, feathers, beads.
Stick, 57 cm. l., hoop, 9 cm. diam.
1938.322, 1953.485. *Illus. p. 67*

In this game, designed to help a boy develop marksmanship skills, a
contestant had to throw his stick through the rolling hoop; points were
determined according to which section of the hoop the stick entered.
Equipment for boys' games was made by male relatives.

30. *BASKET DICE GAME,* Cheyenne, 1885
Willow splints, yucca leaf, bone. Basket, 10.8 cm. diam.
Gift of Mrs. Mary Inkanish. 1950.235. *Illus. p. 67*

In scoring this game, played by children for amusement and by women
for serious gambling, birds counted as two points, crosses as one, and
the unmarked side of each die as zero. Simple coiled plaques like this are
the only surviving form of basketry among the Cheyenne.

31. *BABY'S BALL*, Crow, 1885
Leather, bison hair, beads, 7.5 cm. diam.
1950.73. *Illus. p. 66*

The shiny beads and bright colors of this ball would have attracted and amused the infant for whom it was made. Balls used by older children for sports were undecorated.

32, 33. *PAIR OF PARFLECHES*, Cheyenne, 1880
Rawhide, native and commercial paint, 59.7 x 39.5 cm. each
1955.184.1, 2. *Illus. p. 78*

Usually made in pairs, parfleches are stiff rawhide containers in which Plains people stored such things as clothing, dried food, or household utensils. The word *parfleche* comes from the French *parer une flèche*, meaning "to turn an arrow," as old Plains rawhide shields often did. Later, it became a synonym for the material and, more specifically, for containers of this shape. The fine black outlines, the predominance of rectangular shapes, and the delicate finials of the painted design exemplify Cheyenne women's rawhide painting, which, like their beadwork, is distinguished for its neatness.

34. *PARFLECHE*, Blackfeet, 1885
Rawhide, native and commercial paint, 60 x 32 cm.
1937.200. *Illus. p. 68*

Blackfeet women designed their parfleches with trapezoidal top flaps and a balanced composition of rectangles, triangles, and long, sweeping curves. Although blue was a popular color in Plains rawhide painting, it was not indigenous to the region. The blue on this example came from powdered paint sold by European traders.

35. *PARFLECHE*, Arapaho, 1890
Rawhide, native and commercial paint, 66 x 40 cm.
Gift of Sarah Coolidge Vance. 1943.16. *Illus. p. 68*

The Arapaho favored compositions of repeated vertical figures painted in alternate colors. Preferring a medium palette for their parfleche designs, they tended to avoid dark colors like black and indigo blue, popular with other Plains tribes.

36. *PARFLECHE*, Lakota, 1880
Rawhide, native and commercial paint, 65 x 33 cm.
1936.229. *Illus. p. 71*

Triangular shapes and long, curving lines distinguish the painting style of Lakota women, who made liberal use of red and yellow in their designs.

37. *PARFLECHE*, Crow, 1840s
Bison rawhide, 73.7 x 30.5 cm.
1936.31. *Illus. p. 69*

In this early example of rawhide decoration, the dark outer layers of the hide have been painstakingly scraped away to form a design, a technique apparently confined to the Crow. Fewer than ten of these incised parfleches exist today and are so similar that they may all be the work of a single family or camp group. The isosceles triangles and outlines of varying width in this design became hallmarks of Crow rawhide painting and beaded embroidery.

38. *MEDICINE CASE*, Cheyenne, 1860s
Rawhide, native paint, leather, 32 x 30.5 cm.
1942.227. *Illus. p. 72*

In addition to her other duties, a Plains mother assumed the role of

family doctor. This "medicine chest" would have held her store of herbal remedies for headaches, colds, and other common ailments. The narrow black outlines and small finials characteristic of Cheyenne rawhide painting (32, 33) are prominent design elements here.

39. *CASE FOR SACRED OBJECTS*, Blackfeet, 1860s
Rawhide, native and commercial paint, leather, 33 x 32.4 cm.
1940.136. *Illus. p. 71*

Plains medical remedies extended beyond herbs to various sacred objects believed to have supernatural healing powers. When not actively in use, these "medicines" were suspended in a case directly over the owner's bed, where their beneficent power guarded the entire family.

40. *BOX*, Lakota, 1895
Rawhide, commercial paint, leather, cloth, 23 x 45.7 x 30 cm.
Gift of the Sioux Museum. 1956.162. *Illus. p. 70*

Rawhide boxes are a midwestern form made primarily in Iowa by the Fox and their neighbors. Among nomadic Plains tribes, only the Lakota made boxes, to which they adapted their own parfleche designs.

41. *TOOL CASE*, Lakota, 1875
Rawhide, commercial paint, cloth, leather, 28 x 25.4 x 11 cm.
Private collection. *Illus. p. 70*

The three-dimensional container with a rounded base, used by men and women to store tools for tanning hides, carving, and making weapons, seems to have been a form exclusive to the Lakota. The painting on this example shows the Lakota preference for bright color combinations.

42, 43. *PAIR OF POSSIBLE BAGS*, Cheyenne, 1860s
Bison leather, quills, beads, deer toes, metal, horsehair,
37 x 57 cm. and 35 x 54 cm.
Private collection. *Illus. p. 79*

"Bags for every possible thing" is the translation of the Lakota term for soft leather storage containers, usually made in pairs. These bags show an older style of decoration combining horizontal quilled lines and beaded end panels. The now-faded blue quills were colored with dyes and paints purchased from traders.

44, 45. *PAIR OF POSSIBLE BAGS*, Lakota, 1870s
Leather, beads, metal, horsehair, 45.7 x 60 cm. each
1946.110, 1936.122. *Illus. p. 89*

In the early 1870s, the Lakota, Arapaho, and Crow began to apply increasing amounts of beadwork to possible bags until the entire front was covered. Such extensive embellishment was probably dictated by a desire to make the most of their decorative potential: inside a tipi the bags were leaned or hung around the perimeter, and in a pack train they were displayed on either side of the saddle. Exemplifying an intermediate stage in the development of Lakota beadwork, the design on this pair shows the preference established at this time for right triangles and multiple borders in several colors. Although the basic figures remained relatively simple and strong, later Lakota compositions were more complex (70).

46. *WOMAN'S SADDLE*, Blackfeet, 1870s
Wood, leather, rawhide, native paint, brass tacks.
Frame, 30 x 34 x 20 cm.
1939.312. *Illus. p. 90*

Plains women usually rode on saddles similar to this example. Derived

from a sixteenth century Spanish model, women's saddles were often made with even higher pommels and cantles more closely resembling the prototype, which was built to support a rider wearing partial armor.

47. MAN'S SADDLE, Plains Cree, 1850s
Leather, bison hair, quills, horsehair, beads, metal, 46 x 27 cm.
Gift of the heirs of Allen True. 1933.117. *Illus. p. 91*

When not riding bareback, most Plains men used small frame saddles. On the northernmost plains, however, they often used soft saddles made of leather stuffed with bison hair and equipped with stirrups and girth strap; decoration was usually limited to pendants and medallions at the corners. Here, the medallions are coiled bundles of horsehair wrapped tightly with colored strands of the same material. Later, the wrapping material was often trade thread.

48. SADDLE BLANKET, Cheyenne, 1840s
Bison leather, beads, cloth, 178 x 61 cm.
1939.30. *Illus. p.46*

A Plains bareback rider often fitted his mount with a simple leather blanket secured by a leather girth strap. The decoration on this blanket, which indicates that it was used for parades and other formal occasions, exemplifies beadwork of the 1840s, when the popularity of large "pony" beads encouraged bold compositions. From their introduction, blue trade beads were in demand with Plains artists, probably because that color was unobtainable from native dye sources.

49. SADDLE BLANKET, Crow, 1870s
Bison leather, beads, cloth, 1.67 x 1.04 m.
1946.79. *Illus. p. 89*

The Spanish derivation of this blanket, intended for use under a frame saddle, is indicated by its broad trapezoidal shape and the placement of its decoration. Unlike the preceding example, the beading here is worked in small "seed" beads, which Plains women began using in the 1860s and still use today. Representing an early stage in the development of Crow decorative art, the simple, linear figures were eventually superceded by more complex designs (51).

50. BRIDLE, Crow, 1885
Iron, tin, rawhide, commercial paint, beads, horsehair. Bridle, 79 cm. l.
1945.249. *Illus. p. 92*

Spanish horses, acquired by theft or trade, often came to their new owners with some equipment: Spanish iron bits, for example, have been seen in use as far north as Alberta. When the original leather fittings wore out, the Plains people simply replaced them with others decorated according to their preferences. The prototype for the faceplate of this bridle was a metal ornament attached to Moorish bridles to protect horses from evil. The Spanish reinterpreted the motif as the cockleshell of Santiago and, in turn, introduced it to the New World, where it has undergone still further variation.

51. HORSE COLLAR, Crow, 1890
Leather, cloth, beads, yarn, 96.5 x 37.5 cm.
1936.81. *Illus. p. 92*

Decorative collars were tied around horses' necks for parades and other festive occasions. The beadwork on this example illustrates elements of the mature Crow decorative style: isosceles triangles, either single or in opposed pairs, a varied palette; and, on larger pieces, inlays of red cloth. The entire surface, as well as large figures like the triangles, has been divided into several color areas, thus emphasizing the two-dimensionality of the design. In contrast, the monochromatic backgrounds in Lakota

and Cheyenne beading foster the illusion that the figures have been superimposed on the field.

52. MARTINGALE, Blackfeet, 1885
Cloth, beads, brass hawk bells, 24 x 130 cm.
1938.42. *Illus. p. 91*

Although martingales were originally designed as functional pieces of horse equipment, on the plains they served only as decoration, often incorporating bells or other jingling ornaments. Like most Northern Plains people, the Blackfeet were exposed to floral design by Eastern and Great Lakes Indians who came west as employees of the fur trading companies. By the late 1860s, the Blackfeet were producing floral embroidery which showed a preference for symmetrical figures and the "double curve" motif: two equal, opposed curving lines emanating from a common point.

53. CRUPPER, Blackfeet, 1885
Cloth, beads, leather, 110 x 53 cm.
1938.41. *Illus. p. 74*

Like martingales, cruppers appear to have served primarily as decoration on the plains. In this Blackfeet example, the influence of trade goods on Native American art is quite evident: wool cloth has been substituted for leather, both as the field and as fringe embellishment. Although the beaded figures are based on plant forms, the artist has made no attempt to imitate nature's hues; she has selected her colors purely for decorative effect.

54. CRUPPER, Sarsi, 1890
Cloth, leather, beads, metal, 101 x 15.2 cm.
1974.288. *Illus. p. 91*

Although Sarsi craftsmen were heavily influenced by Blackfeet geometric design, they seldom adopted the floral motifs introduced in the later nineteenth century. An unusual aspect of this crupper is the simplified human figure in metallic beads. Such figures were commonly painted on leather or canvas but rarely rendered in beading.

55. SADDLE BAG, Lakota or Arapaho, late 1870s
Leather, canvas, beads, cloth, 200 x 46 cm.
1947.146. *Illus. p. 94*

A slit at the center back allowed the owner to pack both pouches of this double bag, which was then thrown over his horse's back and attached to the rear of his saddle. Precise identification of the bag is difficult: the large diamond and block motifs are typical of the Arapaho, but the small crosses and the triangular shapes surrounding the diamond are well-known Lakota designs.

56. QUIRT, Cheyenne, 1840s
Wood, leather, beads, brass tacks, 1.2 m. l.
Gift of Frederic H. Douglas. 1956.127. *Illus. p. 44*

To create the bold-figured beadwork decorating this quirt, an industrious Plains housewife used the large pony beads popular in the mid-nineteenth century (48). The design harmonizes well with the sawtooth stock, a standard form among Central Plains tribes.

57. MAN'S CLOTHING, Arapaho, 1880
Leather, native paint, quills, brass beads, cloth
1956.155, 1951.362, 1950.61, 1955.159. *Illus. p. 48*

Southern Plains men wore close-fitting leather shirts embellished with

long, thin fringes on the body; sleeve fringes were applied only to a small area at the back of the elbow. Earlier in the century, the shirt, like these leggings, would have been painted with large areas of solid color. On the southern plains, clothing has always been more sparingly decorated than in the central and northern regions. Thus, even when beading became fashionable, it was limited to narrow edgings or small discs, unlike the wide bands common on Northern Plains shirts (61).

58. *WOMAN'S CLOTHING*, Cheyenne, 1880
Leather, beads, native paint, metal
1936.75, 1951.105, 1956.159, 1970.391. *Illus. p. 49*

Southern Plains leather dresses were made of three deerskins, two forming the skirt and one folded as a bodice. The Southern Cheyenne and Arapaho decorated their dresses with narrow bands of beading at the shoulders and chest and scalloped lines of beading at the lower edge; Comanche and Kiowa women preferred to paint their dresses and limited beadwork to edgings. In Oklahoma today, the Southern Plains style of dress has become a prevailing fashion worn at public festivals by women of many other tribes.

59. *MAN'S CLOTHING*, Lakota, 1875
Leather, beads, quills, human hair, cloth
Gift of Anne Evans. 1927.12, 1953.187, 1978.189. *Illus. p. 50*

Central Plains men wore loose-fitting leather shirts, usually painted yellow and blue to symbolize the earth and sky. The wide, beaded or quilled sleeve and shoulder bands of this example have only been characteristic of Lakota and Cheyenne shirts since the mid-nineteenth century. For the decoration of these shirts, each family member contributed a few locks of hair symbolizing the wearer's war exploits and not necessarily representing specific enemies he had killed. Leggings like this pair, with broad side flaps and decorative bands analogous to those of the shirt, completed the Central Plains costume. (*Denver showing only*)

60. *WOMAN'S CLOTHING*, Lakota, 1890
Leather, beads, quills, metal, feathers
1936.127, 1978.184, 1941.53, 1947.195. *Illus. p. 51*

About mid-century, Lakota women started using considerable beading on the upper portion of their dresses; by the 1870s, the entire bodice was decorated. Unlike this otherwise representative example, the background color was usually blue. The eagle plume and mallard ornaments attached to the beaded figures on the back of the dress indicate that as a child the wearer had been the recipient of a *Hunka* ceremony. Those honored in this way often wore some token of it throughout their lives.

61. *MAN'S CLOTHING*, Crow, 1885
Leather, cloth, beads, ermine, feathers
Private collection, 1940.26, 1945.250. *Illus. p. 53*

Northern Plains shirts tended to be heavily decorated: besides beaded arm and body strips, they often incorporated leather and ermine fringes. Among the Crow, shirts were occasionally painted in solid colors while the Blackfeet sometimes added symbols representing war exploits (102). Here, both the shirt and legging panels show the wide range of colors typical of mature Crow style.

62. *WOMAN'S CLOTHING*, Blackfeet, 1875
Leather, beads, cloth, metal
1938.223.7, 1939.98, 1947.91, 1942.45. *Illus. p. 52*

The long Northern Plains dress, introduced from the west between

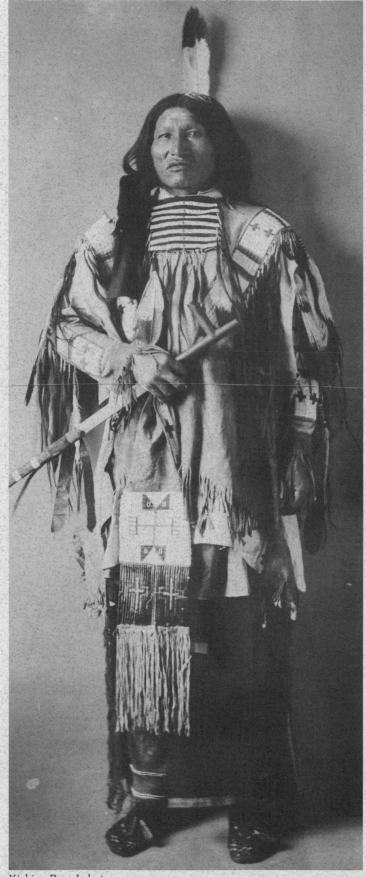

Kicking Bear, Lakota

1800 and 1820, was made from two large deer or mountain sheep skins. Although they do not appear in this example, the tails that were often retained on the front and back of the bodice gave rise to the use of undulating bands of beading. The Blackfeet continued to embroider women's dresses with large pony beads long after they had ceased to use them for other purposes. Visible beneath this dress are decorated, knee-high leggings, which were worn by all Plains women—it was considered improper to appear without them.

63. BOY'S CLOTHING, Crow, 1890
Leather, cloth, beads
1950.69-71. *Illus. p. 54*

Plains children wore smaller versions of adult clothing, usually with less decoration. Perhaps because of the climate, Northern Plains men and boys often wore leggings made from pieces of blanket. The Crow and Blackfeet decorated these with beaded ankle panels instead of the beaded or quilled vertical strips more commonly used.

64. GIRL'S CLOTHING, Cheyenne, 1880
Cloth, shells, leather, beads
1950.102, 1953.158, 1935.30 *Illus. p. 54*

The impact of trade cloth on Plains clothing design is evident in this little dress made of a coarse English woolen called "strouding," which was dyed by a method that left the selvages white. When Native Americans adopted the material, they used these borders for decorative effect. Because trade cloth did not lend itself to traditional clothing patterns, which followed the irregular contours of animal hides, Plains women redesigned garments in rectangular shapes. A vestige of the old style remains in the drop gussets of the skirt, which represent the deer legs retained for decorative effect on earlier, leather dresses.

65. MOCCASINS, tribe unknown, 1840s
Bison leather, beads, cloth, 25.5 cm. l.
1965.249. *Illus. p. 95*

By the mid-nineteenth century, the Northern and Central Plains one-piece moccasin pattern had been replaced by another having separate rawhide soles. This transitional pair, probably from the central plains, is cut in one piece but decorated with a mid-century design.

66. MOCCASINS, Assiniboine, 1890
Leather, beads, cloth, 24 cm. l.
1949.51. *Illus. p. 97*

By the late nineteenth century, most Plains tribes were decorating footwear heavily, a practice they continue today. This example shows a blend of tribal styles. Probably derived from earlier quillwork, the stepped rows of tiny rectangles exemplify the mature Blackfeet beading style, which had spread to neighboring tribes. However, the bold color combinations and especially the backgrounds of dark and medium value are Assiniboine traits.

67. MOCCASINS, Cheyenne, 1885
Leather, rawhide, beads, 27 cm. l.
Lent by the Eastern Washington State Historical Society. *Illus. p. 55*

From about 1820, the predominant Plains shoe style has been the hard-soled moccasin made with a tanned leather upper and stiff rawhide sole. The tall, stepped triangles, particular color combinations, and neat workmanship characterize the classic Cheyenne style.

68. WOMAN'S BOOTS, Comanche, 1870
Leather, rawhide, beads, German silver buttons, native and commercial paint, 48 cm. l.
1948.100. *Illus. p. 56*

Southern Plains women combined moccasins and leggings to make one-piece boots with folded tops. This pair, heavily decorated by Comanche standards, exhibits some of their typical design elements: allover painting and small figures beaded on the uppers. The green color was obtained from pond algae, but the blue, not available through native sources, may be laundry bluing.

69. WOMAN'S BOOTS, Cheyenne, 1870s
Leather, rawhide, beads, German silver buttons, 46 cm. l.
1949.58. *Illus. p. 96*

The principle of appropriateness is illustrated by these boots, which were intended to be worn with a trade cloth dress and, thus, are more lightly beaded than many Cheyenne examples. Beading on boots worn with more formal leather dresses would have fully covered the uppers, as well as the legs to a height of about twenty centimeters.

70. VEST, Lakota, 1895
Leather, beads, quills, cloth, 52 cm. l.
Gift of Mrs. Donald Abbott. 1944.28 *Illus. p. 93*

The European vest was adopted by the Indians, who often cut the garment in the flat, unshaped native style shown here. The beading exemplifies mature Lakota decorative style: right and isosceles triangles, multiple-bordered figures, and various finial elements, all set against a white background.

71. VEST, Cheyenne, 1880s
Leather, beads, cloth, 46 cm. l.
1948.95. *Illus. p. 85*

Occasionally, Plains women copied in beadwork the naturalistic drawings done by men. Here, the artist has shown exceptional skill in adapting the lazy stitch beading technique to the fluid lines of the figures, which include both animals, probably from shields and vision-inspired tipi covers, and mounted warriors from narrative paintings.

72. HALF-LEGGINGS, Eastern Lakota, 1860s
Leather, beads, cloth, brass bells, 47 cm. l.
Lent by Richard A. Novak. *Illus. p. 75*

Part-Indian employees of fur trading companies generally wore cloth trousers, which were very expensive on the mid-century frontier. To protect the lower portions from wear and tear, they commissioned native women to make half-leggings, garments derived from military leggings worn by eighteenth century soldiers. Although the Eastern Lakota borrowed their floral designs from neighboring Woodlands tribes, they characteristically embroidered them in arbitrary colors: leaves, for example, might be pink and blossoms green.

73. CAPOTE, tribe unknown, 1860s
Blanket, cloth, beads, 1.52 m. l.
1970.557. *Illus. p. 93*

Called *capotes* after the French word for hood, blanket coats like this example combined the flat, square-cut pattern and hood form of native leather clothing with a European front opening. Blanket coats were first made in central Canada, probably by native wives of European traders. By the mid-nineteenth century they had spread to the Great Plains, where they were worn extensively until recent times.

74. *BELT,* Arapaho, 1870
Commercial leather, beads, brass tacks, 1.02 m. l.
1946.59. *Illus. p. 95*

Because there seems to be no native prototype for this panel belt made
entirely of trade goods, it may simply represent one of the unexpected
ways in which Native Americans used new materials. Whatever their
origin, panel belts were common throughout the Plains in the later
nineteenth century.

75. *PECTORAL,* Shoshoni, 1880
German silver, 17.8 x 10.5 cm.
Gift of Frederic H. Douglas. 1956.154. *Illus. p. 98*

This pectoral, like the following example, derives from the bridle
faceplate adapted by the Spanish from a Moorish ornament believed
to provide magical protection for horses (50). The crescentlike forms,
which Plains smiths used as pendants, were also adopted by the Navajo
as the *naja* in squash blossom necklaces.

76. *PECTORAL,* Central Plains, 1850
German silver, 8 x 11 cm.
1969.429. *Illus. p. 98*

Scholars disagree about whether pectorals of this type were made
principally by American silversmiths in the East expressly for trade
or by native Plains smiths for personal use. In any case, the prototype
was most likely a native copy of the Spanish bridle faceplate, probably
unknown to American smiths. Plains craftsmen used both standard and
rocker engraving methods to decorate metal ornaments.

77. *HAIRPLATES,* Kiowa, 1865
German silver, cloth, leather, beads, horsehair, 1.96 m. l.
1948.186. *Illus. p. 98*

Circular silver ornaments, or conchas, which probably derived from
prehistoric Southeast shell discs, were introduced to Plains smiths by
displaced Southeast tribes relocated in Oklahoma in the late 1830s.
Among the new uses Plains artists devised for the ornaments were
hairplates, a row of metal discs tied directly into the wearer's back hair.
By mid-century, hairplates had become fashionable throughout the
southern and central plains. This set belonged to the noted Kiowa
warrior Apiatan, or Wooden Lance, who reportedly paid the maker
a fee of one horse. The beaded tassel is a recent replacement.

78. *WOMAN'S BELT,* Cheyenne, 1885
German silver, commercial and native leather, rawhide. Belt, 90 cm. l.,
pendant, 70 cm. l.
Gift of Royal B. Hassrick. 1954.226. *Illus. p. 99*

As the custom of wearing hairplates declined in the 1870s, conchas were
mounted on leather belts. When these became popular, traders made
them commercially available. The Cheyenne and their neighbors,
however, preferred to make their own, which they decorated by
stamping and engraving. Women's belts are distinguished by the added
pendant.

79. *EARRINGS,* Kiowa, 1870
German silver, 6.4 cm. l.
1951.196. *Illus. p. 99*

This traditional and apparently unique Kiowa form representing the
crawdad or crayfish (*Cambarus* sp.) is still made today.

80. *COURTING BLANKET,* Lakota, 1890
Strouding, leather, beads, 1.86 x 2.75 m.
1947.143. *Illus. p. 100*

Plains people used two-color blankets in several ways. Southern Plains
tribes wore them with formal dress and later made them part of the
ritual clothing associated with the Native American Church. Among the
Lakota and other Central Plains groups, however, the blankets were
reserved for courtship. This Lakota example illustrates the essential
requisite of a courting blanket: it is clearly large enough to wrap around
two people.

81. *COURTING FLUTE,* Lakota, 1870
Red cedar wood, native paint, metal, leather, 72 cm. l.
Gift of Rev. C.W. Douglas. 1935.183. *Illus. p. 101*

The bird's head carved on the foot of this flute refers to the Lakota name
for such instruments, *siyo tanka* (the big prairie chicken). The instrument
has a range of about one chromatic octave and is played much like a
recorder. According to the Lakota, if a well-made flute is played
skillfully, its melodies will attract even the most indifferent girl. Some
young men, however, had their flutes blessed by a holy man to ensure
success.

82. *COURTING FLUTE,* Fox, 1860
Wood, leather, metal, 54.5 cm. l.
1941.173. *Illus. p. 100*

Young men were expected to compose original courting melodies. To
embellish a tune, they might overblow certain notes to produce quarter
tones or add a plaintive throat vibrato. The horse's head carved on the
sound block of this flute was meant to aid the suitor by invoking the
ardency of this animal's mating behavior.

83. *PIPE BAG,* Lakota, 1885
Leather, beads, horsehair, metal, quills, rawhide, 81.3 x 18.2 cm.
1948.156. *Illus. p. 112*

The beading on this pipe bag depicts a courtship scene: a young man
brings several horses intended as betrothal gifts to the father of his
fiancée, who stands before her tipi to receive him. Like their Victorian
contemporaries, the Lakota prized moral virtue in young women. This
girl had cause to be proud because the world could see that her suitor
considered her worthy of many horses. The beadworker has revealed
her skill in the details of clothing and figures and in the clever way she
has grouped a herd of horses in a small space.

84. *WEDDING BLANKET,* Crow, 1895
Leather, beads, felt, 1.88 x 2.24 m.
1949.73. *Illus. p. 84*

Although the Crow termed robes decorated in this style "wedding
blankets," women wore them for many other special occasions. At one
time rendered in paint and subsequently in quillwork and beading, the
pattern of horizontal stripes is one of the oldest used in Plains clothing
decoration. Such robes were worn by most Plains groups, but the
variety of colors and the number of small figures within the stripes
here are characteristic of Crow examples.

85. *WAR HONOR DRESS,* Lakota, 1890
Leather, native paint, beads, 1.28 m. l.
1936.120. *Illus. p. 104*

Although only men could participate in warfare, women sometimes
shared in its prestige by wearing garments their husbands had painted

with military narrative scenes. This dress also reflects the nostalgia for traditional life and past glories that obsessed now-idle warriors during the early reservation period. Its skirt appears to have been made from a painted tipi lining, presumably so that its depiction of military prowess would be seen and remembered.

86. *WOMAN'S PIPE*, Lakota, 1880
Wood, stone, 33.5 cm. l.
1951.271. *Illus. p. 103*

Plains women smoked tobacco for personal enjoyment in small pipes like this example, which is simply decorated with bands of pyrography made by applying a heated file to the wooden stem. Men also smoked for pleasure, using similar, though slightly larger, pipes.

87. *CEREMONIAL PIPE*, Lakota, 1830
Wood, catlinite, quills, 1.13 m. l.
1952.418. *Illus. p. 73*

The standard Plains pipe, used by civil leaders for formal smoking, incorporates a T-shaped stone bowl reflecting prehistoric pipes from the Southeast and Midwest, regions traditionally considered the original home of the Lakota, who probably introduced this form to the plains. The stems of pre-1850 pipes were typically long and flat. This example, like many of its period, is decorated with quills applied in a method similar to the ropework technique of racked seizing.

88. *CEREMONIAL PIPE BOWL*, Lakota, 1860
Catlinite, lead, 23 cm. l.
Gift of Miss Edith Thomas. 1941.196. *Illus. p. 103*

To enhance and strengthen the brittle pipestone, bowls of ceremonial pipes were sometimes decorated with inlays of soft metal, especially lead. On this typical example, the elegant geometric figures enrich the shape without detracting from its graceful simplicity.

89. *PIPE TAMPER*, Lakota, 1870
Wood, quills, metal, feathers, 30 cm. l.
1936.343. *Illus. p. 103*

A part of formal smoking equipment, this tool was used to pack the tobacco firmly in the pipe bowl. Women took great pride in furnishing their husbands with decorated tampers like this, as well as with pipe bags.

90. *PIPE BAG*, Cheyenne, 1890
Leather, native paint, beads, metal, horsehair, feathers, 74 x 16 cm.
1946.67. *Illus. p. 83*

When not in use, a pipe bowl was removed from its stem and stored in a bag along with tobacco and a tamper. The mouths of Cheyenne pipe bags were originally cut with four long tabs, which, by the end of the century, had evolved into long pendants hanging from a beaded rim. This example shows the Cheyenne custom of wrapping the upper portion of the fringe with corn husk or other vegetable fiber instead of the quills preferred by the Lakota and Arapaho.

91. *PIPE BAG*, Arapaho, 1885
Leather, rawhide, beads, quills, 94 x 16 cm.
Gift of Mrs. Harry English. 1951.96. *Illus. p. 102*

Central Plains pipe bags were made with compound fringes of stiff, quill-wrapped rawhide above soft leather. The vertical figure at the center of the beaded panel is a characteristic Arapaho motif, and the overall design of the beadwork is less complex than Lakota decoration of the same period (70).

92. *PIPE BAG*, Crow, 1870
Bison leather, beads, cloth, 89 x 15 cm.
1941.33 *Illus. p. 102*

An unusual feature of this bag is the attached case for the wooden pipestem. The dark blue outlines of varying width and the beaded "hourglass" figures are common elements in Crow design.

93. *TIPI*, Standing Bear, Lakota, 1884
Canvas, commercial paint. Base diam. approx. 3.66 m.
1963.271. *Illus. p. 121*

The scenes of battle and horse theft depicted on this tipi, presumably representing experiences of its original owner, illustrate the conventions and relatively realistic proportions of the mature Lakota narrative painting style. A tipi of this small size would have been home to newlyweds or elderly people with no children.

94. *ROBE*, Katsikodi, Shoshoni, 1885
Elk leather, commercial paint, 1.82 x 2.03 m.
1947.268. *Illus. p. 122*

In the 1880s, a Shoshoni artist known variously as Tinzoni and Katsikodi painted a number of robes using this same composition. The robes were probably intended for sale since the design is repeated with little change; the figures of the bison and dancers may even be stenciled. Whether or not the composition records actual war exploits, it shows the culminant style of narrative painting on the plains.

95. *PAINTED SKIN*, Lakota, 1870
Calf leather, commercial ink and paint, 1.03 x 1.2 m.
1952.406. *Illus. p. 123*

Although small skins like this might have been worn by a child, they were usually painted simply "for art's sake." This hide illustrates the usual narrative painting technique, in which the figures were first outlined with pencil or pen and then filled in with color. The artist's careful attention to details of military society regalia is seen in the various feathered lances carried by the charging warriors and in the pompadour hairdresses of their retreating opponents, who are thus identified as Crow or Shoshoni.

96. *PAINTED MUSLIN*, White Swan, Crow, 1880
Muslin, commercial ink and paint, 89 x 221 cm.
1968.336. *Illus. p. 80*

This work illustrates the fixed elements of the narrative painting tradition, as well as its permissible liberties. The artist has rendered all details of clothing, weapons, and action as precisely as his skill allowed. However, he has rearranged the sequence of episodes to achieve a balanced composition and has painted the horses blue and green simply for effect. The protagonist may be identified by his upstanding hairdress and waist-length green shirt (absent in one sequence), both of which indicate his membership in the Lumpwood Society. The Crow alliance with the United States Army against the Lakota explains the American soldier at right center. White Swan himself was an army scout in the 1870s.

97. *PAINTED MUSLIN*, White Bird, Cheyenne, 1890
Muslin, commercial pencil and paint, 1.7 x 2.75 m.
1958.193. *Illus. p. 81*

On his arrival at Fort Keogh, Montana, in 1890, Captain John R. Livermore was billeted in a gloomy log cabin. To lighten its interior, he stretched lengths of plain muslin over the rough walls and asked White Bird, one of his Cheyenne scouts, to paint scenes from tribal history on them. The resulting works depict battles in which the artist's father and uncles took part and reflect the nostalgia his generation felt for the past. Certain figures show rudiments of foreshortening and some variation from the usual profile figures used by Plains painters.

98. *LEDGER BOOK*, Brown Hat, Brule Lakota, 1885
Watercolor on ledger paper, 18 x 13 cm.
1963.272. *Illus. p. 123*

In addition to military scenes, Plains men painted calendars, or "winter counts." Each year was represented by one symbol, which referred to the year's most important event. Although the simple stick figures in Brown Hat's winter count, painted in an Indian Service ledger book, are smaller than those of the original animal-skin calendars, they preserve the painting style in use before mid-century.

99. *WAR REGALIA CASE*, Crow, 1870
Rawhide, commercial paint, leather, 49.5 x 16 cm.
1940.163. *Illus. p. 87*

Although women did not ordinarily use military symbols in their painting, this case for a feathered headdress or protective amulet was undoubtedly painted by a woman. Its borders are decorated in the geometric style typical of women's painting, but its central portion features the military sign for successful horse theft: pairs of small dots representing the tracks of a man and bracket shapes symbolizing those of horses stolen from an enemy camp.

100. *PICKET PIN*, Crow, 1870
Wood, native paint, 32.4 cm. l.
1950.129.3. *Illus. p. 126*

Although wooden stakes were used to tether horses outside tipis, this finely finished pin came from a sacred bundle and was part of a charm invoked to protect a horse thief in enemy camps. The bracket shapes near the top, which represent stylized horse tracks, may be a tally of horses taken with the help of the magic bundle.

101. *ROACH SPREADER*, Pawnee, 1830
Elk antler, metal, 19 x 5 cm.
1968.354. *Illus. p. 127*

The distinctive headdress of porcupine hair called a "roach" is held in place by means of flat plaques of antler or rawhide. This example shows two military symbols: the group of four spear points at the base and the human hand, which signifies that the wearer has engaged in hand-to-hand combat.

102. *MILITARY SHIRT*, Blackfeet, 1880
Leather, beads, native paint, ermine, cloth, 1.19 m. l.
1947.86. *Illus. p. 124*

The small black spots painted on the upper part of this shirt signify that its wearer possessed a war amulet that rendered him immune to bullets. The black tadpolelike shapes sometimes painted on Blackfeet shirts indicate that their owners had been wounded in war. Although typically Blackfeet, the beaded designs on this shirt are probably decorative and without military significance.

103. *DOG SOLDIER SOCIETY SASH*, Cheyenne, 1850
Leather, porcupine and bird quills, maidenhair fern stem, native paint, feathers, plant root, 196 x 18 cm.
1964.288. *Illus. p. 87*

The Dog Soldiers were the most prestigious Cheyenne military society. Like those of similar societies from other tribes, its members sometimes swore never to retreat in battle. During combat, these warriors pinned themselves to the earth by driving a wooden peg through the hole in the bottom of the long sashes that served as their insignia. There they remained until released by a comrade.

104, 105. *TOMAHAWK LODGE STICKS*, Arapaho, 1870
Wood, leather, quills, cloth, deer toes, metal, 1.01 and 1.08 m. l.
1941.202, 203. *Illus. p. 125*

First-degree members of the Tomahawk Lodge, a society open to men in their late twenties and early thirties, carried identifying batons when feasting or dancing publicly. Like all Tomahawk Lodge sticks, these have rudimentary horseheads carved on the ends.

106. *ALL BRAVE DOG SOCIETY HEADDRESS*, Blackfeet, 1860
Cloth, leather, beads, bear claws, feathers, quills, ermine.
Band 52 cm. l.
1938.265. *Illus. p. 86*

Headdresses like this were worn in an All Brave Dog Society dance in which two members designated as "Bear Braves" imitated the motions and growling of bears.

107. *DANCE BUSTLE*, Crow, 1860
Leather, native paint, feathers, beads, brass bells, yarn, 98 x 24 cm.
1948.161. *Illus. p. 88*

This kind of ornament began as a military belt worn by members of the Omaha tribe's Heluska Society. Other Plains tribes adopted the feather bustles for their Omaha societies, which, although based on the Heluska, were more recreational than military. Today the bustle has evolved into a decorative circle of feathers worn by young men in dancing contests.

108. *HANSKASKA SOCIETY SHIRT*, Lakota, 1850
Leather, native paint, human hair, quills, wood, human scalp, 55 cm. l.
1947.235. *Illus. p. 110*

The Hanskaska, or Chiefs' Society, was open only to civil leaders who had distinguished themselves in war. Its most important members, four "shirt wearers," served as the Lakota equivalent of a supreme court. Their shirts, emblems of office, were made ritually and presented to them as part of the investiture ceremony. Although this shirt follows the customary Central Plains pattern, evidence of ritual manufacture by men distinguishes it from secular examples. It is laced together rather than sewn and has no strips of beading or quillwork. The blue and yellow areas symbolize sky and earth, and the hair locks represent all the brave deeds of the Lakota defending their people. Presumably, the wearer personally collected the scalp used as a breast ornament.

109. *MILITARY HEADDRESS*, Lakota, 1890
Leather, beads, feathers, cloth, horsehair, 1.7 m. l.
1947.181. *Illus. p. 105*

Originally, the so-called warbonnets of the plains were the insignia of military society officers. Made from the tail feathers of the golden eagle, they were restricted to a military elite—perhaps fewer than fifty men at any one time among the entire Lakota nation of several thousand. In this century, however, they are worn at Indian gatherings throughout

Foolish Grizzly Bear, Yankton Lakota, 1872

the North American continent. This example shows the military feather headdress in its most fully developed form, with double extensions falling almost to the ground.

110. *HEADDRESS*, Lakota, 1875
Feathers, leather, quills, horsehair, metal, 1.13 m. l.
1936.350. *Illus. p. 120*

This kind of headdress, worn at the back of the head, originally included a protective amulet decorated with quillwork and several feathers trimmed and marked to refer to specific coups. In this example, a later development of the form, the amulet had become a nonsymbolic panel of quillwork and the feathers mere decoration. The traditional method of trimming feathers, however, was retained: portions of the vane were removed, and the quills were shaved to make them flexible.

111. *NECKLACE*, Lakota, 1870
Feathers, cord, beads. Necklace, 52 cm. l., pendant, 45 cm. l.
1947.180. *Illus. p. 127*

Although feathers trimmed to symbolize war honors were usually worn on the head, they were occasionally incorporated into necklaces. The Plains people were aware not only of the meaning of such feathers but also of the varied textures that could be achieved when they were combined effectively.

112. *CLUB*, Lakota, 1850
Oak, brass tacks, cloth, string, feathers, 76 cm. l.
1959.190. *Illus. p. 107*

The ball headed club was known in native North America from New England west through the Great Lakes and onto the northeastern margin of the Great Plains. This example demonstrates that although the Plains people produced little wood sculpture, they understood the principles of three-dimensional composition.

113. *CLUB*, Comanche, 1840
Wood, leather, ribbon, 1.30 m. l.
1956.10. *Illus. p. 126*

Even though the Comanche, who lived in the least-forested part of the plains, rarely made wooden objects, they developed standard designs for articles like this *tekniwup*, a type of club reserved for use by leaders of war parties. Such a club served both as a weapon and as a symbol of the leader's authority over his warriors.

114. *CLUB*, Arapaho, 1850
Stone, wood, rawhide, quills, horsehair, 72 cm. l.
1951.356. *Illus. p. 106*

Lacking suitable hardwoods, men of the western plains used stone for club heads, which were mortised to wooden handles and secured with rawhide sheaths. Women often added quillwork or beading. The unusual amount of quillwork on this club suggests that it may have been the weapon of a war-party leader.

115. *BOW CASE*, Pawnee, 1860
Bison leather, beads, cloth, 1.30 m. l.
1938.86. *Illus. p. 82*

Although most Plains archers wore their bow cases across their shoulders, the Pawnee developed a type which attached around the waist to facilitate shooting from horseback. This example fits the short bow preferred by Plains warriors for equestrian warfare and hunting.

116. *BOW CASE*, Cheyenne, 1860
Bison leather, beads, cloth, 1.03 m. l.
Anonymous gift. 1948.86. *Illus. p. 128*

Unlike the Pawnee example (115), the standard Plains bow case usually carried little decoration. The presence of some beading and cloth trim on this Cheyenne case, however, illustrates the Plains feeling that some embellishment is always appropriate.

117, 118. *BOW AND ARROWS*, Lakota, 1870s
Wood, sinew, metal, feathers. Bow 1.15 m. l., arrows 72 cm. l.
1946.269, 1937.289-291. (In bow case, 116). *Not illus.*

119. *LANCE CASE*, Crow, 1890
Rawhide, beads, cloth, leather, 93.3 cm. l.
1949.3649. *Illus. p. 129*

Only the Crow made protective cases for lance points. Since they were seldom used except for parades, their primary function was probably decorative. The painted and beaded decoration on this case displays hallmarks of the Crow style: long, isosceles triangles and irregular bands of blue bordering most color areas.

120. *GUN CASE*, Crow, 1880
Leather, beads, cloth, 1.05 m. l.
Gift of Mrs. J. P. Dowden. 1942.54. *Illus. p. 128*

While gun cases had the practical function of keeping percussion caps and powder dry, they also fit into the long tradition of making decorated containers for weapons. The beaded and cloth panels on this example seem to be adaptations of bow-case ornamentation.

121. *LANCE*, Salish, 1830
Wood, iron, leather, feathers, 2.56 m. l.
1949.3659. *Illus. p. 125*

Both in fighting and in hunting bison, Plains men used lances with stone, bone, or metal tips. This lance was the property of the noted Salish chief Charlot, who captured it from a Blackfeet warrior.

122. *SPEAR*, Kiowa, 1875
Wood, metal, cloth, beads, feathers, fur, leather, 1.25 m. l.
1941.240. *Illus. p. 125*

Short lances of this design were part of the regalia of officers of the Taime Shield Society, who were protected by the Taime, the most sacred of Kiowa medicine bundles. Understanding of the symbolic decorations, such as the groups of white beads, was lost when the last Taime keeper died in the 1890s.

123. *LANCE*, Big Snake, Lakota, 1940
Wood, otter fur, feathers, leather, 1.77 m. l.
1951.168. *Illus. p. 125*

The Lakota Brave Heart Society and similar groups in adjacent tribes carried such "crooked lances" as part of their regalia. Although they were not actual weapons, the lances were sometimes used in battle to count coup. This lance was made by Big Snake, a Lakota whose grandfather had carried one like it against his enemies.

124. *SHIELD*, Lakota, 1870
Leather, native paint, feathers, wood, 45 cm. diam.
Gift of Rev. C.W. Douglas. 1932.237. *Illus. p. 109*

Shield designs, whose subjects were usually revealed to the artist in a vision, generally include various attachments in addition to the painting itself. The compositions are usually dominated by bold figures that fill most of the circular field like this magic bird who makes thunder by flapping his wings.

125. *SHIELD*, Cheyenne, 1870
Rawhide, leather, native paint, feathers, cloth, brass bells, 48 cm. diam.
1968.330. *Illus. p. 108*

The domestic animals that Europeans brought to the plains became possible subjects for dream art. The figure here represents either a domestic or bison cow whose magic hoofprints marked the earth. Made according to an old pattern, this heavy rawhide shield is covered with a separate, painted, soft leather cover and has various amulets attached to it.

126. *MAN'S LEGGINGS*, Pawnee, 1860
Leather, native paint, feathers, horsehair, cloth, 84 x 38 cm.
1969.459. *Illus. p. 130*

Perhaps because the seminomadic Pawnee of Nebraska were greatly interested in the sky, celestial phenomena figured prominently in their visions. The owner of these leggings, painted with the star figures common to Pawnee dream art, was probably told by his spirit mentor to make them for protection in battle.

127. *MAN'S SHIRT*, Blackfeet, 1930
Leather, beads, native paint, ermine, 81 cm. l.
1938.202. *Illus. p. 111*

When Big Plume, a boy on his first war party, became lost and despaired of finding his way home, he was aided by a shining figure who appeared to him in his dreams on four successive nights. On the last night, the figure instructed the youth to copy the garment he was wearing, a shirt pierced with many holes and painted with red figures. This example, one of several Blackfeet pierced shirts, is the fifth known version of Big Plume's magic garment, which was first made in the 1830s. According to Blackfeet custom, a dream-inspired object may be remade whenever the original wears out, or it may be sold to another person with no diminution of its power.

128. *BUFFALO CATCHER'S HOOD*, Plains Cree, 1845
Leather, feathers, fur, stone, beads, horns, bison skin, 61 cm. l.
1937.139. *Illus. p. 130*

Early Plains hunters camouflaged themselves in bison or wolf skins when approaching bison herds on foot. To give mounted hunters a closer resemblance to their prey, the nineteenth century Plains Cree devised horned hoods, whose efficacy also depended on their magic power to deceive the bison and thereby improve the hunter's luck.

129. *WEATHER DANCER'S SHIRT*, Blackfeet, 1865
Leather, native paint, beads, rawhide, otter fur, ermine, human hair, cloth, 50.8 cm. l.
1938.257. *Illus. p.113*

The red and green spots on this shirt represent rain and cold, which the Weather Dancers were charged with averting during the four-day Blackfeet Sun Dance ceremony. Power to control weather was conveyed in a dream, together with instructions for the necessary paraphernalia.

130. *CEREMONIAL PIPE,* Crow, 1840
Stone, wood, beads, feathers, cotton cord, leather, 80 cm. l.
1938.249. *Illus. on cover*

Some medicine bundles included special pipes believed to bring good
fortune to everyone in the camps where they were kept. The black
stone bowl of this example is a shape typical of Northern Plains tribes,
but the cotton cord tied to the stem is unusual and may have been used
because of its rarity and novelty.

131. *DREAM NECKLACE,* Arapaho, 1820
Wood, leather, beads, ammonites, native paint, 47 cm. l.
1949.145. *Illus. p. 126*

Warriors often had visions of amulets that would protect them in battle.
This necklace, whose power was refreshed by repeated applications of
native green paint, is such a piece. The small stones are ammonites, shell
fossils, believed by the Plains people to contain the spirits of
supernatural bison.

132. *GHOST DANCE SHIRT,* Lakota, 1890
Muslin, watercolor, ink, feathers, 91.5 cm. l.
1942.246. *Illus. p. 114*

Designs dominated by large motifs from the natural world painted
on a plain background are typical of Lakota Ghost Dance garments. In
theory, each Lakota garment was an exact copy of one worn by a dead
relative or friend seen in a vision.

133. *GHOST DANCE SHIRT,* Lakota, about 1895
Cloth, watercolor, 89 cm. l.
Gift of Ella Deloria. 1946.227. *Illus. p. 131*

Big Foot was the leader of the Lakota Ghost Dancers killed at Wounded
Knee. This replica of his vision shirt was made by a survivor a few years
after the massacre, in which Big Foot also died. The design is remarkable
since fish are uncommon in Lakota representational art.

134. *GHOST DANCE DRESS,* Lakota, 1890
Muslin, watercolor, pencil, feathers, 1.3 m. l.
1971.562. *Illus. p. 132*

Because the Lakota were impoverished when the Ghost Dance fervor
began in the late 1880s, they were obliged to make their dance garments
from the cheap trade materials at hand. The haste with which the
clothing seems to have been sewn and painted reflects the dancers'
belief that their aims would shortly be realized. Although carelessly
made, the shirts and dresses are cut like those the Lakota had been
constructing from better quality trade cloth for some forty years.

135. *GHOST DANCE MOCCASINS,* Cheyenne, 1890
Leather, rawhide, commercial paint, beads, 27.3 cm. l.
1941.181. *Illus. p. 115*

Like the shirts and dresses made in the Arapaho and Cheyenne
tradition of Ghost Dance clothing, moccasins were fully painted with
nonrepresentational designs. This pair outlived its sacred function and
was given to a Kiowa, who added the beadwork and wore the
moccasins in secular dances.

136. *GHOST DANCE SHIRT,* Kiowa, 1890
Leather, native paint, 63 cm. l.
1941.187. *Illus. p. 130*

Even tiny children participated in the Ghost Dance in order to ensure

their presence among the redeemed when the apocalyptic winds blew
everyone else away. This little garment follows exactly the pattern of
shirts worn by Southern Plains men in the mid-nineteenth century.

137. *GHOST DANCE DRESS,* Kiowa, 1890
Leather, native paint, 1.84 m. l.
1942.182. *Illus. p. 133*

In painting Ghost Dance clothing, the Kiowa maintained their tradition
of lightly decorated garments. The figures show the Southern Plains
preference for basic geometric shapes rather than the natural forms
chosen by the Lakota. The soft white background of this example is the
natural shade of unsmoked native leather.

138. *GHOST DANCE DRESS,* Southern Arapaho, 1890
Leather, paint, 1.32 m. l.
Lent by Mr. and Mrs. Robert Musser. *Illus. p. 116*

Although this dress conforms to the Arapaho and Cheyenne tendency
to paint the entire surface of leather Ghost Dance garments and to
decorate them with geometric shapes, its use of designs depicting
several natural forms—birds and a human hand—is less common.
(Denver showing and European tour only)

139. *GHOST DANCE DRESS,* Pawnee, 1890
Leather, native paint, feathers, beads, 1.37 m. l.
Lent by the Harrison Eiteljorg Collection. *Illus. p. 117*

This dress is one of seven prepared by a Pawnee Ghost Dancer who had
a vision of seven identically dressed women singing holy songs, a dream
he incorporated into Ghost Dance ritual. Like the Southern Arapaho
dress, this garment combines both natural and geometric forms on a
completely painted surface. *(American tour only)*

140. *FAN,* Harry Buffalohead, Ponca, 1900
Feathers, beads, wood, leather, human hair, silver, 66.8 cm. l.
1951.110. *Illus. p. 41*

Among the Oklahoma artists who have become specialists in making
regalia for Native American Church ceremonies, Harry Buffalohead is
noted for his fans. In this example he has combined feathers from exotic
macaws and green parrots with those of several domestic species to
make a sunburst of color. Tied into the fringe is a tiny religious medal
bearing a portrait of Jesus that reflects the association with Christianity
claimed by some of the sect's members.

141. *FAN,* Cheyenne, 1900
Feathers, wood, beads, leather, 55 cm. l.
1936.76. *Illus. p. 135*

Although Native American Church members call these objects fans,
their actual function seems to be the addition of movement and color
to worship, for they are shaken gently in time to the singing during a
service. Netted beading and trimmed feathers, used on the plains before
the church was established, were incorporated into the embellishment
of its ritual equipment.

142. *FAN,* Kiowa, 1895
Feathers, beads, wood, metal, mescal beans, 66 cm. l.
1941.43. *Illus. p. 134*

Unlike most fans used in Native American Church ceremonies, the
feathers of this example are fixed in a bunch and not movable. The
netted beadwork used to decorate fans of both types lends itself to fine

designs and a wide range of color that apparently refers to dazzling visions sometimes experienced by members.

143. *RATTLE*, Arapaho, 1890
Gourd, wood, beads, leather, 63.5 cm. l.
1936.185. *Illus. p. 135*

During Native American Church services, each member in turn sings his personal vision song while others accompany him with their rattles—gourd resonators that make a soft, percussive sound. The decoration of this Arapaho rattle is noteworthy for the simplicity of its design.

144. *RATTLE*, Comanche, 1895
Gourd, wood, beads, leather, horsehair, 60.4 cm. l.
Gift of Royal B. Hassrick. 1953.366. *Illus. p. 118*

The standard decoration of Native American Church rattles includes the elements seen in this example: netted beadwork, two-ply leather fringes, and a hair or feather tuft as a finial. Some have carved wooden handles as well. The prototype was a similar rawhide rattle associated with medicine bundles.

145. *STAFF*, Cheyenne, 1900
Wood, beads, 97 cm. l.
1949.60. *Illus. p. 134*

Although a sense of equality prevails within the informal hierarchy of the Native American Church, those who organize and host meetings are considered leaders and have certain ritual responsibilities. Leaders may, if they choose, carry decorated staffs to indicate their status. The nonsymbolic motifs on this and many other examples evidently developed as a means of demonstrating the design potential of the netted beading technique..

146. *EARRINGS*, Moses Boitone, Kiowa, 20th century
German silver, 5 cm. l.
1942.127. *Illus. p. 118*

147. *EARRINGS*, Moses Boitone, Kiowa, 20th century
German silver, 4.8 cm. l.
1942.126. *Illus. p. 136*

The metal jewelry associated with the Native American Church makes use of many symbols referring to peyotism and its beliefs. These earrings represent the tipi in which services are held (147) and one of the birds that are believed to carry prayers to the tutelary beings (146).

148. *TIE SLIDE*, Osage, 1880
German silver, 4.8 x 7.3 cm.
1952.331. *Illus. p. 118*

149. *TIE SLIDE*, Osage, 1900
German silver, 5.7 x 8.2 cm.
1952.469.4. *Illus. p. 136*

As part of their costume, men participating in peyote services originally wore silk neckerchiefs secured in front with a tie slide. One of these slides (148) represents the bird symbol common in the sect's metal jewelry. Although the other example (149) resembles the silver pectorals made by Plains smiths in the mid-nineteenth century (75, 76), the engraved fan and crossed drumsticks refer to ritual implements of the Native American Church.

150. *TIE PIN*, Kiowa, early 20th century
German silver, 7 cm. l.
1951.198. *Illus. p. 136*

151. *TIE PIN*, tribe unknown, early 20th century
German silver, 7 cm. l.
1941.124. *Illus. p. 136*

In the late 1890s, peyotists began wearing neckties, either purchased or made from strips of wool cloth, as alternatives to neckerchiefs, and tie pins replaced slides. These examples depict two of the most important images connected with the peyote religion. The "sunburst" (150) symbolizes the peyote button dispersing its benevolent rays to all humanity while the bird (151) represents the scissortail (*Muscivora forficata*), a species believed to carry petitions from worshippers to the all-powerful guardian forces. The movable tail feathers add a lifelike quality to the ornament.

152. *TURBAN*, Kiowa, 20th century
Otter fur, beads, cloth, ribbon, metal, 89 cm. l.
1955.148. *Illus. p. 119*

153. *TURBAN*, Osage, 20th century
Otter fur, beads, ribbon, metal, 92 cm. l.
1950.104. *Illus. p. 119*

The prototype for these turbans, until recently standard regalia for men taking part in Native American Church activities, was the fur turban originally worn on the eastern plains and neighboring midwest regions by tribes, such as the Fox and Iowa, who were forced to relocate in Oklahoma in the late nineteenth century. The style was adopted by the resident Southern Plains people, who, finding otter and other furs scarce, simplified the turban's form and added distinctive decorations, such as the minutely figured, beaded discs and the bands of netted beading on the pendants.

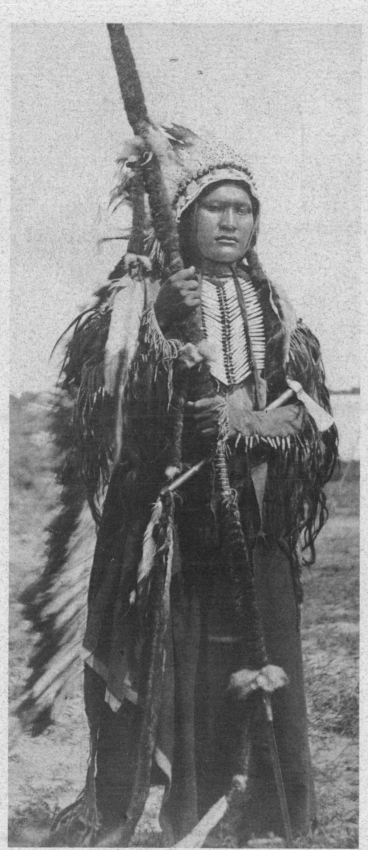

Powder Face, Arapaho war chief, 1870-1871

Ewers, John C. *The Blackfeet: Raiders on the Northwestern Plains*. Norman: University of Oklahoma Press, 1958.

_____. *Plains Indian Painting: A Description of an Aboriginal American Art*. Palo Alto: Stanford University Press, 1939.

Feder, Norman, et al. "Symposium on Crow Indian Art." *American Indian Art*, 6 (1980)): 30-73.

Feest, Christian. *Native Arts of North America*. London: Oxford University Press, 1980.

Grinnell, George B. *The Cheyenne Indians: Their History and Ways of Life*. 2 vols. New Haven: Yale University Press, 1923.

Hail, Barbara. *Hau Kóla!* Providence: Haffenreffer Museum of Anthropology, Brown University, 1980.

Hartmann, Horst. *Die Plains- und Prärieindianer Nordamerikas*. Berlin: Museum für Völkerkunde, 1973.

Hassrick, Royal B. *The Sioux: Life and Customs of a Warrior Society*. Norman: University of Oklahoma Press, 1964.

Horse Capture, George P. *The Seven Visions of Bull Lodge*. Ann Arbor: Bear Claw Press, 1980.

Hyde, George E. *A Sioux Chronicle*. Norman: University of Oklahoma Press, 1956.

LaBarre, Weston. *The Peyote Cult*. Yale University Publications in Anthropology, no. 19. New Haven: Yale University Press, 1938.

Marriott, Alice. *The Ten Grandmothers*. Norman: University of Oklahoma Press, 1945.

Miller, David H. *The Ghost Dance*. New York: Duell, Sloane & Pearce, 1959.

Musée de l'Homme. *Chefs-d'oeuvre des arts Indiens et Esquimaux du Canada/ Masterpieces of Indian and Eskimo Art from Canada*. Paris: Soiété des Amis du Musée de l'Homme, 1969.

Patterson, Nancy-Lou. *Canadian Native Art: Arts and Crafts of Canadian Indians and Eskimos*. Don Mills, Ontario: Collier-Macmillan Ltd., 1973.

Powell, Peter J. *Sweet Medicine: The Continuing Role of the Sacred Arrows, the Sun Dance, and the Sacred Buffalo Hat in Northern Cheyenne History*. Norman: University of Oklahoma Press, 1969.

Slotkin, J.S. *The Peyote Religion*. Glencoe, Illinois: Free Press, 1956.

Trenholm, Virginia C. *The Arapahoes, Our People*. Norman: University of Oklahoma Press, 1970.

Wallace, Ernest, and Hoebel, E. Adamson. *The Comanches, Lords of the South Plains*. Norman: University of Oklahoma Press, 1958.